GAME DEVELOPMENT ESSENTIALS:

VIDEO GAME ART

Todd Gantzler

THOMSON

DELMAR LEARNING

Australia Canada Mexico Singapore Spain United Kingdom United States

THOMSON

DELMAR LEARNING

Game Development Essentials: Video Game Art
Todd Gantzler

Vice President, Technology and Trades SBU:
Alar Elken

Editorial Director:
Sandy Clark

Senior Acquisitions Editor:
James Gish

Development Editor:
Jaimie Wetzel

Marketing Director:
Dave Garza

Channel Manager:
William Lawrensen

Marketing Coordinator:
Mark Pierro

Production Director:
Mary Ellen Black

Production Manager:
Larry Main

Production Editor:
Thomas Stover

Editorial Assistant:
Marissa Maiella

Cover Design:
Chris Navetta

Library of Congress Cataloging-in-Publication Data:

Gantzler, Todd.
 Game development essentials : video game art / Todd Gantzler.
 p. cm.
 Includes index.
 ISBN 1-4018-4066-3
 1. Computer games--Programming. 2. Computer graphics. 3. Video games--Design. I. Title.
 QA76.76.C672G368 2004
 794.8'1526--dc22
 2004007887

NOTICE TO THE READER

CONTENTS

Chapter 3: Polygon Count _____ 68

Chapter 4:
Making the Model for the Texture:
Introduction to Polygon Modeling and Mapping _____ 78

Chapter 5:
Modeling with the Procedural Approach:
Control and Flexibility in Poly Count _____ 122

Chapter 6: Lofting 164

Chapter 7:
Making the Texture for the Model:
Advanced Modeling and Texturing 196

Chapter 8: Box Modeling in Depth ‗‗‗‗‗ 252

Appendix: Choosing the Right Modeling Approach ‗‗‗‗‗ 311

PREFACE

Intended Audience

This book is for anyone who wants to learn to make art for video games. Tiling textures and 3D models are crucial artistic contributions to modern video games. *Game Development Essentials: Video Game Art* teaches a full range of modeling techniques and provides the technical insights and skills necessary to make quality game art effectively and efficiently.

The book is intended for classroom use in any two- or four-year college teaching digital game art. It is useful to anyone who wants to create better game art, inlcuding amateurs and hobbyists. It can also help to expand the skills of less experienced artists working in the game industry.

Background of this Text

In my experience, classes run more smoothly when resources are available that allow students to review material outside of class. Writing syllabi, tutorials, and reference notes, as well as classroom experience, has shown me how to develop and improve those resources. This book is a direct result of my work and classroom experience.

Using this text in the classroom will free up time for the instructor to help individual students and improve their progress in class. With all students supported, better work can be produced.

More institutions of higher learning continue to introduce programs that teach 3D game art creation. These programs need good textbooks to use in class. Existing books on game art are largely aimed at teaching a single modeling method in order to get the would-be game artist up and running quickly. They also focus on more exotic types of models such as humanoid characters, ignoring the more basic but just as necessary game models such as the barrel, the vase, and the lamp. Learning is a process, and many students of game art will need to start with such basic models. Higher education tends to focus on a more thorough and rounded approach. This book is intended for programs that teach low polygon modeling thoroughly, helping the student to learn about all of the modeling techniques available and to know which method is more appropriate for what type of model.

To use this book you will need the following:

+ A working install of 3D Studio MAX version 5 or 6, with all of the Help files (user reference) installed and available.

+ A working install of Photoshop version 7 or higher with all of the Help files (user reference) installed and available.

Both software packages provide documentation so that new users can become acquainted with the software. This book does not duplicate that effort. Unless you have already used 3D Studio MAX, you will need to become somewhat familiar with the software before using this book. A couple of the tutorials that accompany the software should be enough. Under the **Help** menu in 3D Studio MAX, choose **Tutorials....** In the **Contents** panel, read through the items in the list titled **Introduction, Getting Started with 3ds MAX,** and **Introduction to Materials and Mapping**.

Unless you are already acquainted with Photoshop, you will need to become more familiar with the basic functioning of that software as well. Under the **Help** menu in Photoshop, choose **Photoshop Help**. Click **Contents**. Read **An Overview of Adobe Photoshop** and **Looking at the Work Area**. The section on **Selecting** will also be helpful.

Creating 3D art demands the same artistic sensibilities as any art form, and so a background in traditional art is recommended. However, this book does not attempt to teach these things, nor does it assume that the reader has had this sort of experience. It focuses on the technical issues that are for the most part unique to game art and on creative solutions to common problems. It also discusses some of the common artistic concerns and approaches for dealing with them.

Textbook Organization

Chapter 1 explains the basic concepts and vocabulary of 3D. It provides an essential foundation for those who have never used 3D software before and also for those who have dabbled in 3D. Covering this material in class helps to put students, who often have a wide range of prior experience in 3D, on a common level.

Chapter 2 introduces textures. It teaches how to use Photoshop to make textures, how to make textures tile seamlessly, and how to deal with issues of repetition. Strategies for creating and using textures are covered. Complementary sets of textures are discussed.

Chapter 3 deals with polygon counts. The term "low polygon" is explained by offering the polygon rendering specifications of various game consoles and game engines, and by considering the ways that game engines work and the various ways in which low poly

models are used. Questions of where to concentrate detail and how to make effective use of polygon and texture resources are also considered.

Chapter 4 begins to teach 3D modeling and texture mapping. It starts by covering the creation of simple primitive geometry and the manipulation of points and polygons to alter the surface. Texture mapping is often taught after modeling; however, modeling and texture mapping are dependent on one another to some extent. In the case of the spider modeled in the Chapter 4 tutorials, mapping while modeling is more efficient. Readers are introduced to sophisticated texture mapping issues and methods that are expanded upon later. Opacity mapping and bump mapping are explained.

Chapter 5 introduces splines and the value of procedural, or parametric, modeling approaches. Lathe and extrusion are taught. Methods of manually manipulating points, edges, and polygons (often called "box modeling") are expanded upon. Texture mapping is addressed in more detail.

Chapter 6 demonstrates the value and flexibility of lofting, a powerful procedural modeling technique. Tutorials feature appropriate examples that take advantage of the attributes of lofting, including excellent control over shape and polygon count, the ability to modify the model in various ways with minimal effort, and the benefits of a type of texture mapping unique to lofted models.

Chapter 7 introduces patch modeling. A spline-based modeling technique, patch modeling is useful for more organic shapes and offers an approach that some may find a good alternative to box modeling. Chapter 7 also teaches one more approach to texture mapping, an approach that allows one to map with great control any low poly model.

Chapter 8 reveals why some artists prefer box modeling for almost any type of model. A philosophy of box modeling is expounded upon. A simple set of tools are also shown, and used in such a way as to allow the creative process to proceed with minimal interruptions. Tutorials take the reader through the process of modeling a complete humanoid character.

The book thus proceeds from providing a basis in 3D, to an initial understanding of textures and some of their uses, to an introduction of polygons and their uses in 3D games. It then teaches simple 3D modeling and texturing, moves on to several procedural methods of modeling, and covers lofting thoroughly. Simple but effective texture mapping is taught, as well as a more complex but often more effective method. Patch modeling for low poly models and advanced box modeling make up two chapters on advanced modeling.

New concepts and tools are introduced in order of complexity, with each chapter building on information supplied in the previous chapter. Care is taken to insure that skills are supplied as needed to make finished, game-worthy models the result of completing the tutorials in each chapter.

Features

The following list provides some of the salient features of the text:

+ Clearly states the goals of each chapter with a list of learning Objectives.

+ Provides Review Questions at the end of each chapter to quiz a reader's understanding and retention of the material covered.

+ Includes Tutorials throughout the text that teach the skills needed to create 2D and 3D art through techniques using market-leading graphics software.

+ Explains and demonstrates a wide variety of polygon modeling techniques and patch modeling for low polygon models, with discussion of how to choose the most appropriate modeling method.

+ Explains and demonstrates the creation of high quality textures for both models and environments, ways to use textures effectively, and efficient methods for applying textures to models.

+ Offers insight and information about today's game engines to assist in making art that conforms to common technical specifications.

+ Includes a CD at the back of the book containing example files that focus on specific approaches and techniques for the game artist's primary jobs—modeling and texturing.

Before You Start

To get the most from this book, read each chapter in sequence, do the tutorials, and then create models of your own, as prescribed by the exercises in the book, using the methods you just learned. You can do a little preparation that will make the process of choosing an appropriate model or texture go more smoothly.

Choose some theme that you'd like to work with and research it at your local library, on the Internet, and anywhere else you can think of. This might include your local art museum, or just the world around you (for an urban or suburban theme, for example). Collect as much inspirational and referential imagery as possible for your theme. Copy images from books. Download images from the Net. Shoot pictures on film or digital cameras. The images can come from any source and should address such concerns as style, authenticity, atmosphere, color, lighting, and so on. Drawings or paintings may be included. Your theme should allow the design of an environment containing many individual models in addition to the environment or space itself. Chapter 2 goes into some detail on the value of reference and of looking at the real world.

Thus prepared, you should easily be able to choose a model to build by using what you have just learned and creating models and textures based on objects in the reference imagery. Examples and descriptions in the book will help you understand the kinds of models that can be built using each method.

Nearly any theme is possible. The book itself is an example of the progression from research to model and texture creation to complete game environment. The "research and reference" directory on the CD-ROM contains the reference imagery for a Buddhist garden theme. It contains imagery supplying ideas for textures and models created in the book tutorials. It culminates in the scene on the book cover. In many cases, the reference images are converted quite directly into useful game textures or models.

When you finish the book, you will have a small collection of models and tiling textures. With a little extra effort, you can combine this work into a small game environment, possibly for inclusion in a portfolio. You can work entirely in 3D Studio MAX or build your environment in a game engine with which you are familiar.

To really test yourself, build your environment at three Levels Of Detail: one MAX file with the environment at 20,000 tris, one with the environment at 40,000 tris, and one with the environment at 60,000 tris. Limit your texture use to four megabytes of .jpg images. If you choose to work in a game engine, try to choose one that allows LOD models and build three LOD for each model you make.

E.Resource

The CD was developed to assist instructors in planning and implementing their instructional programs. It includes sample syllabi for using this book in 8-, 11-, or 15-week semesters. It also provides answers to the Chapter Review Questions, as well as PowerPoint presentations, digital slides for classroom use, and additional instructor resources.

ISBN: 140184068X

Back of Book CD

The back of book CD-ROM contains some very helpful and widely used plugins for 3D Studio MAX: Chilliskinner, by Colin "Chilli" Semple; Meshtools, by Laszlo Sebo; and Texporter, by Cuneyt Ozdas. It also contains 3D files and image files for use with the book tutorials. Other files are included as examples of subjects discussed in the book. Among these are various .avi animation files demonstrating 3D concepts.

How to Use this Text

The sections that follow describe text elements found throughout the book and how they are intended to be used.

OBJECTIVES

Learning objectives start off each chapter. They describe the competencies the reader should achieve upon understanding the chapter material.

NOTES AND SIDEBARS

Notes and sidebars are interspersed throughout each chapter. Notes provide special hints and practical techniques. Sidebars offer additional valuable information on specific topics.

EXERCISES

Short exercises are provided throughout the text to assess the reader's understanding of the content through practical application.

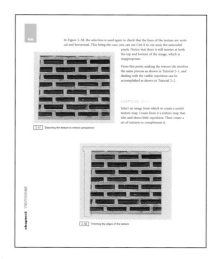

TUTORIALS

Tutorials are located throughout the text. They serve as a hands-on introduction to the skills and methods needed to create 2D and 3D art using industry-standard graphics software.

INSIGHT FROM INDUSTRY PROFESSIONALS

Successful game artists provide industry insight and tips of the trade.

REVIEW QUESTIONS

Review questions are located at the end of each chapter and allow readers to assess their understanding of the chapter.

About the Author

Todd Gantzler is the Program Leader for the Computer and Video Games honors degree program at the University of Salford in England. Todd designed and taught the first game art classes at the San Francisco State University Multimedia Studies Center and the Academy of Art College in San Francisco. He has been teaching 2D and 3D computer graphics since 1997 and has taught digital game art and design since 2000. He worked as a 3D artist on such game titles as *Gex 3D*, *Cyberia*, and *Akuji the Heartless*. He spoke on the subject of "Foxing" and intellectual property rights at Quakecon 2000.

Todd graduated from an early masters degree program in computer graphics and animation at The Ohio State University, at the Advanced Computing Center for the Arts and Design, after earning an undergraduate degree in Fine Arts.

At the University of Salford, Todd is responsible for administration, admissions, and day-to-day running of the Computer and Video Games degree program. He teaches game art and final year game design/production and portfolio classes.

Acknowledgments

Thanks are due to the following people:

Tony Lupidi, for quality insight and input in the form of detailed feedback, and for his extensive words of wisdom quoted in the text.

Mick Lockwood, for sharing his expertise in box modeling and writing much of Chapter 8.

Paul Jaquays and Tom Heaton, for sharing their experience and words of wisdom.

Giuseppe Lucido, for research into game console specifications.

The creative people of the Republic of Korea, for artistic and other inspiration.

Thanks also to the folks who wrote the valuable software included on the CD-ROM:

Hugh A.J. McIntyre, for his 3D model viewer program

Laszlo Sebo, for Meshtools

Colin "Chilli" Semple, for Chilliskinner

Cuneyt Ozdas, for Texporter

Delmar Learning and the author would also like to thank the following reviewers for their valuable suggestions and expertise:

Daniel Brick
Director, Game Art & Design Program
The Art Institute of Portland
Portland, Oregon

Eric Gillam
Game Art and Design Department
The Art Institute of Phoenix
Phoenix, Arizona

Tim Langdell
Director, Game Art & Design Department
The Art Institute of San Francisco
San Francisco, California

Vi Ly
Director, Game Art & Design Department
The Art Institute of California-Los Angeles
Santa Monica, California

Royal Winchester
Art Department
DigiPen Institute of Technology
Redmond, Washington

The author would like to thank the following people at Delmar Learning:

Jim Gish: Senior Acquisitions Editor

Jaimie Wetzel: Developmental Editor

Marissa Maiella: Editorial Assistant

Tom Stover: Production Editor

Rachel Baker: Art & Design Specialist

And at Argosy Publishing:

Kevin Sullivan: Project Manager

Laura Proietti: Page Layout and Composition

Todd Gantzler
2004

Questions and Feedback

Delmar Learning and the author welcome your questions and feedback. If you have suggestions that you think others would benefit from, please let us know and we will try to include them in the next edition.

To send us your questions and/or feedback, you can contact the publisher at:

Delmar Learning
Executive Woods
5 Maxwell Drive
Clifton Park, NY 12065
Attn: Graphic Arts Team
800-998-7498

Or the author at:

SMMP
Adelphi Campus
Adelphi Building
Peru Street
Salford M3 6EQ
United Kingdom
todd@toddgantzler.com

In 3D modeling it is essential to have a good understanding of 3D space and the ways in which it is represented in two dimensions. It is important to develop a good spatial sense, and the terminology of 3D must be learned and understood.

CHAPTER

1

BASIC 3D

OBJECTIVES

+ Learn the essential, most basic principles of 3D

+ Learn the vocabulary of 3D

+ Understand x, y, and z and 3D space

+ Learn to navigate and understand 3D space using 2D orthographic (and other) views

+ Become familiar with points and polygons

+ Become familiar with surface normals and backfacing polygons

+ Learn about the basic transformations

+ Understand the various transform systems

The Third Dimension

Much of drawing and painting involve representing three-dimensional objects and three-dimensional space in two dimensions. The same techniques are used to display 3D computer graphics on 2D computer screens. Although these media are flat (two-dimensional), various methods are used to communicate the third dimension. The perception of the third dimension in two-dimensional images, as in Figure 1–1, has become second nature.

1–1 Three dimensions depicted in two dimensions

Figure 1–2 is a two-dimensional representation of a two-dimensional object: a square. Experience tells us that this could also be an artist's representation of a cube, however information about the third dimension is not visible in this image. Let's call the two dimensions represented width and height, and the dimension that is missing depth.

A square is one possible type of **polygon**. A polygon is a closed figure, bounded by three or more line segments, connecting three or more points (sometimes called a "poly" for short). A **point** is simply a location in 3D space. There must be at least three points in a polygon, since two points can only define one line segment, which has length but no surface area. A point is also called a **vertex**; multiple points **vertices**. A line segment that defines one side of a polygon is called an **edge**.

A square is made up of four lines. A line is a one-dimensional entity; it has length, but no width or depth. Each line (or line segment) connects two points (vertices), which have no dimension, but are merely locations in space. There is a point (vertex) at each corner of the square. A square is one possible surface. A cube has six surfaces. The term "surface" is used in different ways in 3D, but it conveys the right idea for the moment.

1–2 A square

It is obvious that the object shown in Figure 1–3 is a cube, because the third dimension is clearly represented. Note that you perceive this as a cube even though only three surfaces are visible. This representation is similar to an **isometric** drawing, one type used in drafting to accurately represent a three-dimensional object in two dimensions. Another is the **orthographic** drawing.

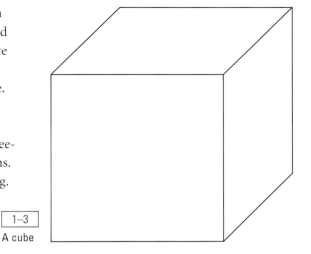

1–3
A cube

Orthographic Drawing

In an orthographic drawing, separate drawings, each from a different angle, represent a single three-dimensional object. Figure 1–4 is an example of an orthographic drawing. This drawing, like many orthographic drawings, uses a grid to communicate information about the size of the object. This particular drawing looks like the viewports of 3D Studio MAX. For now, think of the dark gray lines as representing units, and the lighter gray lines quarter units.

Computer graphics takes the concept of orthographic and isometric views from earlier methods used by engineers and architects, who drew their two-dimensional representations of three-dimensional objects on paper. In 3D Studio MAX, the different orthographic views are displayed in separate windows within the interface. These windows are called **viewports**.

Note that a true orthographic drawing will represent hidden lines, or lines that would not be visible when looking at the actual solid object because they are behind other surfaces of the object (from a given view), as dotted lines. In many 3D systems, such as 3D Studio MAX, all lines are drawn the same.

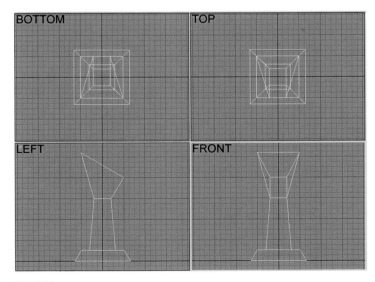

1–4 Orthographic drawing

In Figure 1–5, the blue circle identifies the same point on the object in the four views. Note that the drawing is arranged in such a way as to make the relationships between the four views as clear as possible. The point circled in the front view lies on the same horizontal line as the point in the left view, which lies on the same vertical line as the circled point in the top view (this relationship doesn't work between top and bottom views). Orthographic drawings are drawn in this way.

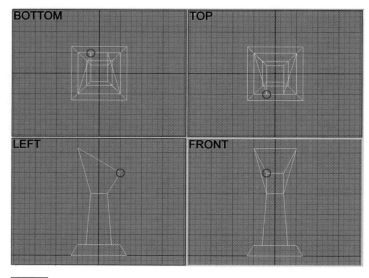

1–5 | Orthographic drawings and three dimensions

Figures 1–6 and 1–7 are two isometric views of the same object. In an isometric drawing, the object is drawn from an angle 45 degrees from the orthographic views; if the object were a cube, the camera would be looking directly at one corner. Figure 1–6 is a **wireframe** representation of the object—just the outlines are drawn. Figure 1–7 is an example of **faceted shading**, which is one type of **rendering**. Wireframe is another. Rendering in the context of 3D software is the drawing of a 3D model by a computer. **Shading** is the drawing of each polygonal surface, not just the line segments that define each polygon. Shading can be very simple, as in the case of faceted shading, where each face is filled with a single color. Of course it can be much more complex, as you will learn later in this chapter.

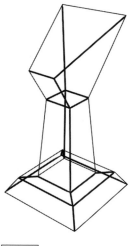

1–6 | Isometric: wireframe

1–7 | Isometric: shaded

::::: Orthographic Viewports

Ani-01-01 (a short video available in the Ch01\animations directory on the CD-ROM) may help to clarify the relationships between the four views and between the orthographic drawing and the 3D model. The model, drawn in black, rotates as it moves from one view to the next, aligning itself with the two-dimensional projection in the drawing. There are six possible views that can be included in an orthographic drawing. This drawing includes four. What are the two missing views? Models this simple can usually be accurately described using three views. Of the four shown in Ani-01-01 (and Figure 1–5), which is the least necessary?

EXERCISE 1–1 :::

Refer to the orthographic drawings in this chapter (such as Figure 1–4) to create a physical model of this object, using graph paper and rubber cement or tape. You can think of the dark gray squares as equal to 1 inch, and the lighter squares as 1/4 inch. At this scale, the model would be 3 1/4 inches tall. If this is smaller than you would like to work, you can double every measurement. You will probably first need to recreate the full orthographic drawing. The graph background helps in measuring heights, widths, and depths, but you will also need to measure the dimensions of the individual surfaces, and they are not always perfectly vertical or horizontal. As you can see in Figure 1–8, the height of the red highlighted surface in the drawing is not equal to its actual length. This is a 2D drawing of a 3D model; in order to construct it, you will have to create an accurately proportioned two-dimensional drawing of each surface.

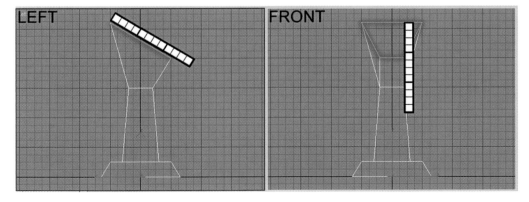

1–8 Measuring surfaces

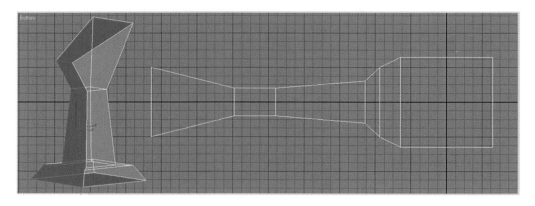

1-9 | Folded paper model

Figure 1–9 shows what the red highlighted faces would look like if they were laid out flat. If you redraw the portion of the drawing on the right, you can construct the entire model just by duplicating it and modifying the two leftmost polygons.

If you have problems with your model, you can print out *Fig-01-10* (Figure 1–10) from the CD-ROM. Compare it to the orthographic drawings, try to understand the relationships, and then cut out and assemble. Tabs for gluing are not provided, but you can use tape to assemble the model.

Figure 1–11 shows the model as constructed from Figure 1–10.

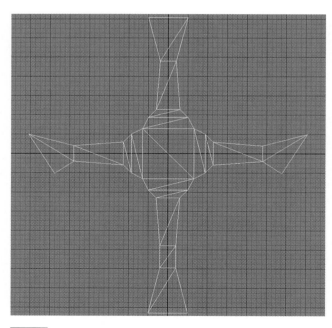

1-10 | Folded paper model, complete

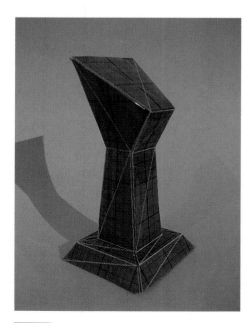

1-11 | Folded paper model, assembled

EXERCISE 1–1A:::

Next, make an orthographic drawing of a simple object of your own creation. Then create a 3D model of this object, using graph paper and/or card stock and rubber cement or tape.

Points and Polygons

The term **surface** has been used to describe the square in Figure 1–12. This term can also be used to describe the entire surface area of a model, such as the one shown in Figure 1–13.

This model, like many computer models, is composed of many simple, quadrilateral (four sided) surfaces. Simple surfaces like these, called polygons, are the basic building blocks of polygonal models.

1–12 Surface: one definition

1–13 Surface: another definition

1–14 | A line segment

This bears repeating: a polygon is a closed figure, bounded by three or more line segments, connecting three or more points. A point is simply a location in 3D space. There must be at least three points in a polygon, since two points can only define one line segment, which has length but no surface area (see Figure 1–14). A point is also called a vertex; multiple points vertices. A line segment that defines one side of a polygon is called an edge.

There are several more characteristics required of polygons by most, but not all, 3D systems. Most systems cannot handle a polygon that is not **planar**; that is, one whose points do not all lie in the same plane. If you draw a square on a piece of paper, you can be certain that all four points lie in the same plane. This is not necessarily true in a 3D medium. As the square in *Ani-01-02* on the CD-ROM turns so that you can see it from the side, you can see that the four points do not all lie in the same plane.

::::: Terms with Many Meanings

You will encounter many terms in computer graphics that are used to mean different things, as with the two uses of the word "surface." You will also find that there is often more than one word that is used to describe a single thing; for example, **faces** are the same as polygons. You will also learn that the exact definitions of these words can change depending on the school or work culture you may find yourself in. To site one important example, in 3D Studio MAX version 3, faces are *not* the same as polygons—"face" is used to describe three-sided polygons, and "polygon" is used to mean four or more sides. A three-sided polygon is also called a **tri** or triangle. A four-sided polygon is a **quad**. Fortunately, this ambiguity of terminology doesn't seem to get in the way of understanding 3D.

In a complex model, it can be difficult for the user to be sure that all faces are planar. Because of this, some 3D systems require that all polygons be three-sided. Three-sided polygons are always planar, since any three points always share a common plane. In such a system, a quadrilateral is constructed of two triangular polygons, as shown in Figure 1–15.

3D Studio MAX is such a system. Sometimes it appears that polygons have four or more sides, but there is a hidden edge, or edges, which, if displayed, would reveal that the polygon is composed of triangular faces.

1–15 Quadrilateral composed of two triangular polygons

Most 3D systems require that polygons be convex. With a convex polygon, you can draw a line between any two points without going outside of the polygon. Figure 1–16 shows an example of a convex polygon. The polygon in Figure 1–17 is concave. Systems that demand three-sided polys avoid this issue, since triangular polys are always convex. The shape in Figure 1–17 should be constructed from two triangular polys.

1–16 Convex polygon

1–17 Concave polygon

On the computer, a polygon is defined by listing the points in a particular order. Improper ordering of points can produce undesired shapes, and possibly invalid polys. Figure 1–18 shows the proper sequence of points for a square polygon. Figure 1–19 is the result of improperly ordered points. Not only is the shape incorrect, it is also self-intersecting, which means that two or more lines cross. This cannot be drawn by many 3D systems.

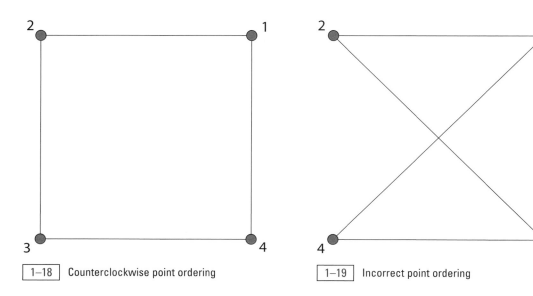

1–18 Counterclockwise point ordering 1–19 Incorrect point ordering

Backfacing Polygons

The order in which the points are listed is important for another reason: point ordering allows the computer to tell which way the point is facing. Many 3D computer models are **closed mesh**, which means that the surface completely encloses some area. A closed mesh can be said to have an outside surface and an inside surface, which is never visible. The model you've been working with is such a model. When the object is drawn flat shaded, as in Figure 1–20, many of the polygons are not visible. Without special instructions, however, the computer will still have to draw every polygon. The concept of backfacing polygons allows the computer to save time by not rendering polys that face away from the viewer.

1–20 Shaded view

The wireframe renderings in Figures 1–21 and 1–22 allow you to see through the surface of the model. The model in Figure 1–21 was rendered with backfacing polygons removed; the model in Figure 1–22 has all faces rendered.

See also *Ani-01-03* and *Ani-01-04* on the CD-ROM.

| 1–21 | Wireframe view, backfacing polys culled | 1–22 | Wireframe view, backfacing polys drawn |

You may have noticed something odd about Figure 1–21—there are some polygons that are actually visible through the model (those on the base). This is not unusual; those polygons do face toward the viewer, so they are drawn in their entirety. Backface removal is not the same as hidden-line removal, which turns out to be relatively complex, and thus slow, for a computer to calculate. A computer does backface removal very quickly.

In order to determine in which direction a polygon is facing, the computer looks at the order in which the points are listed. In a properly constructed polygon, as in Figure 1–23, the points are listed counterclockwise around the poly as it appears from the front. If the computer encounters a polygon in which the points appear in clockwise order, it knows that the poly is currently facing away from the viewer. Discarding backfacing polygons saves a lot of render time (time spent drawing the model or scene). The user can usually choose to have backface removal performed on some objects in a scene and not on others. With **open mesh** models, such as the vase in Figure 1–24, you will probably need to

have both sides of the polygons rendered; therefore, no backface removal should be performed. (You can tell this model is an open mesh because the walls of the vase are only as thick as the planes they are built from, meaning they have no thickness. You can tell this by looking at the rim. Although this is usually not good modeling practice, it is useful in some situations—real-time 3D, such as games, for instance.)

Backfacing is relative

It is important to be aware that no polygons are inherently backfacing or frontfacing; it depends on the viewer. A polygon that is frontfacing when viewed from one side will be backfacing when viewed from the other side.

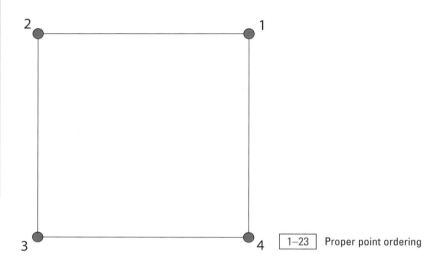

1–23 Proper point ordering

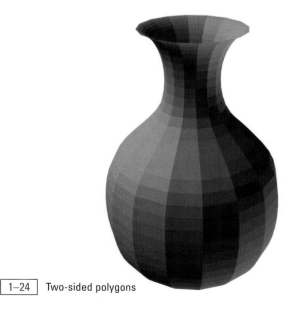

1–24 Two-sided polygons

EXERCISE 1-2:::

The model in Figure 1–25 has two quads that are non-planar; that is, they consist of two triangular faces that do not lie in the same plane. Refer to Figures 1–25 and 1–26 to identify them, and draw in the appropriate edges.

Then divide the model you designed in Exercise 1–1a into triangular polygons. Try to find any quads that may be non-planar.

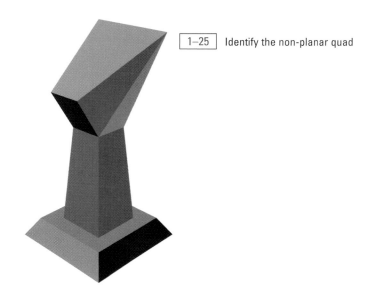

| 1–25 | Identify the non-planar quad

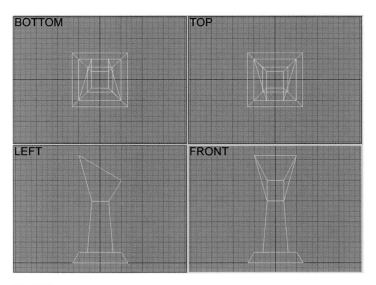

| 1–26 | Identify the non-planar quad

Shading

In the process of shading, the computer determines what the object looks like at each point on its surface. To do so, it must consider such factors as the color of the object, the location and brightness of the lights, and any texture information. An especially important piece of information used by the computer is the **surface normal**. A surface normal is basically a line (technically a ray, which starts at a point in space, and extends infinitely in one direction) perpendicular to the plane of a polygon, indicating which direction a polygon is facing. The surface normals are usually calculated by the computer for each polygon in an object. Figure 1–27 shows a simple polygon and a representation of its surface normal.

Surface normal

Surface

| 1–27 | Surface normal

The simplest and fastest approach to shading is Lambert shading, or faceted shading. The computer uses the surface normal of each polygon to determine how directly the poly is facing each light, and thus how brightly the poly is lit. The entire surface of a polygon gets its color information from this one calculation. Objects shaded this way tend to look faceted, meaning that the many flat surfaces of which they are composed are apparent.

Objects with large flat surfaces are relatively easy to model with polygons, and render well with faceted shading. Objects with curved surfaces, like the cylinder in Figure 1–29, are somewhat less straightforward. Using large numbers of polygons begins to approximate smoothness, but large polycounts increase the time it takes to render. The cylinders in Figures 1–28 and 1–29 represent two different cases; in Figure 1–28 the cylinder has eight quads around its circumference; Figure 1–29 has twenty-four.

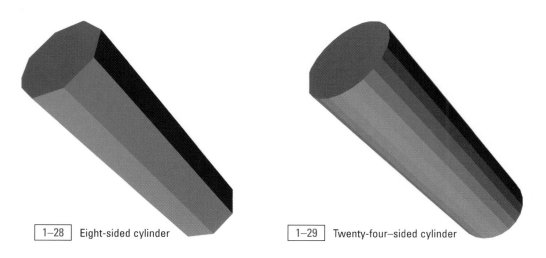

| 1–28 | Eight-sided cylinder

| 1–29 | Twenty-four–sided cylinder

See also *Ani-01-05* on the CD-ROM, in which the cylinder animates between eight and twenty-four sides.

There are several smooth-shading techniques to aid in the modeling and rendering of curved surfaces. These methods use **vertex normals** in different ways to calculate the appearance of a curved surface. Polygons often share vertices with neighboring polygons. The vertex normal is an average of the surface normals of all polygons sharing the vertex. Figure 1–30 shows a visual representation of a vertex normal, an average of the four surface normals.

The vertex normal of each point in a polygon may be different, thus shading may vary over the surface of each polygon. The area closest to a vertex shared by several polygons will be nearly the same color on each polygon, since the same vertex normal is being used in the calculation. The result is that hard edges are smoothed out, helping to hide the fact that the object is composed of flat surfaces, as in Figure 1–31. This method is also called **Gouraud shading**.

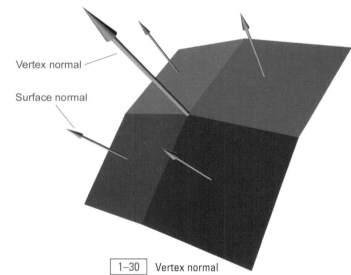

Vertex normal

Surface normal

1–30 Vertex normal

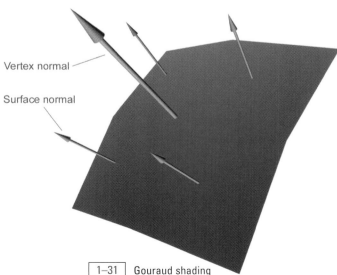

Vertex normal

Surface normal

1–31 Gouraud shading

Phong shading uses a somewhat more complex calculation, producing better results, although more slowly. Gouraud shading calculates the color at each vertex, and **interpolates**, or transitions smoothly, from one color to the next between vertices. Figure 1–32 shows color interpolated over the surface of a polygon based on the color of each vertex.

1–32 | Gouraud shading

Phong shading uses **vertex normal interpolation** to create a separate normal, and does a separate lighting calculation, for each location on the surface of a polygon. Similar to the way a vertex normal is calculated by averaging the normals of the surrounding faces, vertex normal interpolation averages the vertex normals of the polygon, weighted toward the vertices closest to the surface area in question. This calculation is done once for each **pixel** that makes up the poly. Computer images are composed of many discrete dots of color; each dot is called a picture element, or pixel. A computer display monitor displays pixels, as does a television screen. Pixels are also the dots of color that make up a digital image; these pixels may not correspond directly to the pixels on a computer monitor. For example, a digital image may be displayed on your monitor in such a way that a single pixel in a digital image is made up of numerous screen pixels.

Shading, normals, and the game artist

How does an understanding of the types of shading help the game artist? An understanding of the basic working of 3D systems is important to understanding 3D systems. You can learn to use a 3D system's interface without understanding what the system is doing at a low level, but a real understanding of the workings of 3D systems will make it easier to understand any 3D system. Once you know what 3D systems can do, you merely need to find out how a particular interface makes the functionality available to the user.

For the most part, a game artist's interaction with normals is to flip them when necessary—when they are facing the wrong way. In some tools you may find that you will need to recalculate the normals so that the model is shaded correctly. Both are generally accomplished with the push of a button. It is usually just as simple to choose Gouraud or Phong shading as available in a particular game.

xyz Space

Orthographic drawings attempt to describe a three-dimensional object with (approximately) three two-dimensional views. These 2D views are planar projections of a 3D model; that is, they are rendered without perspective. The planes described by these views are perpendicular to one another, like the faces of a cube. The graph helps to measure vertical and horizontal distances. So far, the three dimensions have been referred to as width, height, and depth. 3D computer graphics generally uses the Cartesian Coordinate System to deal with 3D space. Terms like width and height are relative to what one considers the front of the object; all of these terms are relative, and will have different meanings for different people. The Cartesian Coordinate System comes from the field of geometry, and uses the labels x, y, and z for the three dimensions. Most systems treat x as similar to width, y as height, and z as depth. There are exceptions even to matters as basic as this, however; 3D Studio MAX treats z as the vertical axis, and y as depth. Coordinate systems use the concept of the **origin**, the reference point from which all locations in space are measured. The origin can be thought of as the center of the computer universe. The origin is the intersection of the x, y, and z axes (plural of axis).

In Figure 1–33, the x axis is red, the y axis green, and the z axis blue. 3D Studio MAX uses this convention.

The locations of all points in 3D space are defined by their distance from the origin in x, y, and z. The origin is at 0 in x, 0 in y, and 0 in z, or 0, 0, 0. The axes, as represented,

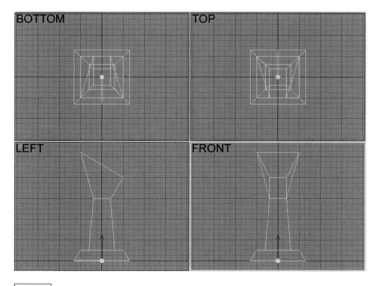

| 1–33 | Coordinate system, origin, and axes |

point in the positive direction. Figure 1–34 shows locations along the x and y axes. It was previously suggested that you think of the light gray lines as quarter units and the dark gray lines as units. The point circled in blue lies at approximately −1.0 in x and 5.25 in z. Its y location cannot be determined from this view. In this case, the front view is a view of the x-y plane.

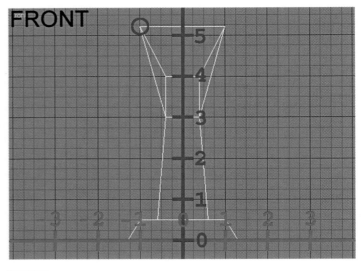

1–34 Distance from origin

In Figure 1–35, eight of the points are labeled with their vertex numbers. Points that lie behind one another in a view are listed with a separating slash (0/1), with the point closest to the viewer listed first. The text in Table 1–1 is the actual 3D data in Wavefront's Object file format, a plain-text file format for storing 3D models. There are a great many file formats for storing 3D objects and scenes; Object file format is used here because it is very easy to read and understand. These files have an .obj extension (for example, model.obj).

Highlighted in red are the four faces that make up the top and bottom of the object (for visual clarity, the top and bottom views only show the top and bottom faces in red, respectively). Vertices are listed by their locations in x, y, and z. Neither faces nor vertices are numbered

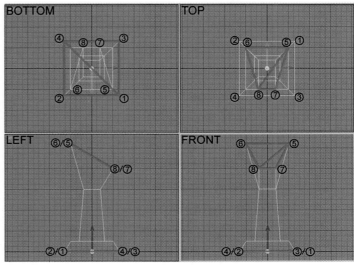

1–35 Construction of polygons

in the object model format, but numbers have been provided in separate columns in Table 1–1 for your convenience. Faces are listed with the points that compose them, in the proper sequence. The top- and bottom-most faces (and the vertices of those faces) are listed in red in the data, to make them easier to locate. Although this model appears to be made up of quadrilateral polygons, each face is actually composed of two triangles. Some 3D systems allow shared edges within quads to not be displayed. Shared edges are not shown in Figure 1–35 for purposes of simplicity, although they are shown in the highlighted faces. Study Figure 1–35 and the data in Table 1–1. Check the location of the points against the data. Notice the counterclockwise ordering of points in face definitions. This file is available on the CD-ROM, named *sample1.obj*.

Table 1–1

1	v	1.3000	1.3000	0.0000	9	f	13	14	18
2	v	−1.3000	1.3000	0.0000	10	f	18	17	13
3	v	1.3000	−1.3000	0.0000	11	f	17	18	6
4	v	−1.3000	−1.3000	0.0000	12	f	6	5	17
5	v	1.0000	1.0000	5.2000	13	f	2	4	11
6	v	−1.0000	1.0000	5.2000	14	f	11	10	2
7	v	0.4000	−1.0000	4.0000	15	f	10	11	15
8	v	−0.4000	−1.0000	4.0000	16	f	15	14	10
9	v	1.0000	1.0000	0.5000	17	f	14	15	19
10	v	−1.0000	1.0000	0.5000	18	f	19	18	14
11	v	−1.0000	−1.0000	0.5000	19	f	6	18	19
12	v	1.000	−1.0000	0.5000	20	f	19	8	6
13	v	0.6000	0.6000	0.5000	21	f	4	3	12
14	v	−0.6000	0.6000	0.5000	22	f	12	11	4
15	v	−0.6000	−0.6000	0.5000	23	f	11	12	16
16	v	0.6000	−0.6000	0.5000	24	f	16	15	11
17	v	0.4000	0.4000	3.0000	25	f	15	16	20
18	v	−0.4000	0.4000	3.0000	26	f	20	19	15
19	v	−0.4000	−0.4000	3.0000	27	f	19	20	7
20	v	0.4000	−0.4000	3.0000	28	f	7	8	19
					29	f	3	1	9
1	f	1	3	4	30	f	9	12	3
2	f	4	2	1	31	f	12	9	13
3	f	5	6	8	32	f	13	16	12
4	f	8	7	5	33	f	16	13	17
5	f	1	2	10	34	f	17	20	16
6	f	10	9	1	35	f	20	17	5
7	f	9	10	14	36	f	5	7	20
8	f	14	13	9					

Number the points from your previous orthographic drawing, and list their x, y, and z values. Divide the faces into triangles, and number the faces, listing the point ordering for each. Type the data in using a text editor, following the Object file format shown previously. Save as <filename>.obj.

To help with the proper formatting of your file, you can use *box.obj,* available on the CD-ROM. This is an Object file for a very simple object—a cube. The contents of this file are shown in Table 1–2. In Table 1–2, the vertex data are highlighted in red, the face data in green. To create your own Object model, use this file as a template. Remove the vertex and face text and insert your own mesh data. Be careful to follow the simple format of the Object file, and be sure that vertex definitions start with "v", and face definitions start with "f", as in box. obj.

Use the viewer program provided on the CD-ROM (*Viewer.exe,* written by Hugh A.J. McIntyre and available in the directory: tools\OBJviewer) to inspect your model. You can run it directly from the CD-ROM or copy it onto your hard drive.

It should be mentioned that what you have seen so far is just a subset of the Object file format. An Object file can contain things other than vertices and faces. The viewer program on the CD-ROM may not successfully open and display all .obj files. It will, however, serve the purposes of this exercise.

To familiarize yourself with the viewer program, first load a sample file. Click the **Open** button, and use the standard file browser to select *Sample1.obj* from the tools\OBJviewer directory on the CD-ROM. A familiar model will be loaded and displayed in the viewport. Left-click and drag to rotate the model. Click the **Fullscreen** button to display the model using your full screen. Press Esc to return to a windowed display. Under **Options**, check **View as Wireframe** to see a wireframe display. Check **Hide Back Faces** to turn off the display of backfacing polygons. Use the **Help** menu to learn about other features of the viewer.

Next, open your own .obj file. Study the model from different angles. If there is an error in the format of your file, an error message will be displayed that identifies the line in your file that is causing a problem. Look at that line in your text editor and be sure that it conforms to the Object file format.

If the file loads without errors, there may still be problems with your model. Vertices may be in incorrect locations, and faces may have points listed in the wrong order. Use both rendered and wireframe display, toggle on and off display of backfacing polygons, and refer to your orthographic drawing in order to understand your model. Correct any problems in your .obj file.

Table 1–2

1	v	5.00000	5.00000	−5.000000	3	f	7	6	5
2	v	−5.00000	5.00000	−5.000000	4	f	5	8	7
3	v	−5.00000	−5.00000	−5.000000	5	f	3	4	6
4	v	5.00000	−5.00000	−5.000000	6	f	6	7	3
5	v	5.00000	5.00000	5.000000	7	f	4	1	5
6	v	5.00000	−5.00000	5.000000	8	f	5	6	4
7	v	−5.00000	−5.00000	5.000000	9	f	1	2	8
8	v	−5.00000	5.00000	5.000000	10	f	8	5	1
1	f	3	2	1	11	f	2	3	7
2	f	1	4	3	12	f	7	8	2

As this can be a difficult process, there is further help available on the CD-ROM. Open *Exercise_1-3_Help.htm* (in the ch01\Exercise_1-3 directory) in your favorite web browser. Review this file if you have any doubts about the process.

Figure 1–36 is an orthographic drawing of the cube data in Table 1–2. The cube measures 10 units on a side, and is centered about the origin (0,0,0).

File extensions

Be sure that you save your file as a plain text file with the proper extension. Files in other formats can contain formatting characters and may not be read properly by the software. Wordpad and Notepad will sometimes add an extra extension; for example, "filename.obj.txt." You'll need to remove the .txt in such cases by renaming the file in Windows Explorer.

1–36 Orthographic drawing of a cube (plus perspective view)

Basic Transformations

Skewing in 3D Studio MAX

Skewing is a basic transformation in the sense that it is accomplished using the same mathematical methods as translation, rotation and scaling. However, skewing in 3D Studio MAX is done in a very different way from the other transforms. Therefore, when using MAX, the similarities will not be apparent.

Transformation is moving or otherwise changing the dimensional properties of an object in 3D space. There are several basic transformations ("transforms" for short). They are **translation**, **rotation**, **scaling**, and **skewing**. Translation is movement from one location to another. Rotation should be self-explanatory. Scaling is making an object larger or smaller. Skewing will be demonstrated visually later in this section, along with the other transforms. First, however, it is useful to understand more about the functions of the origin, axes, and coordinate systems.

Although 3D systems often give the user more options for convenience, at a basic level transformations take place relative to the origin. The origin is a single point in 3D space—it is the center of the computer graphics universe, the point where the x, y, and z axes intersect (the exceptions will be explained later in this chapter, when a better foundation of the concepts involved has been provided). An object is rotated, for example, about the origin. *Ani-01-06*, found on the CD-ROM, shows the effect of rotating the object about its z axis. In *Ani-01-07*, the object has been moved away from the origin so that it is no longer centered about the origin (this could be accomplished by adding 30 to each y coordinate, for example). It still rotates about the origin, but the effect is quite different—it seems to orbit the origin.

Ordering of transformations is important. In Ani-01-07, the object has been translated, or moved, and then rotated. In *Ani-01-08*, the object has been rotated first and then translated. The order in which an object is rotated about two or more axes is also important; rotation in x, then in y, then in z will produce different results than rotation in z, then y, then x. Most modern 3D systems give the user complete control over the order in which rotations, and transformations in general, are applied.

Many systems provide the user with more convenient ways of determining the center of rotation. This is accomplished by giving each object its own **local coordinate system** in addition to the **global coordinate system**. (The global coordinate system is the same as the 3D system described previously, based around an origin and x, y, and z axes. This is just a new name for it.) The **global origin**, or **world origin** (exactly the same as what's been called the origin up until now) is still the center of the universe, but each object also exists within its own local coordinate system, which can itself be moved or transformed relative to the global origin. *Ani-01-09* shows the changing orientation of the object's local coordinate system, and axes, as it rotates about the global origin. *Ani-01-10* shows the object rotating about the z axis of its local coordinate system while rotating simultaneously about the z axis of the global coordinate system.

Many systems allow the user to interactively choose and move the **pivot point** (another name for the local origin) of an object. Often the user will have the choice of operating in the global, local, or other available coordinate systems. 3D Studio MAX is such a system.

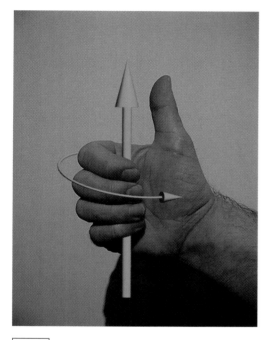

1–37 | Determining positive rotation about an axis

Order of transformation and modeling

When using most modern 3D software, you may never notice the effects demonstrated in Ani-01-06, Ani-01-07, and Ani-01-08 while modeling, but this is a simple way to introduce the concepts being discussed.

ROTATION:::

Rotation normally takes place about the x, y, or z axis, or some combination of the three. The amount of rotation is usually measured in degrees, with 360 degrees being a full rotation. A positive value indicates rotation in one direction; a negative value indicates rotation in the other direction. The right hand rule can be used to determine which direction is positive rotation for a given axis. (This is true in many systems, but not all. It is the case in MAX.) If you imagine your hand grasping the axis, with your thumb extended in the positive direction of that axis (see Figure 1–37), the direction in which your fingers curl is the direction of positive rotation. In 3D Studio MAX, the interaction is much more visual, and you will be more concerned with which direction to drag the mouse to rotate in a certain direction.

TRANSLATION:::

Translation is movement through space along one or more axes. In *Ani-01-11* and *Ani-01-12,* the object, which has been rotated −45 degrees in x (so that the local and global axes are no longer in the same orientation), translates along the global (Ani-01-11) and local (Ani-01-12) y axes.

Coordinate systems and transform tools

Each time you change transform type in 3D Studio MAX (for example, from move to rotate), check to see which coordinate system you are using—it is set separately for each transformation.

SCALE:::

Scaling is enlarging or compressing an object along one or more of its axes. Consider the following animations on the CD-ROM: *Ani-01-13* and *Ani-01-14* show the results of a uniform scale, or equal scaling in all three axes. In Ani-01-13 it is being scaled about its local pivot point; in Ani-01-14 it scales about the global origin. In both cases the coordinate values of the vertices approach zero as the object gets smaller (for example, scaling 10 by 50% gives you 5). What looks like translation is actually a result of scaling in this case: scaling about the global origin, as shown in Ani-01-14, causes the object to move toward the origin. *Ani-01-15* shows scaling about the local origin in the x and y axes only.

SKEW:::

Skewing looks like a translation that varies along the length of one axis. *Ani-01-16* shows the object being skewed along the z axis. The amount each point is moved depends on its location along the z axis.

LAST WORD ON TRANSFORMS:::

Figure 1–38 shows a portion of the 3D Studio MAX toolbar. The drop-down menu allows selection of the coordinate system, and the button menu allows selection of the origin about which to transform.

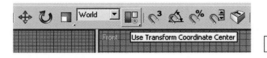

1–38 Choosing coordinate system and center of transform

3D Studio MAX allows you to choose which coordinate system you work in and which pivot point to use. Use Transform Coordinate Center means that the origin of the selected coordinate system is used. In Figure 1–38, it is the world coordinate system. For example, consider *Ani-01-17* and *Ani-01-18*. Ani-01-17 shows the object rotating about its local origin, using the local coordinate system. Ani-01-18 shows the same object rotating about its local origin using the global coordinate system. This shows how it can be handy to have the option to rotate relative to the world or to the object itself. The flexibility provided is very useful.

For more on coordinate systems in 3D Studio MAX, see *Transform Coordinate Systems.avi* in ch01\animations on the CD-ROM.

:::CHAPTER REVIEW QUESTIONS:::

1. Why are x, y, and z so important for working with 3D space?

2. Why are the 2D orthographic views so important for understanding 3D space?

3. What are the most important geometric components of 3D models?

4. What is the relationship between surface normals and backfacing polygons? Why are backfacing polygons important?

5. What are the four basic transformations?

6. Name and describe as many of the various transform systems as you can.

Now that you understand the basic concepts of 3D and have a vocabulary to discuss it, you have the foundation necessary to learn 3D modeling.

First, though, let's take a look at a large part of the game artist's job: textures.

2

A large part of a game artist's job involves the creation and application of textures. Textures are digital images applied to 3D surfaces to give them the appearance of different materials, such as brick, wood, or fabric. In this chapter you will learn primarily about making textures for game environments. In some games, an environment is called a **map** or a **level**.

TEXTURES

OBJECTIVES

+ **Learn what resolution is appropriate for a given application**

+ **Learn the technical constraints of various game engines**

+ **Experience the advantages of working from source and reference**

+ **Make textures that tile**

+ **Learn how to minimize visible repetition in tiling textures**

+ **Create texture sets, and learn how to use them**

Texture Overview

In the case of low poly game art, textures are often used to create the illusion of greater surface detail. Consider Figures 2–1 and 2–2.

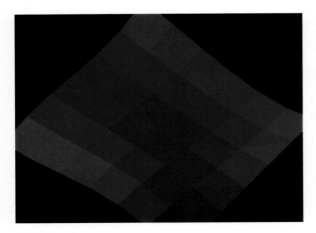

Using textures requires two steps; creating or acquiring the texture, and applying it appropriately to the 3D surface. The application of a texture is called **texture mapping** or just **mapping**.

The exploration of textures creation starts with examining the type of textures that are intended to repeat, or **tile**, seamlessly over a surface. Such textures are usually applied to an environment, such as building architecture or terrain. These are different from textures applied to 3D models; in the latter case the texture usually does not tile, and the texture mapping is much more complex. Textures for models will be discussed in greater detail in later chapters, although they are considered in this chapter as well.

The number of textures that can be used in a game is limited. A texture can be created in such a way that, when copies of it are placed side by side, one cannot easily tell where one copy ends and the next begins (such textures are said to tile). In this way, large surfaces can be covered by as few as one relatively small texture. In Figure 2–2, a single grass texture tiles over a grid of 6×6 quads, interrupted by two more grass textures with plants.

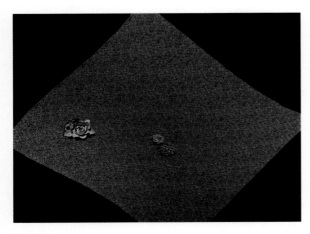

2–2 | Textured surface

When a single texture is tiled over a large surface, patterns may be visible due to the repetition of certain details. You will learn to minimize extreme detail in order to minimize the appearance of obvious repetition, and so to make a texture that can be used over a large surface.

You will create a second texture that tiles seamlessly when placed side by side with your first, in order to break up the repetition of the first texture. Such a texture may contain detail that makes it unsuitable for use over a large surface. You can also create further textures based on your original in order to add visual interest, like the grass textures with plants in Figure 2–2.

The textures created are a simple example of a **texture set**. You will learn of other reasons to create texture sets, and strategies for creating them.

What Resolution?

A **game engine** is the software that makes a game run. It might also be called the **software platform** upon which the game is built. The Playstation 2 is an example of a **hardware platform** (your PC is another). *Quake III Arena* is a game built on the *Quake III Engine* (which is also called the *Quake III Arena Engine*). The engine is the software that makes the game *Quake III Arena* run; it displays all of the 3D models and environments, detects collisions between objects, and much more. Many games may be built upon a single game engine. *Return to Castle Wolfenstein* also uses the *Quake III Engine*. Although the engine may be the same, the content, such as models, textures, player models and environments, and gameplay is entirely different. (The *Quake III Engine*, *Quake III Arena*, and *Return to Castle Wolfenstein* are products of id Software.)

You might ask what resolution should be used for textures in games. If you know which game engine is being used, a simple answer may be possible, but it will not be a complete answer. Beyond the technical constraints and memory limits of the game engine, there is also the size of the texture in the game world to consider, the amount of detail to be included in the texture, the location of the texture, and how close the player can get to it. In a game in which the player tends to be always at street level, it may make sense to use textures of lower resolution for the upper floors of buildings. If the player can fly, or otherwise approach the upper levels more closely, it will be necessary to use the same resolution as in the ground floor. The artist must even consider where the player is likely to spend most of her time looking. For example, game characters may have texture maps that dedicate the most resolution to the head and face, followed by the hands and torso, with fewer pixels still dedicated to the legs and feet. This takes advantage of the human psycho-visual system. Your brain devotes a large portion of its neurons to processing and identifying faces, so a strong human tendency is to look at the face of another person first.

HOW MUCH DETAIL AND WHERE?:::

This part of the discussion takes us somewhat beyond consideration of textures alone. The issue of texture detail versus polygons is addressed more fully in Chapter 3, "Polygon Count." This section addresses considerations of where to concentrate detail and applies to both textures and polygons, for both environments and models.

Paul Jaquays

*Paul Jaquays is a content designer for Ensemble Studios of Dallas, Texas. A con-
tent designer is similar to a level designer. Previous positions include: level
designer at id Software; illustrator and director of graphics for TSR, Inc.; freelance
artist/writer/designer/editor; and director of game design for Coleco Industries. He
has been involved professionally in game art and development since 1976. He holds
a bachelor's degree from Spring Arbor, and is Guildmaster of Guildhall at Southern
Methodist University (curriculum design advisor for art for games curriculum). He
shares his insights on spending your resources wisely:*

Art directors and lead artists often have to make decisions about where to spend
their "budgets" of polygons and pixels. In an ideal game world, all content would be
treated equally and have the same amount of detail in terms of polygon and pixel
density. Everything would be robustly modeled and richly detailed. While that might
be a nice fantasy world to live in (not just a fantasy GAME world), the reality is that
time, cost, and the power of the game engine or target game platform just won't
allow for that level of detail. So, how to focus the player's attention on what is
important and spend the art budget wisely? In a traditionally created painting or
drawing, the artist uses things like detail, color, and contrast to draw the viewer's
eye where he or she wants it to go . . . to see what the artist wants the viewer to
focus on. Focus is the operative word here. For everything that is not in direct focus
can appear to be out of focus . . . or simply have less detail. In a game character
this means making sure that the most detail in a character skin is where the player's
eye is likely and naturally to be drawn. In a third person game, where the player fol-
lows above and behind a game avatar, the eyes are going to be resting frequently
on things like the back of the head, the shoulders and buttocks . . . the parts of the
body less likely to be flailing about in motion.

Depending on the type of gameplay, that can possibly be further limited or refined.
Since the player is going to be watching those areas for the entire game, polygon and
pixel budget should be liberally spent. In a similar manner, when defining the skins for
other characters in a game, it may not be necessary to make all parts of the charac-
ters equally detailed. If the player's eye is not likely to see a part of the model in a
static state (i.e.; not moving) then the artist may not need to make it as detailed.

Detail can be reserved for parts of the model like the face and upper torso, parts of the character that would naturally draw the player's eye and that are also likely to be at the player's eye level in the game. Distance from the player's point of view in game should also define the amount of detail used. If an object is never going to be close to the player, it doesn't require a great deal of detail. This rule of thumb can be applied to both characters and the game world. In the game world, the artist should assign greater geometric and texture complexity to the world near the level of the player's point-of-view. The farther away, the lesser the amount of real detail that will be required to create the illusion of reality.

Tony Lupidi

Tony Lupidi, Art Director for Knockout Kings 2000 *and* The World is Not Enough, *on where to concentrate the detail in game art:*

When starting on the art technical design of a game you need to think about the world you are creating and then assign your limited resources in order of importance. You spend your texture, polygon and computation budget based on where the player will be looking most of the time. For a boxing game I art directed for the Playstation 1 (*Knockout Kings 2000*) I thought about polygon and texture budgets in the following manner. The most polygons and texture budget went to the fighters in the ring first, then the ring, then the near crowd and finally the venue. Since the camera was locked on the fighters, in a 3rd person view, crowds and venue could be rendered as very low-resolution flat backdrop polygons and textures.

The same process of optimization happens with the in game player models as well. When looking at other people, humans look at the eyes and then the rest of the face before moving to the body. Thus the heads of the fighter models had almost as many polygons as the rest of the models. The same went for the fighter texture maps. The face textures were higher resolution than the body and limbs. To save on texture map space the body textures took advantage of the bilateral symmetry of the human body and were only half a chest and back. There was also only a single arm and leg texture that was reflected on the other side. I used roughly the same breakdown when specifying the polygon and texture layouts for the character models in the James Bond Playstation 2 game.

When you hear "size" mentioned in relation to textures, you may think it means resolution. Those who have worked with 3D software, but are new to games, may be surprised to find that in many games a pixel has a specific size in the game world. In 3D Studio MAX, for example, a texture of any size can be applied to a surface of any size; since the texture can be stretched to fit whatever it is applied to, you probably don't think of the texture as having any particular width or height (in units of measurement, such as inches, meters, etc.). With many game engines, however, mapping defaults are used, which makes the process of texture mapping easier.

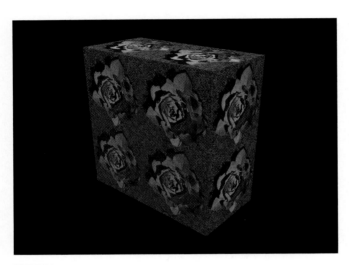

2–3 Tiling and texture size

The easiest and quickest approach to mapping for games might be called **world coordinate mapping** (also called **solid texture**). *Doom* and the *Quake* series handle most mapping this way. By default, textures have an absolute size; in the case of *Quake III Arena*, a texture map of 256 pixels square occupies 128×128 units of world space. Apply any texture to a surface, and it will have this type of mapping applied;

if the surface sits with one edge at 0,0,0, the center of the coordinate system, then the texture that appears on that surface will have one corner at that point—and the opposite corner at 128, 128, 0. Textures tile by default, so the entire surface will be covered by tiling the texture. Figures 2–3 and 2–4 show a 256×256 texture applied to a box with dimensions of 256×256×128.

2–4 Tiling and texture size

Even in systems like the one just described, it is often possible to use settings other than the default—in *Quake III Arena,* for example, the user can make a 256×256 texture fit perfectly onto a 256-unit square surface. The default mapping is just a good first choice.

World coordinate mapping has an advantage other than speed and convenience—it helps insure that textures are consistent in detail. If a surface of 256×256 world units sits next to a surface of the same size, and one is mapped with a texture of 256×256 pixels and the other with a texture of 512×512 pixels, the difference will usually be quite noticeable.

COMPARATIVE RESOLUTION AND TEXTURE MEMORY:::

Even when the game engine allows flexibility in texture size, game production teams usually find it convenient to agree on a sort of "standard texture size" for their game. In *Quake III Arena,* for example, the typical texture is 256×256. Textures that are intended to tile over large areas, such as brick or stone, are almost all 256×256. However, there are many textures of many other sizes. A texture created to be used as trim around a window, for example, might be 256×16.

On the Playstation games of Crystal Dynamics, such as *Gex 3D, Legacy of Kain: Soul Reaver*, and *Akuji the Heartless*, the texture display buffer was 64×64 pixels in size, so any texture larger than that would need to be drawn using two or more passes through the buffer. Since this slows down render time, there was a strong motivation to make nearly all textures 64×64. Frequently, larger textures were chopped into a number of 64×64 tiles.

The texture limitations of the *Quake III Arena* game engine depend on the 3D video card in your computer. All textures for the map, or level, you are playing are loaded into texture memory on the display card. If the textures in a given map occupy more memory than is available on the display card, the speed with which frames are displayed is slowed dramatically. You must also remember that the game interface shares the same texture memory with environment textures, model textures, etc. All image elements must fit into the same display memory.

The Playstation 2 offers little more texture memory than the first Playstation, but it is capable of rendering many more polygons. Thus, game artists can use polygons to compensate for limited use of textures.

Powers of 2

OpenGL and DirectX, 3D systems used by 3D accelerator cards, deal only with textures with resolutions that are powers of 2, most commonly: 64, 128, 256, 512, or 1024. A texture with a resolution of 150×150, for example, would be resized by the system to 128×128 before storing in memory. The resulting image is inferior to an image resized in Photoshop, so you should always resize the textures to powers of 2 yourself.

What's in a Texture?

When it comes to using textures to compensate for lack of polygonal detail, what should be included? The answer is almost anything. You've seen some obvious examples of grass and small plants in Figure 2–2. The most obvious restriction involves size; a standing tree included in a texture intended to cover the ground, for example, would not create an effective illusion. A doorway, if the door cannot be opened, might consist of a flat polygon textured with the wall and door, shadows and all. A window that the player cannot pass through or break might be treated the same way. Cracks and stains should, of course, be included in the texture. A brick texture might contain a wall lamp. It might also include a pool of light on the wall, cast by the lamp.

The discussion of texture sets at the end of this chapter will shed more light on detail that can be included in textures.

Source and Reference

Reference material is what gives your game art the authority of authenticity

—Paul Jaquays

Perhaps the most obvious way to get textures is to paint or draw them yourself. Often this is done digitally, using a program such as Photoshop, but it can sometimes be even more effective to use traditional media, such as oil paints on canvas, and then use a scanner to get a digital copy. Your approach will be dictated by the aesthetics of the project, by the art direction, and by economics (oil painting is not a fast way of producing textures).

See Chapter 7, "Painting Texture Maps," for a good example of hand-drawn texture maps.

Game production is a time- and labor-intensive job. It is also expensive, so a great many game companies make extensive use of existing textures from various sources. There are many texture collections available for use, some available for purchase, some free to download from the Internet. Such collections will sometimes include textures that tile and are ready for use in games. In other cases you must manipulate the textures to make them tile, adjust the colors, scale them down to a usable resolution, or otherwise change them so they are suitable for your specific purposes. It is important to read any legal documentation that accompanies the source to find out exactly what sort of use is allowed. The images are probably copyrighted by someone, or some company or organization, and if they have been made available, the copyright holder will most likely have stated very specifically how the images may be used. Texture Store.com is a Web site that

sells images to be used for texture maps (http://www.texturestore.com/). There is a large community of hobbyists and other amateur game makers who offer texture collections for general use but forbid commercial use. If you are buying a texture collection, you'll want to know how they may be used before you make the purchase. This is not the place for legal advice on the subject; suffice it to say that there can be legal implications for the use of copyrighted materials, and therefore it is very important to know what is allowed.

Photography is another useful way of capturing digital imagery for use in creating textures. Digital cameras are very convenient, many are inexpensive, and they allow an artist to move captured images onto the computer and begin working with them very quickly.

Regardless of how you proceed, it is important to look at the world around you. Far too often in the games industry, and even among artists creating high-end 3D for film and television, artists proceed without any research into their subject. A game artist and a 3D artist are still artists. If you have any knowledge of art history, you know that great artists use models when painting the human figure, beautiful locales when painting landscapes, even painting at specific times of day in order to capture different kinds of light. This does not mean that you have to copy exactly what is in front of you. If you do not have a photographic memory, then there are a great many small details—for example, details that make a building look real, worn, and most importantly, interesting—that you will simply not remember.

The comic artist Robert Crumb, in the film *Crumb* (released March 9, 1999 by Columbia/Tristar Studios, directed by Terry Zwigoff, ASIN: 0767821505), cites the example, from his own work, of electric and telephone lines, poles, transformers, etc. These are things which one filters out, almost to the point where one simply doesn't notice them. Perhaps you've had the experience of taking a picture of an interesting building, and noticing only as you look into the camera to compose your shot that there are more poles and wires blocking the view than you might like. Crumb took rolls of photos of telephone poles and wires and accompanying gizmos so that he had these available as reference when drawing in his studio. His comics are known for the dense grid of wires and hardware over his street scenes. They add realism to his drawings, but more important, they add interest. "A Short History of America" (see Figure 2–5) is a good example; in this comic, the poles and wires actually play a part in the story.

It is not the purpose of this book to teach the reader to draw, to paint, or to be an artist. The intent is to teach the reader to efficiently and effectively prepare art for use in games. In this chapter you will start with digital images and turn them into game textures. The process is the same regardless of the manner in which the digital imagery is created.

2-5 A Short History of America, © Robert Crumb, 1979

There will almost certainly be those readers who will be learning to create game art while at the same time learning or improving their basic art skills. Working from existing source, such as digital photographs, makes good sense in such cases. While this chapter won't teach you to draw or paint, it will offer insight into recognizing why an image doesn't look as good as it could, and what steps to take to improve it.

Tiling and Repetition

This section explains the issues of tiling and repetition, and methods for resolving those issues.

TUTORIAL 2–1: BASIC TOOLS AND TECHNIQUES:::

Workflow

It will be helpful for you to have an overview of the process so that you can keep your goals in mind while following the fairly specific steps of the tutorials. Don't worry if you don't entirely understand what is being described in each step; it will be explained as you proceed.

The process you will follow next, and in creating most textures, is as follows:

- Make a texture of twice the necessary resolution.
- Use a working .psd file to save work in case of changes.
- Work the edges of the texture to make it tile.

This tutorial addresses some of the basic tools in Photoshop that you will use to work with textures. The most basic techniques for making a texture tile will be demonstrated, and some of the aesthetic issues that are common to working with textures will be discussed.

Start with a digital photo of grass (Figure 2–6). In Photoshop, open *Fig-02-06.tif*, available on the CD-ROM.

First address the basic aesthetic issues. The color and **contrast** of this image are not as good as they can be (contrast is the degree of difference between the brightest and darkest parts of an image). It looks like grass, but the colors are a bit too bright and could be greener. There are many possible reasons for this, but what is important is to recognize any problems and correct them.

If a number of textures for your game have already been created, it is important that you make your new textures match. Elements to consider include color, **saturation**, brightness, and contrast (saturation is the vividness of color. An image with 0 color saturation has no color, like a black and white photograph). Looks and styles vary in games. Cartoon games, such as the Mario games, tend to use bright, saturated colors. Games like *Doom* and *Quake* use a darker, less saturated pallet with colors in the brown and gray range. If you load your texture in Photoshop, along with existing textures from your game, you can adjust your new textures so that they fit the look of the game.

Since you will be using various parts of your source image in various ways, you should make your color adjustments before you proceed. If you will be working with multiple

2–6 | Digital photo of grass

images from the same source, you will probably want to color correct them all at the same time—or at the very least, make notes about the adjustments you made.

To adjust the saturation and brightness, select ***Image>Adjustments> Hue/Saturation*** (keyboard shortcut Ctrl-U). This dialog, shown in Figure 2–7, is one you will use often. This figure shows that settings of +50 saturation and −25 lightness have been applied. The hue has been adjusted as well, to make the image more green. The elliptical vignette has been added so that you can easily compare the texture before adjustment to the texture after changes are made. Like

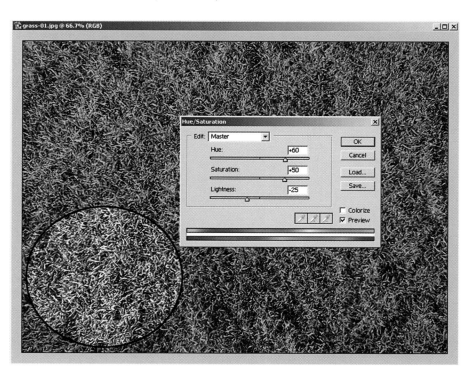

2–7 | Color correction

More on variations in Photoshop

For more information on using Variations, choose **Photoshop Help** under the **Help** menu in Photoshop. Click **Search**, type "variations," and press the **Search** button. A list of topics will appear; double-click on the topic titled "Using the Variations command."

most features in Photoshop, the **Hue/Saturation** dialog is WYSIWYG—what you see is what you get. With the **Preview** box checked, the image is updated to show what it will look like if you apply the setting shown by the sliders. You can check and uncheck the **Preview** box to see your changes.

Image>Adjustments>Variations offers another way to make similar changes. This approach may be more intuitive to some users. The original image is shown, labeled "Original," as well as the "Current Pick" (the image that will result if you click **OK**). Each of the other images in the dialog show what the current pick will look like if you click on that image. See Figure 2–8.

After you've made your color adjustments, save the image to a location on your hard drive. You will be selecting just a part of the image to work with, but you may want to use other parts later, and by saving now you can avoid the need to correct the color again later.

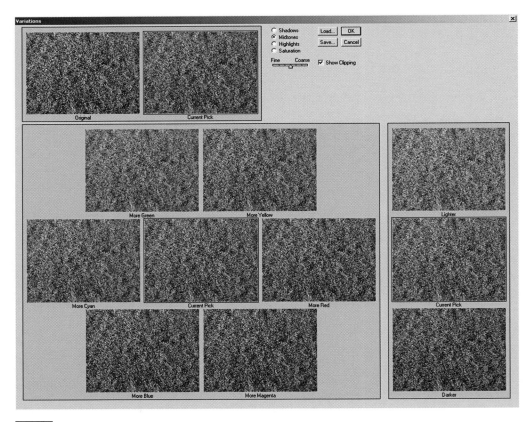

2–8 | Variations in Photoshop

It is recommended that you work at twice the resolution you need for your game. For this tutorial you'll assume a "standard" texture size of 256×256, and work at 512×512. It is often easier to work at higher resolution, and you may find that you need more resolution than you expected. Small details can be difficult at low resolutions. These details hold up very well when resized, often looking better than they would if they were painted at the lower resolution. Working larger than the intended resolution will also insure that the work you do can be used later. Grass is a good example of a texture that is useful in many games, and not so distinctive that it will be easily recognized. If you want a different look for your grass, modifying existing textures is always faster than creating new ones from scratch.

In order to work at very high resolutions, you may find that you need to set the resolution of your display to the highest possible setting.

Setting your Windows display resolution

To set your windows display, right-click anywhere on the desktop (where there's not an icon) and choose **Properties**. Click the **Settings** tab and set **Screen Resolution** (**Screen Area** in Windows 2000) to your desired setting. You should set **Colors** to **Highest (32 bit)** (**True Color (32 bit)** in Windows 2000). See Figure 2–9.

The grid in Photoshop is helpful when working with textures. To change the settings, select *Edit>Preferences> Guides, Grid & Slices.* This will open the window shown in Figure 2–10.

2–10 Changing grid color

Set *Gridline every:* to 512 and pixels. This will help you when working with textures of 512×512 pixels. Set *Subdivisions* to 2. This causes Photoshop to place grid lines every 256 pixels, which will give some extra flexibility when working. The default gray grid color will be very hard to see against your busy grass texture; set it to a brighter color, such as yellow. Click *OK* when finished. Ctrl-" turns on the grid, and will also turn it off again. With the grid on, your image will look like that shown in Figure 2–11.

2–11 Using the grid in Photoshop

Turn on the grid. Choose the *Rectangular Marquee Tool*. It is shown selected in Figure 2–11. A left click selects the tool; left-click and hold for a menu of other marquee tools. Click and drag in the image window to select an area the size of four grid squares, as shown in Figure 2–11. The various tools will snap to the grid when they get close enough, which makes selecting an area exactly the size of four grid squares—an area 512 pixels square—much easier. Turn off the grid, and move the marquee around the image to select the best 512×512 pixels worth of grass. Try to choose an area with the

best looking grass, and which has the same look throughout, as much as possible. In this image, the upper left corner suits your purposes, and is shown selected in Figure 2–11.

The selection outline can also be difficult to see against the busy grass texture, so it has been enhanced with a white outline in the figures in this chapter.

Use Ctrl-C to copy the selected area to the clipboard; Ctrl-N to create a new image the same resolution as the clipboard, and Ctrl-V to paste the selected area into the new image. You now have a 512×512 grass image as shown in Figure 2–12. Now is a good time to save the image.

You have a 512×512 texture, but you haven't yet made it tile. First you'll learn a quick, simple approach. Choose **Filter>Other>Offset....** In the **Offset** window, set **Horizontal** and **Vertical** both to 256. Be sure **Wrap-Around** is checked. Click **OK**. Your texture should now look like Figure 2–13.

2–12 | 512×512 resolution texture

What you've done is shift the leftmost edge (and the top edge) of the image to the middle. What are now the edges of the image will tile, because they used to be continuous before the offset. What used to be the edges are now in the middle where you can see them. They aren't glaringly obvious in this image because it is somewhat busy, but if you look closely you should be able to see straight lines running right through the middle of the image, one horizontal, one vertical. These are referred to as **seams**. This will definitely show up in the game if left as is.

The area you need to work on is now located where you can see it. To make this texture tile seamlessly, you need to eliminate the seams. Another thing to remember, however, is that you must leave the edges of the image alone—those edges tile, and you don't want to change that.

2–13 | Using the Offset filter

Turn on the grid. Choose the **Polygonal Lasso Tool**, right below the **Rectangular Marquee Tool**. Click and release on all four edges of the image, where the grid line meets the edge, so that you have a selection as shown in Figure 2–14. Since only the areas within the selection can now be altered, you can be sure that you can fix the seams without affecting the edges of the image.

The seams can be painted over using the **Clone Stamp Tool**. This tool allows the user to copy from one part of an image to another part; it works like the **Brush Tool** except that you are painting copied pixels instead of a solid color. With the **Clone Stamp Tool** selected, you choose the area to copy from by holding the Alt key and clicking where you want to copy with the left button. Your next left-click defines the offset between where you are painting and the area copied.

2–14 Defining selection to alter seams, not edges

Often when painting with the **Clone Stamp Tool** it is good to "feather" your selection. This gives your selection "soft" edges, so that what you paint there does not entirely cover what is already there; instead, the new pixels are blended with the old. Without these soft edges it is easy to end up with a hard edge where the selection ends. To feather your selection, right-click inside the selection and choose **Feather. . ..** In this case, set the **Feather Radius** to 1 pixel.

For the same reasons, work with a soft-edged brush. Figure 2–15 shows the brush menu, available at the top right of the Photoshop screen. A soft-edged brush looks like the one with the number 21 to the left of it; a hard-edged brush looks more like the one with the number 19 (these numbers indicate the size of the brush, and can be adjusted using the **Master Diameter** slider below the brushes).

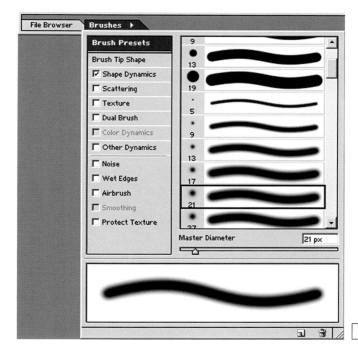

2–15 | Choosing a brush

You can also choose to work with the ***Clone Stamp Tool*** (and many other tools and brushes) set to be partially transparent; such a brush will not paint over the underlying pixels completely, but will blend the new colors with the old. The setting for this is actually called ***Opacity***; 100% Opaque is the same as 0% transparent. Figure 2–16 shows the ***Clone Stamp Tool*** selected (on the left side of the screen), and the ***Opacity*** set to 50% (at the top of the screen).

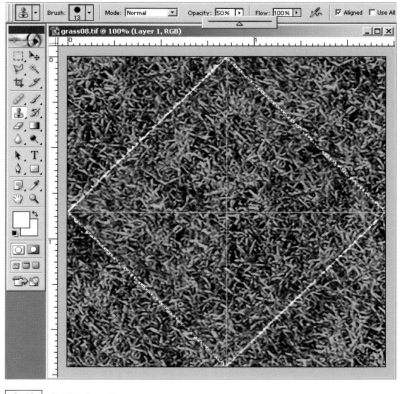

2–16 | Setting Opacity

There may be an easier way. Open the color-corrected grass image you saved earlier. Choose one of the selection tools, and drag the diamond-shaped selection you made earlier from the 512×512 image onto the other grass image. When you do this with a selection tool, no pixels are copied to the other image, just the selection itself. You can now move the selection around your grass image, and select a nice diamond of grass to copy to your texture. Figure 2–17 shows a good selection.

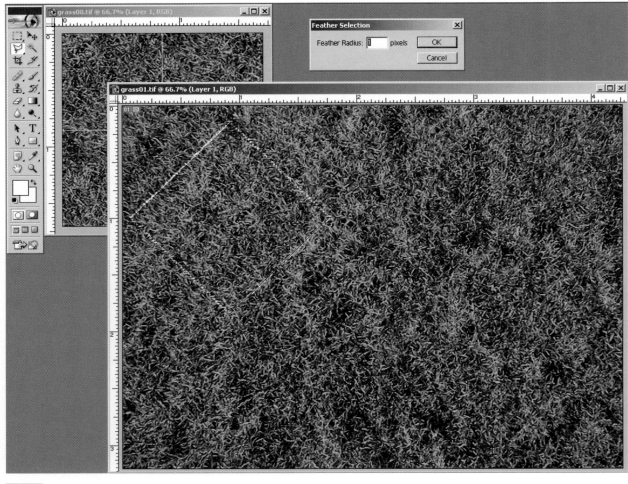

2–17 A new piece of grass

Right-click in your selection. Choose **Feather. . .** from the menu that opens, and enter a value of 1 for the **Feather Radius** (the **Feather Selection** dialog is shown in Figure 2–17). Ctrl-C to copy the selected region. Select the 512×512 texture, and Ctrl-V to paste.

Note that the grass you have just pasted over your texture has been placed in a new layer. The **Layers** window is shown in Figure 2–18. If the **Layers** window is not visible on your screen, open the **Window** menu and check **Layers**.

A new layer

Even though you feathered your selection, some of the edges are still noticeable if you look closely. But because the new grass is in another layer you can easily erase around the edges until they are no longer apparent. Turn off the grid. Choose the **Eraser Tool** and choose a soft-edged brush. As you erase around the edges be careful not to erase as far as the seams—you don't want to reveal the parts you've been working to cover up. If you need a reminder of where those seams are, you can turn on the grid; the grid lines lay precisely over the seams. You may want to erase with the grid turned off; the danger is that your brush will jump to the grid lines if you get close enough. If you find it difficult to see the edges as you work, you might want to use the **Zoom Tool** to double the size of your image on the screen. Left-click and drag on the corners of the image window to resize it as necessary. Another trick that may help is to turn off the background layer so that you can clearly see Layer 1. To do this, click on the little eye icon next to the background layer in the **Layers** window (Figure 2–18). With the background layer turned off, you can clearly see the effect of erasing with a soft-edged brush.

Look at *Fig-02-19.psd* on the CD-ROM (Figure 2–19). Turn off and on the two layers to see the effect described. The figure shows the resulting texture.

Save your texture. It is strongly recommend that you save in .psd format so that your layers are preserved. This gives you the flexibility to make adjustments later, and keeps both parts for possible subsequent use. You never know what may come in handy.

You should now have a texture that tiles. But how do you know for sure? You can test this in Photoshop.

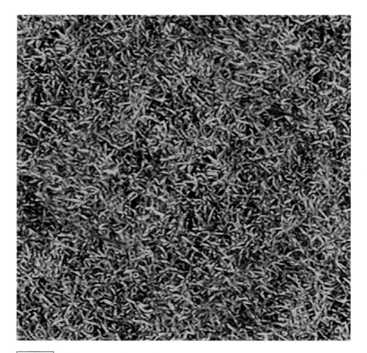

2–19 Tiling texture in two layers

TEXTURES

chapter2

Flatten the image (*Layer>Flatten Image*). This will merge all of the layers together. Then choose *Image>Canvas Size. . .*. Set *Width* to percent, and set the percentage to 300. Do the same for *Height*. Click *OK*. Turn on the grid. Select the 512×512 region of grass texture, then use Crtl-C to copy and Crtl-V to paste into a new layer. Turn off the background layer. The image should now look like Figure 2–20.

2–20 Creating a workspace image to test tiling

Use the *Move Tool* to move the top layer to the left so that it sits right beside the grass in the background layer. Choose *Layer>Duplicate Layer. . .* again, and move the new layer to sit above the previous layer. Do this once more so that four copies of the texture border one another as shown in Figure 2–21. Turn off the grid to check the tiling.

It is convenient to work with textures in this way, with room for nine, when creating a set of similar textures. You will learn about texture sets later in this chapter. If you'd like to save this image, save it with a new name so that you don't overwrite the other file. For example, if you saved previously as "grass.psd," save this file as "grass-02.psd." Hard disk space is cheap, and you can always delete unneeded images later.

You now know your texture tiles, but you aren't finished yet. Looking at a texture as you just have in Photoshop doesn't tell you everything you need to know about how it will look applied to terrain in a game. You'll deal with this next.

| 2–21 | Inspecting tiling in Photoshop |

TUTORIAL 2-2: DEALING WITH VISIBLE REPETITION:::

Certain details in your texture may draw unnecessary and unwanted attention to the fact that it is a single texture tiled over a surface. Such details should be corrected. Tiling is useful but should be as close to invisible as possible.

Workflow

In this tutorial you will:

- Test your texture for visible repetition
- Paint over any details causing problems

Figure 2–22 shows the grass texture applied to a simple plane in 3D Studio MAX, and the problems that still remain with the texture. There are details, such as a dark spot that catches the eye, that create a pattern when the texture is tiled. This spoils the illusion to some extent; the surface that receives this texture should look natural and organic. You might find regular patterns on grass on a golf course, but that's not the intended effect, and it's not what this pattern looks like. This tutorial shows ways of addressing this problem.

Applying a new texture to a plane is a quick and easy way to see how it will look tiled over a large surface, in perspective. In MAX, create a plane 200 units in length and 300 units in width. Set **Length Segs** to 4, and **Width Segs** to 6. Add a **UVW Map** modifier, and set the type of **Mapping** to Face. Then drag-and-drop your texture onto the plane (you can drag it from a Windows Explorer window directly onto an object in MAX).

2–22 | Inspecting texture for visible repetition

::::: MAX File for Testing Texture Repetition

The procedure just described is relatively simple, but only if you have some previous experience with 3D Studio MAX. If you have never used MAX before, you can open *testplane.max* (available on the CD-ROM) and use that to test your textures. Drag-and-drop your texture onto the plane to see it tiled.

Pressing F4 in MAX toggles the display of **Edged Faces** on and off. Figure 2–23 shows the edged faces displayed. This helps to identify the edges of the texture, making it easier to tell which part is causing the unwanted pattern.

In Figure 2–24 the main area of concern is identified. There are also bands of lighter grass that run diagonally across the plane, right through the dark spot, which should also be addressed. Note that the dark spot lies on the edge of the texture. If you simply paint the right and left edges of the texture, you will then need to fix the tiling. But with a more creative approach, you can avoid this.

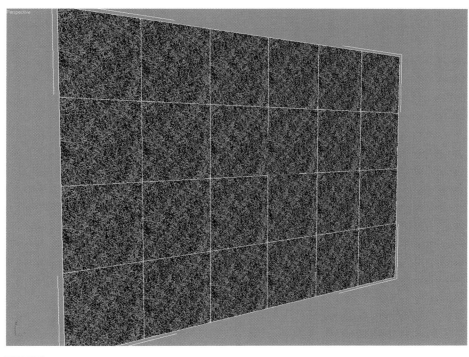

2–23 Edged faces in MAX help to identify edges of texture

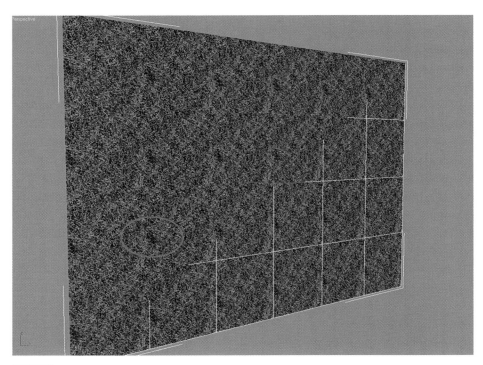

2–24 An area that attracts attention when tiled

Figure 2–25 shows the .psd file in which four copies of the texture have been placed side-by-side, and above and below one another, to test the tiling. Load yours in Photoshop, or create another. Using the grid, select a 512×512 region that overlaps two of the textures, as shown in Figure 2–25. Flatten the image and copy the selection to use as the new texture. By doing this you have moved the dark spot into the center of the image, where you can paint it over safely with no fear of ruining your tiling.

From here you begin a process of painting over the problem areas using the **Clone Stamp Tool** and testing the results in MAX. Use the technique described in the previous paragraph as necessary to fine-tune the texture.

2–25 | Moving the area to be corrected to the middle of the texture

Figure 2–26 shows the results. The bottom half of Figure 2–27 shows the texture before it was worked to remove visible repetition, while the top half reflects the image after the alteration is applied to the plane in MAX.

2–26 | Improved texture

Perspective

| 2–27 | Before and after the latest alteration |

You've been looking closely at this texture for some time now as you've worked to remove noticeable detail that would show as a pattern when the texture is tiled. You may see recognizable patterns in the texture when tiled, even now. Certainly the patterns are less obvious. But now you may feel that the grass is so consistent in appearance that it looks like artificial turf rather than grass. This is the sort of trade-off that making games is all about. You have learned what some of the issues are in making textures for games, and some ways of dealing with them. The use of texture sets can help with the compromise between textures that repeat well, and those that look more natural.

Texture Sets

It is usually useful to create sets of textures with a similar theme. The first texture is a base texture, like the grass texture you made in Tutorials 2–1 and 2–2. It tiles well, and doesn't have extreme detail that becomes very obvious with repetition. But an environment will often look somewhat boring with a single texture applied. See Figure 2–28.

2–28 A single texture applied to a large surface

Depending on the way terrain is created in your particular game tool and game engine, you can (with more or less difficulty) apply an alternate texture to certain parts of your environment to help break up the repetition of a single texture. It might be good to have another grass texture for variety, to further obscure repetition. A new tiling texture can be made easily by copying a new 512×512 grass region from the original (color adjusted) grass image, pasting it over the base grass texture, and erasing around the edges until it blends naturally. Such a texture has been applied to some quads in Figure 2–29.

2–29 A second texture introduced for variation

In 3D Studio MAX a texture can be easily applied to just one or more polygons in a model. Some game engines allow terrain to be built in 3D Studio MAX and software like it (Fly3D is a game engine for which environments can be made in MAX: http://www.fly3d.com.br/).

Further variations in Figure 2–30, like the plants, add further variety and visual interest.

Figure 2–31 shows a modest grass texture set.

2–30 More grass textures to add variation and visual interest

2–31 A modest texture set

When a top surface texture, like the grass in Figure 2–32, "wraps" onto a side surface, like the red earth textures below, the hard edge of the geometry can be broken up a bit. The result is a more organic look. Compare the top edge of the cliff to the bottom edge in the figure. The "edge wrapping" approach could also be used at the bottom.

2–32 | A transitional texture

These are just some of the kinds of textures you'll find useful when making texture sets.

MORE ON TEXTURE SETS:::

Another reason to make sets of related textures is so they can be used in different combinations to produce very different results. To some extent this is always possible. The examples shown in this chapter are of a texture set designed primarily for this purpose.

All of the textures in this section are available on the CD-ROM, as well as a MAX file, *sets-01.max*, which shows the textures used in various ways.

When working from photos, it can be especially tempting to create a texture like that shown in Figure 2–33, and use it to cover an entire wall as shown in Figure 2–34.

2–33 | Wall texture

2–34 | Textured wall

The resolution of this texture is not powers of 2 in either axis; the resolution is 704×448. Converting it to 1024×512 is a big change and a large use of texture space. Converting it to 512×256 is also a big change and results in a large sacrifice of detail. It is also wasteful in that large parts of the image are made up of repeated patterns. The pattern at the top and bottom, and the diagonal brick pattern that makes up most of the wall can be made into smaller textures that tile. Furthermore, what you have in this case is one large wall texture that can be used in one way. If you were to break it up into smaller individual components—separate textures as shown in Figures 2–35 through 2–39—you could use them in combination with an assortment of complementary textures to create a wide variety of different walls.

2–35 design1.tif

2–36 design2.tif

2–37 brick-diagonal.tif

2–38 t-pattern.tif

2–39 bottom-trim.tif

It will be necessary to use more polygons in a wall mapped with such a set of textures, as you can see in Figure 2–40, but this is a worthwhile trade-off.

2–40 Geometry for texture set

Add just nine more textures, like those in Figures 2–41 through 2–49, and the number of possible combinations becomes quite large.

2–41 circle-gray.tif

2–42 circle-red.tif

2–43 brick-black.tif

2–44 brick-red.tif

2–45 brick-diamond.tif

2–46 brick-diamond-red.tif

2–47 brick-hex.tif

2–48 design3.tif

2–49 mural.tif

Figures 2–50 through 2–54 show just a few of the different walls possible with this texture set.

Using the geometry available in *sets-01.max*, and creating variations of that geometry, you can create many more viable walls.

2–50

2–51

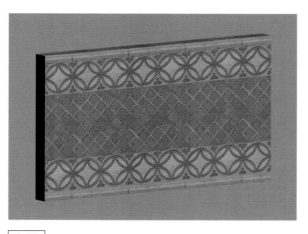

2–52

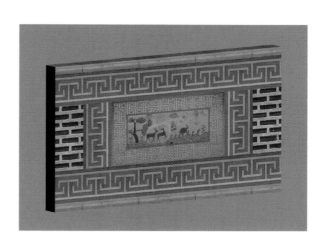

2–53

Just a few of the combinations possible with this texture set.

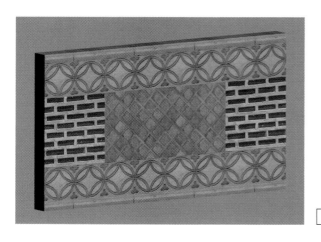

2–54

Last Word on Tiling Textures

More regular textures, such as brick, pose certain challenges that very organic textures, such as grass, do not. One example is dealing with the distortion that occurs from perspective when using source photos. The digital photo shown in Figure 2–55 was shot with the camera very square to the wall, but there is some distortion from perspective, as there usually is. If you look closely you can see that the vertical lines converge slightly toward the bottom. The image shown, *R&R-37.jpg*, is available on the CD-ROM.

Holding down the Shift key while dragging out a rectangular selection insures that the selection is square, as in Figure 2–55. The selection helps you to see how far from vertical and horizontal the lines in the image are.

You can save yourself some time by recognizing that brick patterns often alternate, with bricks overlapping. Therefore you will need to be sure that the pattern at the top of the tiling texture is not the same as at the bottom, or that pattern will be interrupted by two layers of brick that are the same. The selection in Figure 2–55 anticipates this issue.

2–55 | Distortion from perspective

You can also see from Figure 2–55 that the selected area will not tile horizontally because it only includes approximately $2^3/4$ bricks horizontally. To make a square texture that tiles, you will need to distort the shape of the bricks somewhat.

Figure 2–56 shows the selection expanded to include three bricks in width, and includes the mortar to the left of the previous selection.

2–56 | Expanded selection

Edit>Transform>Distort allows you to move each corner of a selection or layer in order to change the shape. Figure 2–57 shows the selection from Figure 2–56 cut and pasted into a new layer. The background layer has been turned off. Figure 2–57 shows the distort function at work. The upper left corner has been pulled to the right and slightly up to try to correct for the perspective in the image and make the mortar on the left side of the texture more vertical.

In Figure 2–58, the selection is used again to check that the lines of the texture are vertical and horizontal. This being the case, you can use Ctrl-X to cut away the unneeded pixels. Notice that there is still mortar at both the top and bottom of the image, which is inappropriate.

From this point, making the texture tile involves the same process as shown in Tutorial 2–1, and dealing with the visible repetition can be accomplished as shown in Tutorial 2–2.

EXERCISE 2-1:::

Select an image from which to create a useful texture map. Create from it a texture map that tiles and shows little repetition. Then create a set of textures to complement it.

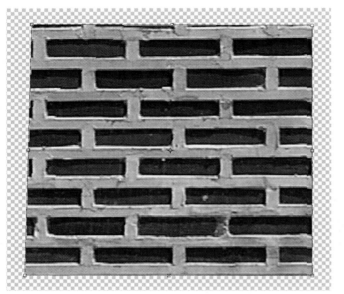

| 2–57 | Distorting the texture to remove perspective

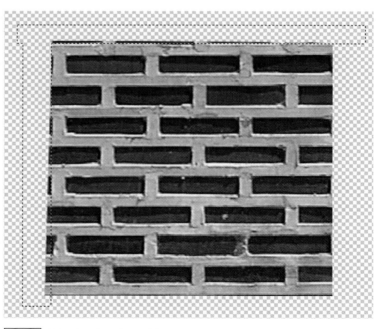

| 2–58 | Trimming the edges of the texture

:::CHAPTER REVIEW QUESTIONS:::

1. What are some ways in which texture maps are used to make up for lack of polygonal detail?

2. What are the advantages of textures that tile?

3. When can textures be said to have an actual size in 3D space?

4. Discuss the value of using source and reference.

5. If you have a texture image that is 300×300 pixels, and you need to use it on a system that uses openGL, to what resolution should you resize it?

6. Discuss the uses of texture sets, and describe some of the textures that might be included.

This chapter has given you a great deal of information about textures. You should now be prepared to meet the technical challenges of preparing tiling textures and texture sets for environments. You should also have useful insight into the technical limitations of various game engines and be prepared to make textures that work within them.

Next you will learn about low polygon models and how to build them.

It is a simple question with no simple answer: How many polygons are there in a low poly model? The answer depends on many things. Computer hardware and game console hardware are moving targets. Computer power doubles roughly every 18 months, and display hardware (3D accellerator card) performance has been improving even more rapidly. However, the general approaches to effecient modeling and optimization taught in this book will remain applicable for some time, even as the computing power of hardware continues to increase. Models made for the Playstation 2 (PS2) have many more polygons than those built for the Playstation, but the general approach to modeling is still mostly the same.

It also depends on the intended use for the model—one that will appear in numbers (such as a wall lamp) will need to be very low in polygons, while a **set piece** model, one intended to be the showpiece or visual highlight of a level or map, may be very high in polygons compared to the average model for a given game or game engine.

In this chapter you will learn about the various considerations and factors that come in to play when determining the number of polygons you can use in a model.

POLYGON COUNT

OBJECTIVES

+ **Learn how many polys make a low poly model**

+ **Gain insight into some limitations of various game engines**

+ **Compare polys in environments versus polys in models**

+ **Understand the advantages of detail in textures versus detail in polys**

+ **Use Level Of Detail models to reduce polycount**

Approximate Polycounts for Various Game Engines

Quoting the number of polygons that a given game engine can render at 30 frames per second does not answer the question "how many polygons are there in a low poly model?"—but it does give some indication. The Playstation could render 1.5 million flat-shaded polygons per second; the PS2 can render 25 million polygons per second. The Nintendo GameCube can render 33 million polys per second, and the Xbox from Microsoft can render 125 million.

Environment versus Model

The environment often makes up the vast majority of the polygons in a game. Environment in a game usually means the walls, floors, and ceilings of the space, or the terrain in outdoor environments. Many game engines use the environment to limit the number of polygons that are drawn at any time, for example, by not drawing those obscured from the player's view by walls or floors. Because of this, game environments are often constructed in a very different way from models. The environment is the game world, in some ways the fabric and structure of the game, often intimately involved in the play of the game. The game environment is often essential to both the look and the play of a game, while models are sometimes present purely for aesthetic reasons. These are some of the reasons that many more polys go into environments than into models.

Models of all kinds need to share a maximum polycount with the polygons in the environment. The maximum polycount is the total number of polygons the game engine can render per second divided by the target frames per second. For example, if an engine can render 300,000 polys per second, and the developer wants the game to run at 30 frames per second, then the maximum number of polys that can be rendered in a single frame is 10,000. This means that the maximum number of polygons visible at any time must be 10,000 or less. It is easy to overlook various types of models, but every polygon drawn takes its toll on the render time. You must consider weapons and other pickups (health, etc.), character models, and sometimes even the HUD (Heads Up Display—the interface that reports such information as player health).

In *Quake III Arena*, released in 1999, id Software worked to a limit of around 12,000 tris, not counting characters; when running the map without other players, in the map location in which the most triangular faces are visible, the count should have been no higher than 12,000. A count of 8,000 to 10,000 was considered to be the limit in areas most often navigated by the player. This would include all pickups and the HUD (the count would go above 12,000 when player models were added; the 12,000 tris limit was a guideline for those designing environments). By the release of *Quake III: Team Arena* in 2000, id maps had views with as high as 25,000 tris.

Models vary in complexity. A more complex shape will necessarily need to use more polygons than a simple model. In *Quake III Arena*, models used roughly between 50 and 500 polygons. Models of a similar nature can be a better indicator; character models in *Quake III Arena* used between 700 and 900 polygons. In *Unreal 2003*, released in 2003, characters weigh in at well over 3,000 polygons.

GAMEPLAY, GAME DESIGNERS, AND GAME ARTISTS:::

The concern behind this discussion of polycount is gameplay. When the game system is slowed because too many polygons are displayed, or for any other reason, gameplay suffers.

Game artists commonly work closely with game designers. Gameplay is the primary concern of the game designer. While the game artist always works with the question of efficiency in mind, the look of the game is the primary concern. The game designer also wants the game to look as good as possible, but should think of gameplay first. Of course, it can be argued that the look of a game can contribute significantly to the game experience, and in that sense, to the gameplay as well. The game designer and game artist work toward the same end but have different priorities. In this way, the game designer and game artist balance one another.

The game environment is very important to gameplay. In a game that challenges the player to make carefully timed jumps, for example, the difficulty of the jumps is affected by the distance between solid surfaces. For this reason it is common for game designers to build environments. The game artist makes textures, which the designer often applies to the environments, and models, which the designer uses to add visual interest to the environments. They often use different sets of tools. In the production of *Quake III Arena*, for example, the designers used a tool created at id Software for building environments, while the artists used 3D Studio MAX to create the models.

It is important for artists and designers to know the limitations of the game engine they are working with. They must understand the implications of the content they create. Some things will have a very large impact on the performance of the game engine, other things very little.

One example of something that's free in some game engines is transparency in a texture; if a pixel is 100% transparent, the system doesn't have to draw it, which saves some time. A game engine still needs to perform all of the operations on the texture, and it has to determine if a certain pixel is transparent, but such transparency is free in the sense that no extra time is required to draw it. Chapter 4 offers some discussion of transparency in textures and using transparent textures to create models that would otherwise require a large number of polygons.

Tom Heaton

Tom Heaton is a Senior Game Designer.

I'm a designer and I will always try to work out what's best for the gameplay and then fit the resources around that. One of the projects I'm working on potentially requires a large number of characters to be on the screen at the same time. The lead programmer and lead artist told me that I could have a maximum of 30 characters on screen at the same time (this was on handheld). But that was no good to me and I insisted on 60—and he had to go and build lower poly models.

Often resource limits are local to particular areas of the game and can be worked around by compartmentalizing. So it's perfectly possible to have two amazingly high-poly rooms as long as they're separated—possibly even loaded in separately. It's often necessary to balance the degree of compartmentalization against the look—that's a difficult decision for designers.

Considered purely in terms of a strict resource limit, I will try to maintain an evenness in visual quality because bad or cheap stuff always stands out. I have a set of techniques for reusing assets on the cheap—I'm always looking for a good return on my assets. I might use two-thirds of an available limit to get a good general look and the last one-third on special stuff that will act as a focus and draw the player's eye. That's a rule of thumb only.

And finally, I'm always on the lookout for anything free. I quiz my programmers constantly about the exact cost of anything and if they don't know, I run my own tests. I often find that an engine has certain features that are very cheap or free, so I use them a lot.

Texture Detail versus Polygons

In most game engines it is necessary to use textures to make up for detail that is not included in the model (or environment). One example came at the beginning of Chapter 2—no game engine yet can handle the number of polygons necessary to build a field of three-dimensional grass (in which each blade of grass is modeled); therefore a texture map is used. This is an easy choice. In earlier game engines, a window that didn't open would usually be merely texture—the windowsill, glass, and all (Figure 3–1). Today, with more polygons at your disposal, you might choose to put more polygons into such a window for purely aesthetic reasons (Figure 3–2).

3–1 Window as texture

3–2 Window as geometry and texture

It really is all relative; although it is nearly always the case that textures are used to make up for limited poly detail, there is a notable exception:

> For example the Playstation 2, compared to a PC 3D display card, has a really limited amount of texture memory available for rendering but a great deal of internal memory bus bandwidth, and can render a huge amount of triangles in a given frame. Thus, for the Playstation 2 to achieve high levels of detail you can trade polycount for texture memory, instead of having large highly detailed texture maps break up a model and use lots of vertex colored triangles to add small details. A typical contemporary PC 3D card has 128 megabytes of memory and, compared to a Playstation 2, a constrained amount of both memory and bus transfer bandwidth. So the solution for this particular device is to use lower polycount models and much higher resolution texture maps. The end result for both is great looking art content, but both achieve this via different avenues.

—Tony Lupidi, Art Director, *The World Is Not Enough*, EA

Level Of Detail (LOD)

Level Of Detail (LOD) is one way to reduce the number of polygons drawn by the game engine. Most often the modeler builds three or more versions of the same model with varying poly counts. In *Quake III Arena*, the player models used LOD; if the highest LOD model contained around 900 polygons, the second highest would be around 600 and the lowest around 300. When the player is very, very close to another character model, the 900 poly model is displayed. At medium distances the 600 poly model is displayed. At greater distances the 300 poly model is displayed, making distant players a relatively small load on the rendering engine.

Any model can have multiple LOD (depending on the game engine). In some game engines, even terrain can have LOD. Sometimes the game engine handles the LOD. Some game engines can convert a patch model (a spline-based model, potentially very high in detail—more in Chapter 7) to polygons on the fly, choosing more detail or less depending on distance from the player. DirectX can weld vertices before rendering, so that distant terrain has fewer polygons when rendered.

LOD is a game artist's friend. It allows models to be highly detailed when they need to be—when examined closely—and to be less of a demand on the renderer when such high detail isn't necessary. The modeler can hope that a given game engine can make different LOD itself, but for the present you will most often have to build the various LOD models yourself.

3–3 | Minegun (from *Political Arena*, © 2001 Todd Gantzler) at 200 polygons

Figures 3–3 through 3–6 show the minegun from *Political Arena* (http://planetquake. com/politicalarena) at various LOD. You can inspect these models more closely in the file *minegun-LOD.max*, available on the CD-ROM. (Unless you have previous experience with 3D Studio MAX, you may want to come back to this after you've worked through the next few chapters.)

3–4 | Minegun at 168 polygons

3–5 | Minegun at 133 polygons

3–6 Minegun at 99 polygons

:::CHAPTER REVIEW QUESTIONS:::

1. How many polys are in a low poly model?

2. What are some differences between models and environments?

3. List some details that are typically included in textures.

4. If you have made a model with 900 polygons, what would be good polycounts for two lower Level Of Detail models?

Now that you know more about the various ways in which polygons are used in a game, and some of the tricks used to reduce the number of polygons rendered, you should have a better idea about what makes a low poly model. It will always depend on the technology you are using and what kind of game you're making. If you are working with a team, it is important to decide on some guidelines, even if they are just for reference, as to how many polys should be visible at once, and how they should be used.

In the next chapter, you will begin to learn how to make low poly models.

CHAPTER

MAKING THE MODEL
FOR THE TEXTURE
INTRODUCTION TO POLYGON
MODELING AND MAPPING

OBJECTIVES

+ Build a model starting with a texture

+ Learn box modeling from primitives

+ Learn texture mapping and Unwrap UVW

+ Use transparency in textures

+ Learn about bump mapping

Introduction

In this chapter you begin to learn the basics of 3D modeling. As a game artist you will occasionally find yourself in the position of having a texture for the model, in some form, before the model is built. To use the texture in such cases, you will often need to allow the texture to dictate the way you build the model to some extent. Generally speaking, this approach can be less flexible, and an experienced modeler may well avoid it. However, there are times when starting with the texture is entirely appropriate. It really depends on the model itself.

You will learn about modeling from **primitives**, a modeling approach well-suited to working from the texture. A primitive is a simple geometric shape such as a cube, sphere, or cylinder. Situations when the texture-first approach is appropriate are discussed, with examples. You will also begin to learn texture mapping, which involves applying a digital image to a model for a more realistic appearance.

In the texture-first scenario, you usually have an image to use as reference when modeling. This may be the image from which the texture is created; perhaps it is the texture itself. Often the type of mapping used will be planar mapping, sometimes followed by the use of the *Unwrap UVW* modifier, which allows you to manually adjust texture mapping. This strategy is also a good approach for beginning modelers, and a good introduction to texture mapping models, so it is ideal as an early lesson in modeling.

You will learn to use *Edit Mesh* to manually change the shape of 3D mesh. This approach is sometimes called **box modeling**, because it can involve actually starting with a box and creating from it any model whatsoever by moving vertices around one at a time or in groups, adding vertices, welding vertices, and dividing and/or extruding faces and edges. You will also learn the uses of transparency in textures, and create opacity maps and alpha channels.

Working from Primitives

This approach to modeling is good for those learning modeling. One starts with the basic primitives, moves points about manually, and performs various other operations in order to achieve the desired 3D shape. Box modeling is preferred by many modelers because with a fairly simple set of modeling tools and simple techniques one can build almost any model.

It should be noted, however, that this modeling approach lacks much of the flexibility and control over polycount described in later chapters. Making changes after the model is built is likely to involve rebuilding some or all of the model.

Figure 4–1 is the image you will use as reference to build your spider. You can find it on the CD-ROM (titled *Fig-04-01.tif*).

In 3D Studio MAX you can load an image as a background for one or more viewports. Follow these steps:

1. Select the **Front** view (in this case; a background image can be loaded into any viewport).

2. Choose **Views>Viewport Background** (or type Alt-B).

3. Click Files, find Fig-04-01.tif on the CD-ROM.

4. Under **Aspect Ratio**, choose **Match Bitmap**.

5. Check **Lock Zoom/Pan**.

6. If image is not visible, select **Front** view, right click in upper-right corner, choose **Show Background**.

7. Zoom out if necessary to see the full image.

Workflow

In this tutorial you will:

- Load the reference image into a viewport background to guide your work.

- Create various primitives that are fairly similar in shape to the parts of the spider model.

- Use **Edit Mesh** and box modeling techniques to modify the shape of the primitives. You will build your model so that texture mapping can be applied easily and efficiently.

- Apply texture mapping to the model.

4–1 Reference image for tutorial

In the *Perspective* viewport, create a cone with six *Sides* and three *Height Segments*, as shown in Figure 4–2. In the *Create* panel, under the *Object Type* rollout, click *Cone.*

Click and drag to set the radius of the base, then release and drag up, clicking to set the height. Drag again to change the radius of the top, clicking to set it to a point. Under the *Parameters* rollout, set *Height Segments* to 3 and *Sides* to 6. The spider's leg has two joints, and you'll need the two cross-sections in the middle to bend the leg.

Select the *Front* viewport again, and rotate the cone –90 degrees in z, to orient it as shown in Figure 4–3. Move it to place the cone, and adjust *Height* and *Radius* to make the cone roughly as thick and long as in Figure 4–3.

4–2 Starting with a cone primitive

4–3

Adjusting the cone

∷∷ Important: Viewports and Transform Systems

Chapter 1 included a discussion of the various transform systems (or reference coordinate systems) and centers of transform that one can use when working with 3D Studio MAX. This flexibility can be very helpful, but it also makes useful terms like "z axis" ambiguous.

In the previous step in this tutorial, you were instructed to rotate your cone by -90 degrees in z. However, as mentioned in Chapter 1, the z axis in the *View* coordinate system may not be the same as the z axis in the *Local* coordinate system. If your *Reference Coordinate System* is set to *Local*, you need to rotate your cone in the y axis to orient it as shown in Figure 4–3.

For orthographic views, *View* is the default coordinate system. In a perspective view, *View* acts like the *World* coordinate system. Tutorials in this book use these defaults. As a beginner, you may find it difficult to always be aware what coordinate system you are using. Because of the potential for confusion, you should always look closely at the figures and text to understand what you are trying to achieve and choose the appropriate axis accordingly.

If you have not watched the short video on this subject—*Transform Coordinate Systems.avi*, in the ch01\animations directory on the CD-ROM—you should do so now.

You may also need to rotate the cone 90 degrees in z in the *Left* view. Figure 4–4 shows the cone in an orientation that is improper for **planar mapping**. You will planar map the spider model from the front. Planar mapping is a simple form of texture mapping, also called **planar projection**. Imagine a slide projector projecting an image onto the surface. The red arrows in Figure 4–4 indicate the direction of the planar mapping. You might think of them as rays of light from the projector. Planar projection does not use rays of light, however, so the surfaces on both sides of the model will receive the texture. The faces highlighted in red, though, are parallel to the direction indicated by the arrows. They will not be mapped in a useful way. There will be streaking of the texture along the faces highlighted in red.

You can also recognize the problem from the *Front* view. Only two sides of the cone are visible, and you should see three sides of the six.

If your cone is oriented improperly, simply rotate it 90 degrees in z in the *Left* viewport (using *View* or *Local* coordinate systems). You must be sure the cone is oriented properly before proceeding.

4–4 Improper orientation for planar mapping

More on using Weld

For more on using **Weld**, choose **User Reference** under the **Help** menu in 3D Studio MAX. In the **Search** panel type "weld" and press **Enter**. A list of topics will appear; double-click on the topic titled "Editable Mesh (Vertex)."

Apply an **Edit Mesh** modifier—go to the **Modify** panel and choose **Edit Mesh** from the **Modifier List**. Go to sub-object **Vertex** by clicking the appropriate button under the **Selection** rollout, which turns yellow when selected as shown in Figure 4–5. Begin to adjust the various points as shown in Figure 4–5, using the **Move** and **Rotate** tools, and possibly **Uniform Scale** as well. Select and move entire cross-sections of the cone simultaneously. Rotate the points of the cross-section as necessary so that they form the best joints, and maintain the shape of the leg. Scale them to fit the thickness of the leg in the reference image. Use **Uniform Scale** so that they change in size but remain circular in shape.

4–5 Edit mesh

Switch to sub-object **Face** by clicking the appropriate button in the **Edit Mesh** modifier, as shown in Figure 4–6. Select the faces at the end of the leg (faces highlighted in red in Figure 4–6) and delete them. The easiest way to select these faces is in the **Front** viewport, with the **Window/Crossing** button (circled in red in the figure) set to **Window**. This end of the legs will be inside the body of the spider, so these faces will never be visible to the viewer.

Go back to sub-object **Vertex**. Select all of the points at the opposite end of the leg, the tip, and **weld** them. Under **Weld**, in the **Edit Geometry** rollout, click the **Selected** button. There may be extra points here, and possibly extra faces as well. Welding causes them to fuse into a single point.

4–6

Delete unnecessary faces

Add a *UVW Map* modifier. Set *Alignment* as necessary to align the gizmo as shown in Figure 4–7. Go to sub-object *Gizmo*, and rotate it as necessary so that the green side is at the top and the yellow line is on the left side, as shown in the figure. In sub-object *Gizmo*, the transform tools affect the gizmo and not the entire model. You can move, rotate, or scale the gizmo to align it as shown in Figure 4–7. The *Fit* button is a quick way to scale it to the exact size of the selected object.

More on the UVW Map modifier

For more information on using the *UVW Map* modifier, choose *User Reference* under the *Help* menu in 3D Studio MAX. In the Search panel type "UVW map" and press *Enter*. A list of topics will appear; double-click on the topic titled "UVW Map Modifier."

4–7

UVW mapping

More on using the Material Editor

For more on using *Material Editor*, choose *User Reference* under the *Help* menu in 3D Studio MAX. In the *Search* panel type "material editor" and press *Enter*. A list of topics will appear; double-click on the topic titled "Material Editor."

A **material** in 3D Studio MAX is a collection of all of the characteristics that define the look of a surface. A texture map is one part of a material. Most material settings are not easily exported from MAX for use in a game engine, and often need to be defined separately using some tool particular to the game engine. Information about texture maps and texture mapping are commonly exported from 3D software for use in game engines.

You could drag the texture map from a Windows Explorer window directly onto an object in MAX, as suggested in Chapter 2. Instead, open the *Material Editor* (press *M* on the keyboard). Choose the first gray sphere in the material palette. Open the *Maps* rollout, and click the *None* button beside *Diffuse Color*. This opens the *Material/Map Browser*. Choose *New* under *Browse From:* and *Bitmap* from the list in the main window.

A **bitmap** is another name for a digital image. By choosing *Bitmap*, you are choosing to use a texture map rather than one of the procedural materials that MAX offers.

A file browser opens; choose the texture map, named *Fig-04-08.tif* (available on the CD-ROM).

With the spider leg selected, click the *Assign Material to Selection* button (place your cursor over the buttons in the *Material Editor* and a small rollover window will appear identifying the button). This assigns the material to the spider model, but it will not be

4–8

The texture map

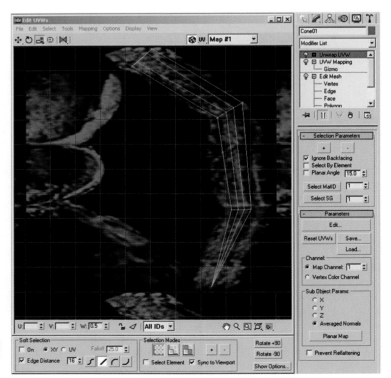

4–9

Adjusting UVWs

visible in the viewports yet. Click the ***Show Map in Viewport*** button. Now the texture map displays in the viewports.

Apply an ***Unwrap UVW*** modifier. Click the ***Edit*** button to open the ***Edit UVWs*** window as shown in Figure 4–9. Using the ***Move***, ***Rotate***, and ***Scale*** tools in the ***Edit UVWs*** window, and arrange the points over the texture map as shown in the figure.

::::: Adjusting Texture Coordinates

UVW mapping is texture mapping. The points you are working with in the ***Unwrap UVW*** modifier are not the model's vertices; they are UVW coordinates, or texture coordinates. They describe how the texture is applied to the surface. U, V, and W are similar to x, y, and z, except that the latter are used to specify locations in 3D space while the former are used to specify locations in a 2D bitmap and the way that the bitmap covers the surface of a 3D model. The ***Edit UVWs*** window shows the UVW coordinates for each vertex by displaying them over the part of texture to which they are mapped.

If a shaded viewport is visible, you will notice that the mapping on the model is updated each time you adjust the points in the ***Edit UVWs*** window. This is handy for checking your work as you progress.

It is important to remember that there may be multiple UVW coordinates in the same location. With the UVWs located as shown in Figure 4–9, one side of the spider leg is mapped with the same part of the texture map as the other side—the vertices on one side have similar UVW values to the other. To select all vertices in a given location, use **region select** in the ***Edit UVWs*** window; click and drag, and surround the UVW coordinates you wish to select (region select them), rather than just clicking to select.

When working with texture coordinates it is important to respect the original shape as planar mapped. If you simply move individual points around you can usually expect the texture to stretch and streak. You can avoid this if you start by rotating, scaling, or moving all of the points at once. In the example above, you will then need to select the points of the various cross-sections, and move, rotate, and possibly scale them as a group.

As a final adjustment, select the outermost points of a single cross-section in the ***Edit UVWs*** window, as shown in Figure 4–9, and scale them to move them apart from one another. The outermost faces on the leg are represented in the UVWs as planar mapped and as narrower than they actually are; scaling makes them appear larger in the edit window and gives them a larger portion of the texture. To put it another way, this gives all of the faces on the leg a more similar number of pixels.

To copy this leg, choose **Clone** from the **Edit** menu. In the **Clone Options** window, choose **Copy**, and click **OK**. Move the new leg to a new location along the body, and add another **Edit Mesh** modifier to adjust the vertices to match the next spider leg to the background reference image. Make the four legs on one side of the body, then select them all, and clone them all at once, to make the legs for the other side. Rotate them all 180 degrees in y, rather than mirroring them. See Figure 4–10.

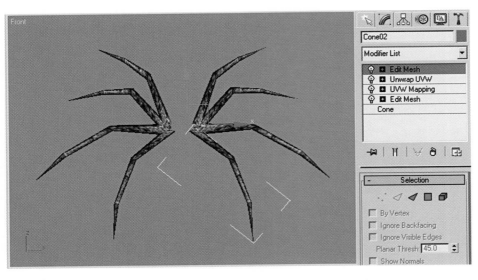

4–10 | Finished legs

You have finished the legs! Save the file and take a break, then proceed on to the body. You can examine *Ch 04-10.max*, which contains the spider in its current state, and compare it with your spider legs. The file is available on the CD-ROM.

Create a cylinder with six **Sides** and five **Height Segments**. Place it as shown in Figure 4–11.

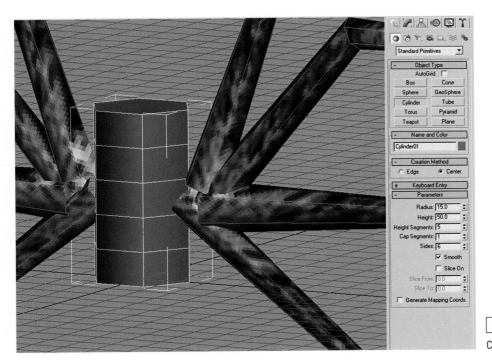

4–11

Cylinder primitive

Add an *Edit Mesh* modifier. Manipulate the vertices using the *Uniform Scale* and *Move* tools, and the *Rotate* tool. Arrange the vertices over the background image as shown in Figure 4–12.

Select and delete the faces on one end of the cylinder, as these faces would not be visible in the final model. When working from primitives, it is important to remember to delete unneeded faces as you build—it may be difficult to find and remove them later.

The faces on the bottom end of the cylinder would not map well using planar mapping from the front. You will flatten out the tip of the cylinder, and eliminate six polygons.

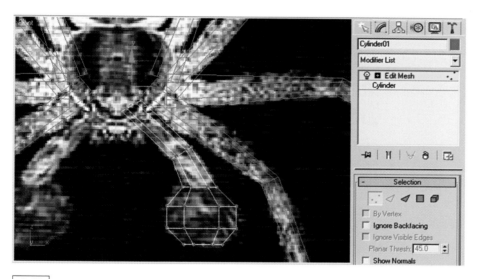

4–12 Editing the cylinder

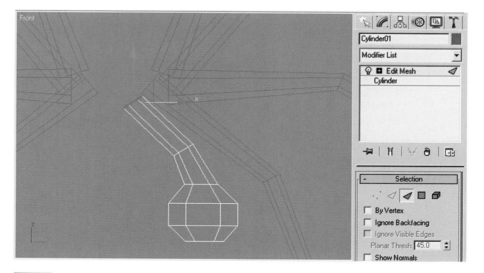

4–13 Delete unneeded faces

Select the three points shown in Figure 4–14. In sub-object *Vertex*, set the *Weld* threshold (the number next to the *Selected* button) to 50. All selected points within 50 units of each other will be welded when you click the *Selected* button. This number should be large enough to guarantee that the three selected points will be welded into one. If it is not, if all three points don't weld into one, undo, set the weld threshold higher, and try again.

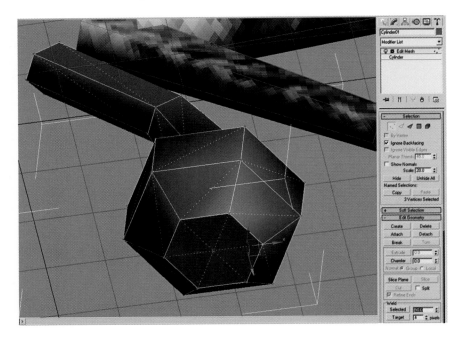

4–14

Weld vertices to remove faces

Select and weld the three points on the other side.

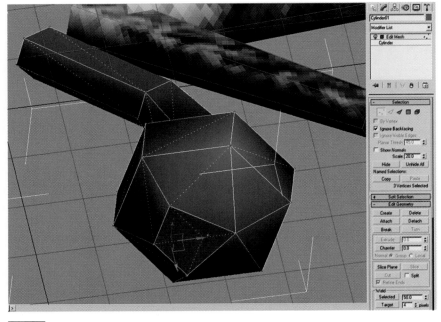

4–15 More vertex welding

A wireframe view shows that an extra point remains. Select it, and click the **Target** button under **Weld**. Drag the selected point until it is very close to the unselected (blue) point to the right of it. If you release the mouse button with the vertex close enough to the other vertex, the selected vertex will be welded to the other. If you have difficulty dropping a vertex near enough to weld, you can increase the *pixels* setting (next to the **Target** button). By default, you must drop a vertex within 4 pixels of another target weld.

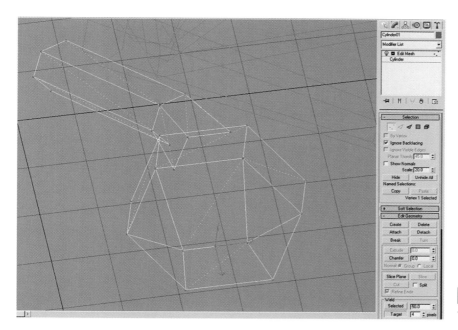

4–16

Target weld

Open the **Material Editor**, and apply the spider texture map material to the object. Add a **UVW Map** modifier. Align the gizmo as shown in Figure 4–17.

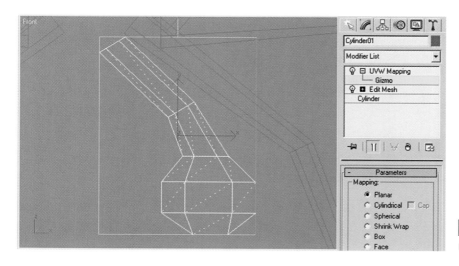

4–17

UVW mapping

Add an **Unwrap UVW** modifier. Use the tools within the **Edit UVWs** window to move, scale, and rotate the texture coordinates to place them over the spider reference image as shown in Figure 4–18.

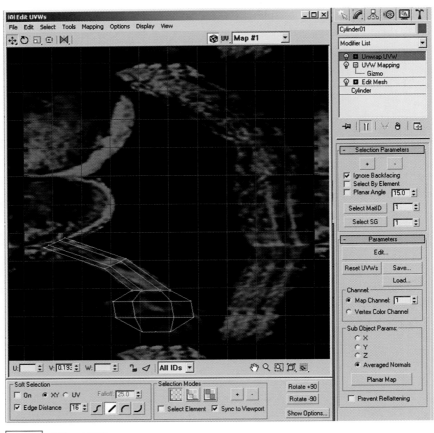

4–18 Adjust UVWs

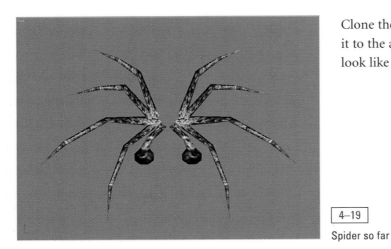

Clone the new limb, rotate it 180 degrees, and move it to the appropriate location. The model should look like the image in Figure 4–19.

4–19

Spider so far

Save your file. Continue when ready.

Create a sphere of about the size and location shown in Figure 4–20. Set **Segments** to 8.

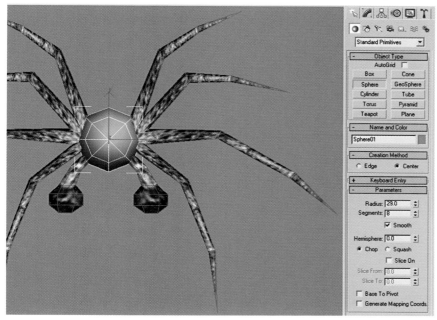

4–20 Sphere primitive

Incremental save

It is a good idea to save multiple versions of your MAX file as you work. If you continuously save using the same file name, it is fairly easy to lose all of your work if the file becomes corrupted or if you make a mistake. If you choose **File>Save As**, and click on the **+** button, the file name will be incremented; that is, "file01.max" will be saved as "file02.max" ("file.max" will be saved as "file1.max").

This is good to do when using any software tool. Because Photoshop doesn't have the explicit incremental save function, you can manually increment filenames as you save your work.

Move, rotate, and scale the sphere as necessary to place it over the background image as shown in Figure 4–21.

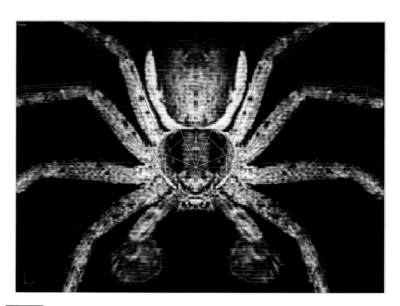

4–21 Sphere head

Clone the sphere and move it up. Scale it to fit the background image.

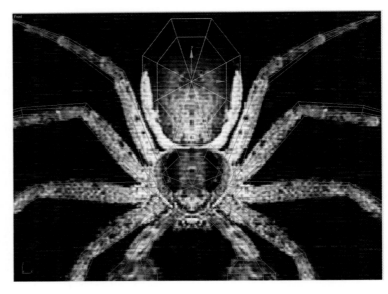

4–22 | Sphere body, scaled

This particular spider will look better if its body isn't so round.

Select both spheres and scale them together in x, using the left viewport. Figure 4–23 shows a scale of about 60%.

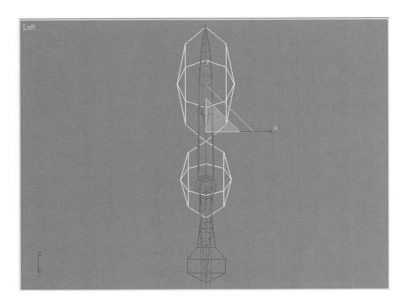

4–23 | Scaling both spheres



In order to make efficient use of texture memory, the texture map contains only half of the spider, so it will need to be applied to both halves of the model. Currently, there are no vertices along the center of the model, so you will need to divide the model in half vertically.

Select the first sphere. Add an **Edit Mesh** modifier. Go to the **Polygon** sub-object, and select all the faces. Click the **Slice Plane** button in the **Edit Geometry** rollout. The slice plane appears as a yellow plane. You will need to rotate the slice plane, probably in more than one axis, to line it up vertically so that it will slice the sphere down the center (Figure 4–24). When it is ready, click the **Slice** button to perform the slice.

4–24 Slice the sphere

You should now see new vertices as shown in Figure 4–25. Chances are, the slice plane was not located exactly in the center, and extra vertices were produced near those that already existed. Do a region selection around the center points, and **Weld** them using a low threshold (0.1 should work).

The odd shading shown in Figure 4–26 is a good indication that the points are still not properly welded. If your model shows this type of shading, with

4–25 Extra vertices from slice

triangular faces visible on the surface, try welding them with a higher threshold. Check the bottom of the sphere, and repeat this process if necessary.

4–26 | Shading reveals need for welding vertices

The slice added several vertices where they are not needed, which adds faces where they are not needed. Select the point shown in Figure 4–27 and target weld it to the point above it. Do the same with a similar point on the bottom of the sphere, and with two more points on the back. This eliminates four points and eight faces.

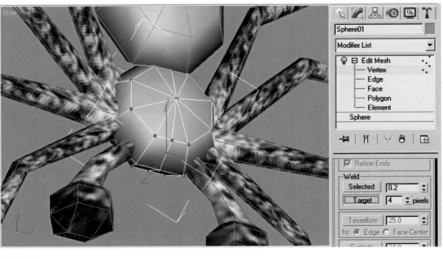

4–27 | Target weld vertices

Repeat the last few steps to slice the abdomen sphere in half vertically, and eliminate the extra vertices created.

Select one of the spheres, add an *Edit Mesh* modifier, and *Attach* the other sphere to it (click the *Attach* button in the *Edit Geometry* rollout and click the other sphere). This will make it easier to work with the two together. See Figure 4–28.

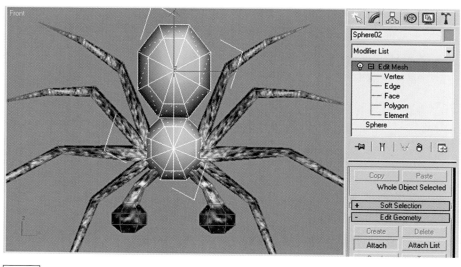

4–28 | Attach the two spheres

Apply a *UVW Map* modifier, and orient the gizmo as shown in Figure 4–29.

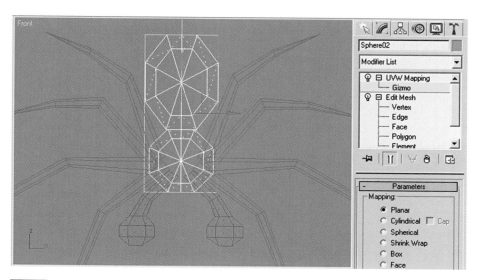

4–29 | UVW mapping

Apply the spider material to the spheres. Add an **Unwrap UVW** modifier. In the **Edit UVWs** window, arrange the points over the spider-map image as shown in Figure 4–30.

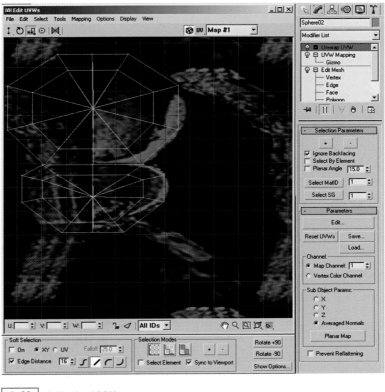

4–30 | Adjusting UVWs

Select all the points on the left side of the body—those that are not over the correct part of the texture. You will use the button in the **Edit UVWs** window to **Mirror Horizontal** these points and use **Move Horizontal** to place them over the points on the other side of the body. This way, the two halves of the model will share the same part of the texture map. See Figure 4–31.

Figure 4–32 shows the selected points placed so that they receive the same part of the texture as the points on the opposite side of the body. In this way you take advantage of the symmetry of the spider's body to reduce the size of the texture used. This is why you sliced the spheres in half.

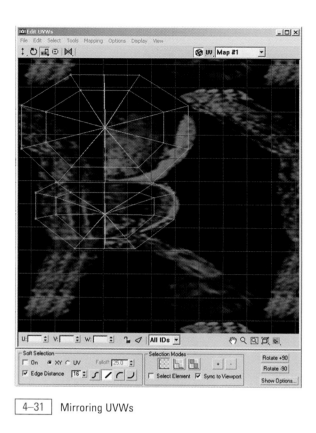

4–31 Mirroring UVWs

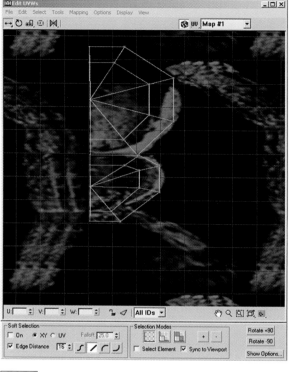

4–32 Mirrored UVWs

Figure 4–33 shows the spider model nearly completed.

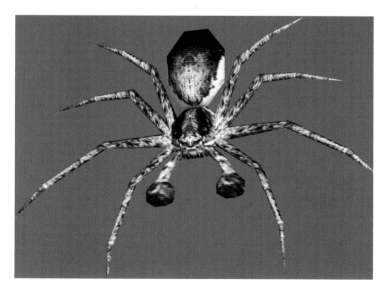

4–33

Model in progress

Select all the parts of the spider. Select the **Rotate** tool, then right-click to open the **Rotate Transform Type-in** window. Type in 90 in z under **Offset: Screen**. This brings the spider into an on-the-floor pose rather than on-the-wall. Now select all the legs on one side of the body, choose the **Local** coordinate system, and choose **Use Transform Coordinate Center**. Rotate in z until the tips of the legs are slightly lower than the bottom of the spider's body, so that they seem to be touching the ground. About 17 degrees, or −17 depending on which side you chose first, should be about right. The back leg will need further rotation, roughly another 6 degrees. Next, rotate the legs on the other side.

The spider will actually look more ferocious if you raise the front legs into the air a bit. Rotate by different amounts for an asymmetrical look.

Figure 4–34 shows the finished spider with shadows to help see the positioning of the legs.

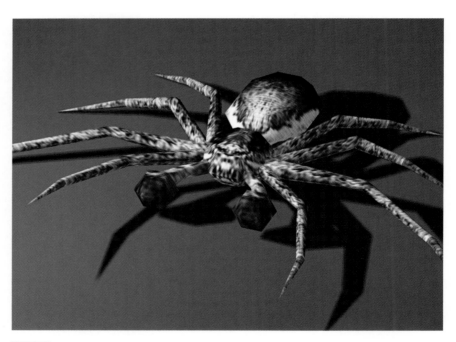

4–34 | Finished spider model

You're done! Save your work.

EXERCISE 4–1:::

Choose an object for which box modeling from primitives is an appropriate creation method, and build it using what you have learned.

Texture Mapping

The next two tutorials demonstrate the ways in which more than one texture can be applied to the same object, and how texture coordinates, or mapping, can be applied differently to different parts of the same object.

Learning is a process. The first method demonstrated will not work for many game engines, because many current game engines only allow one texture map per object. This will be explained in more detail in the following sections. However, learning this approach first is important to understand the concepts, and in learning the second approach. Furthermore, game engines and related tools continue to become more sophisticated, and it is likely that in the near future the first approach will work with many, perhaps even most, game engines.

TUTORIAL 4-2: MANY TEXTURES ON ONE OBJECT:::

3D Studio MAX allows you to apply different textures to different parts of a model. This tutorial shows you how.

Choose *File>New*, select *New All*, and press *Enter*. Create a box as shown in Figure 4–35.

Workflow

In this tutorial you will:

• Apply six different textures to six different surfaces of a 3D model.

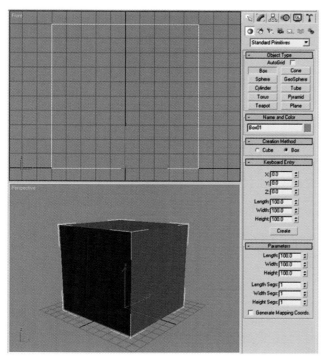

4–35 | A box primitive

Figure 4–36 through Figure 4–41 are available on the CD-ROM as *1.jpg* through *6.jpg*. You will map one texture to each surface of your cube.

4–36 1.jpg

4–37 2.jpg

4–38 3.jpg

4–39 4.jpg

4–40 5.jpg

4–41 6.jpg

In the *Material Editor*, make a material for each of the six textures. Click the *Show Map in Viewport* button to cause the textures to display on the object in the viewports. Select the material using 1.jpg and click the *Apply Material to Selection* button to apply the material to the cube.

The texture 1.jpg will appear mapped onto all surfaces of the cube.

Add an *Edit Mesh* modifier. You want to change the material on one side of the box. If you use sub-object *Polygon*, you can easily select an entire side of the box with one click of the left mouse button. On a box primitive, a polygon is a quad, made up of two triangular faces.

Default mapping coordinates

You need NOT have applied mapping coordinates to the box. As with extruded models, MAX has default mapping coordinates for most primitives and modeling types. Note the *Generate Mapping Coords* checkbox in Figure 4–43; the software checks this box automatically when a material that requires UVW mapping is applied.

4–42 | Six materials for six textures

4–43 | 1.jpg as a texture on a cube

Select one side of the box. Select the material using 2.jpg and click the ***Apply Material to Selection*** button to apply the material to the selected part of the cube. Selected faces and polys are displayed in red, obscuring any texture applied—deselect the poly to see the texture. See Figure 4–44.

Select another side of the box, and apply the material using 3.jpg. See Figure 4–45.

Repeat the process until each side of the box is mapped with a different texture. See Figure 4–46.

4–44　Applying a material to selected faces

You can quickly apply different materials, and thus different textures, onto different parts of a model in this manner.

4–45　Apply a third material

4–46　Multiple materials on a single object

Many game engines (including *Quake III Arena*) require that each object have only one texture map. The box you have been working with currently has six materials using six different textures. The exporter for a particular game engine, the tool or tools that are usually required to convert your models to a 3D format used by the game engine, may not understand such a model, and the game engine may not be able to display it. One solution would be to detach each side of the box so that it becomes six separate objects, and then map each with a different texture. There is a better solution, however, which allows us to discuss how different texture coordinates can be applied to different faces on the same model.

Continue with the next tutorial when you are ready.

TUTORIAL 4-3: UNWRAP UVW:::

3D Studio MAX allows you to apply different parts of a single texture to different faces of a model. This tutorial shows you how.

The image titled *123456.jpg*, available on the CD-ROM, consists of all six texture maps combined into one image file, as shown in Figure 4–47. This

> ### Workflow
>
> In this tutorial you will:
>
> • Apply six different parts of a single texture to six different surfaces of a 3D model.

tutorial shows you how to apply a different part of the texture map to each polygon on the box. To put it another way, you will apply different texture coordinates to each polygon.

4–47

Six texture maps combined into one

Type Ctrl-N, or choose *File>New* . . . and then *New All*.

Create a box. Load the new texture map, *123456.jpg*, into the diffuse channel of a new material, and apply this material to the whole box. By default it is box-mapped, as in Figure 4–48.

Apply an *Unwrap UVW* modifier. Click the *Edit* button to open the *Edit UVWs* window. Adjust the points to match the corners of the "2" square as shown in Figure 4–49. Use *Move Vertical* and *Move Horizontal*—Figure 4–49 shows the menu to select these tools (in the upper left corner). Left click and hold the button shown to drop the menu. Note that you will need to use the various tools—move, rotate, scale—that are located at the top of the *Edit UVWs* window, rather than those in the toolbar.

4–48 Default box mapping

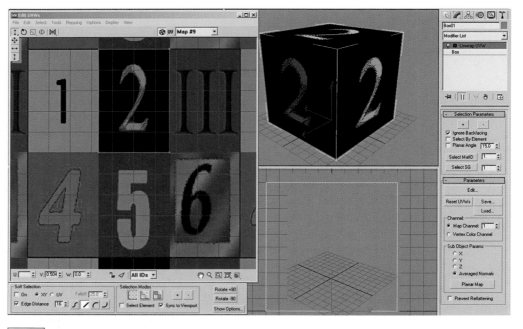

4–49 Editing UVWs

The entire box is mapped with the 2. From here you will need to adjust the UVW mapping of each quad individually.

Apply a *Mesh Select* modifier. This modifier does not allow any characteristics of the sub-object entities (vertices, edges, faces . . .) to be changed; it merely allows them to be selected. Go to sub-object *Polygon* and select the poly on the left in the *Perspective* view, the poly already mapped with the "1" in Figure 4–50. Add another *Unwrap UVW* modifier.

More on the Unwrap UVW modifier

For more information on using the *Unwrap UVW* modifier, choose *User Reference* under the *Help* menu in 3D Studio MAX. In the Search panel type "unwrap uvws" (include the double quotes) and press *Enter*. A list of topics will appear; double-click on the topic titled "Unwrap UVW modifier."

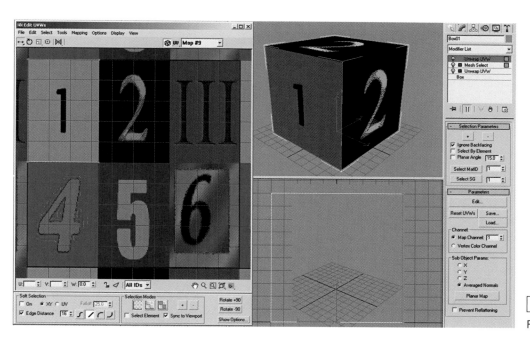

4–50

Further UVW editing

::::: Using Mesh Select

By selecting a part of the model in a *Mesh Select* modifier, you can cause the next modifier you apply to affect only the selected part. If the *Mesh Select* modifier was left on sub-object *Polygon*, this new *Unwrap UVW* modifier will only change the UVW coordinates of the selected polygon and not the entire model. Only the UVWs of the selected quads are included in the *Edit UVWs* window, not those of the whole box.

Click the **Edit** button and move the points to match the corners of the "1" part of the texture map, as shown in Figure 4–50.

Add another **Mesh Select** modifier and select the top polygon. Add another **Unwrap UVW** modifier and adjust the points to match the "III." The cube should look like Figure 4–51. Take a close look at the stack.

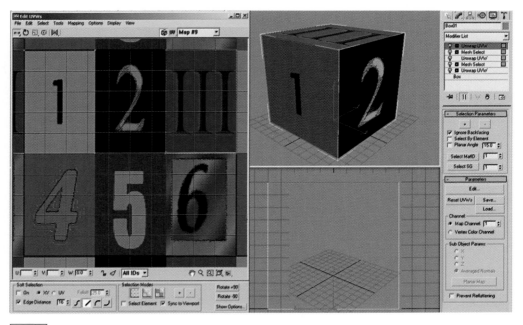

4–51 The stack reveals the method

Continue this process until you have mapped all six sides of the cube, each with a different number.

You have learned important fundamentals of texture mapping and gained new insight into the use of the modifier stack in 3D Studio MAX.

Transparency in Textures

There are times when it is necessary to make part of a texture transparent. Figure 4–52 shows a good example: the fence could be built entirely of polygons, but this would require a large number of polygons. Using a texture with some transparent areas makes a relatively realistic looking fence using only eight tris. You usually want textures like this to be visible from both sides, and many game engines allow you to cause backfacing polygons to be drawn for certain models or textures. If this is not possible, you can simply place two quads back to back, facing in opposite directions. Using transparency in this way only works well with objects of relatively little thickness.

The use of transparency can also allow you to create the illusion of more organic forms. Polygons always have straight edges, but using transparency you can give the illusion of a more uneven edge. Consider the plant model in Figure 4–53.

4–52 Texture with transparency

4–53 Plant model using transparency (©2000 Todd Gantzler)

More on opacity mapping

For more information on using opacity mapping, choose **User Reference** under the **Help** menu in 3D Studio MAX. In the Search panel type "opacity map," and press **Enter**. A list of topics will appear; double-click on the topic titled "Opacity Mapping."

Figure 4–54 shows the geometry. Each leaf of the plant is essentially four quads. (Don't be deceived by the lines down the center of each leaf. These are lofted models, and the center line is the path—see Chapter 6 for the details on lofted models.) Figure 4–55 is the texture map. Figure 4–56 is a type of map used

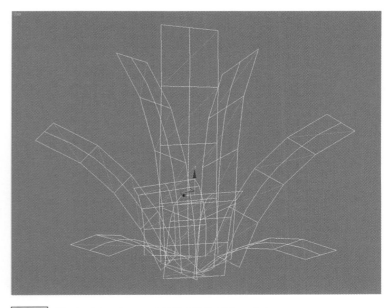

4–54 Mesh of the plant model (©2000 Todd Gantzler)

by 3D Studio MAX to assign transparency to certain areas, called an **opacity map**. The opacity map is used as a set of instructions by the software; white areas are treated as opaque, black areas are treated as transparent, and the many possible shades of gray represent varying degrees of transparency.

4–55

Texture of the
plant model
(©2000 Todd Gantzler)

4–56

Opacity map of the
plant model
(©2000 Todd Gantzler)

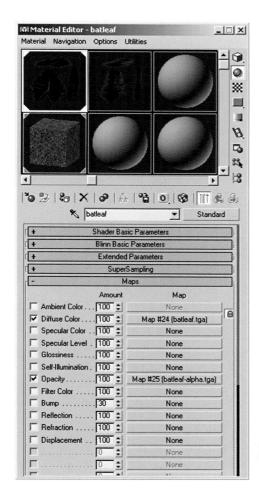

4–57

Material with opacity map

A material can use many types of maps. So far you have only used the **Diffuse Color** map channel. Figure 4–57 shows a material with an image named "batleaf-alpha.tga" in the opacity map channel.

TUTORIAL 4–4: MAKING AN OPACITY MAP:::

This short tutorial will walk you through the process of making an opacity map.

In Photoshop, open *batleaf.tga*, available on the CD-ROM. Selecting the leaf in this case will be easy; choose the **Magic Wand Tool** (you can press *W* on the keyboard), select the gray background, and then choose **Inverse** from the **Select** menu. Create a new layer (**Layer>new>Layer . . .**) then create a second new layer. See Figure 4–58.

Workflow

In this tutorial you will:

- Create an appropriate opacity map for an existing texture
- Check the edges in MAX and correct the opacity map as necessary
- Learn to soften the edges when appropriate
- Learn to add an alpha channel to an image and copy your opacity map into it.

Save the image as "batleaf-alpha.psd" to keep a working version of the image with layers preserved. Then in the top layer use the **Paint Bucket Tool** to fill the selected area with white. It must be 100% white to be 100% opaque. By clicking on the foreground color (circled in red in Figure 4–59), open the **Color Picker** window. You can use the **Color Picker** to mix the color you need. 100% white has red, green, and blue values of 255.

Select the middle layer, type Ctrl-D to turn off your selection of the leaf shape, and use the **Paint Bucket Tool** to fill the entire layer with black. Save the image.

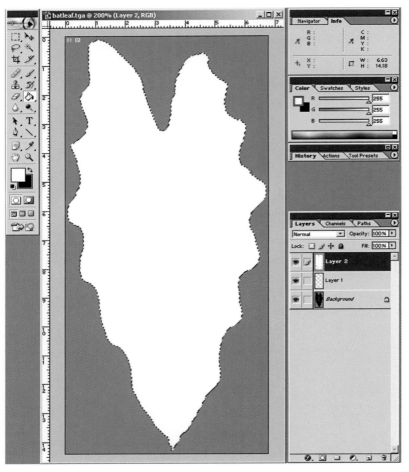

4–58 | Making an opacity map

4–59

100% white

Duplicate your image (*Image>Duplicate*), flatten the new image, and save it as
batleaf-alpha.tga. Load MAX and load the file *plant.max* from the CD-ROM. Make a new
material using batleaf.tga as a texture in the **Diffuse Color** channel, and batleaf-alpha.tga
as an opacity map in the **Opacity** channel. Zoom in on the plant, and render the image
(click the **Quick Render** button, shown circled in red in Figure 4–60).

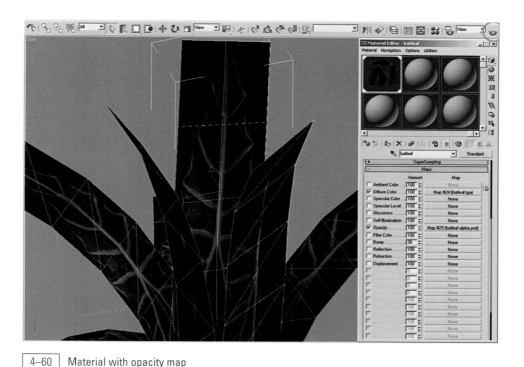

4–60 Material with opacity map

Figure 4–61 shows the resulting rendered image. There is a slight white edge around the
leaves of the plant. This is the result of the white in the opacity map being very slightly
larger than the leaf in the texture map, which means that a bit of the gray background is
also opaque. A closer look, as in Figure 4–62, reveals that a jagged edge is also visible.
What you are seeing here is the rectangular pixels of the opacity map. This effect can be
reduced by making the edges of the opacity map partially transparent (neither black nor
white, but shades of gray), which produces a softer looking edge. As mentioned in
Chapter 3, fully transparent pixels can be rendered by most game engines very efficiently.
Rendering of partially transparent pixels usually takes slightly longer. There is thus a
trade-off between a better appearance and the greater impact on render time. Knowing
this, you can make the right choice for the situation.

4–61 White edge around the leaves

4–62 Jagged edges

Repeat the process again, this time making an improved opacity map that fits the texture better and has partially transparent edges.

Load your batleaf-alpha.psd. Delete the layer with the white leaf and turn off the black layer. Select the background layer. Select the gray background, then choose **Inverse** from the **Select** menu.

Create another new layer. This time, **Select>Modify>Contract . . .** and enter a value of 1 to cause the selection to contract by one pixel. The selection is now slightly smaller. Right-click the selection, choose **Feather . . .** , and enter a Feather Radius of 0.5. Then, in the top layer, use the **Paint Bucket Tool** to fill the selected area with white. With a soft-edged selection, the pixels at the edges, when filled, will be partially transparent, in this case grays.

The difference should be apparent. See Figure 4–63.

4–63 Comparison of the opacity maps

4–64 Results of new opacity map

Try your new image as an opacity map. You should see an improvement. See Figure 4–64.

Many applications, including many game engines, use an **alpha channel** for transparency in an image rather than an opacity map. An alpha channel is very similar to an opacity map but it is stored as part of an image, such as a texture map, rather than as a separate image.

To add an alpha channel to batleaf.tga, open it in Photoshop. Go to the *Channels* window and click the little arrow shown circled in red in Figure 4–65. In the menu that opens, choose *New Channel . . .* , and click *OK* in the window that opens. The image window will now display only the new

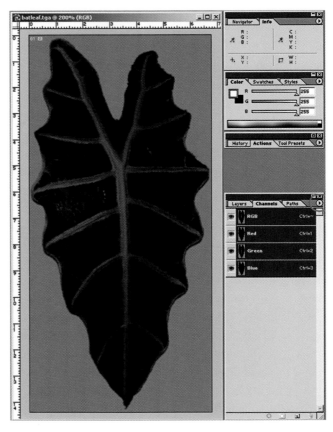

4–65

Adding an alpha channel

channel, Alpha 1. Cut and paste to copy the image from your opacity map into the alpha channel of batleaf.tga. See Figure 4–66.

In the **Channels** window you can click on the RGB channel to view the image. Click on the **Alpha 1** channel to view the alpha channel.

To save an image with an alpha channel, you must save it as a 32-bit image. The old batleaf.tga was a 24-bit image. To save the changes to your image, choose **Save As . . .** and enter a new name. The **Targa Options** window will open; choose **32 bits/pixel** and click **OK**.

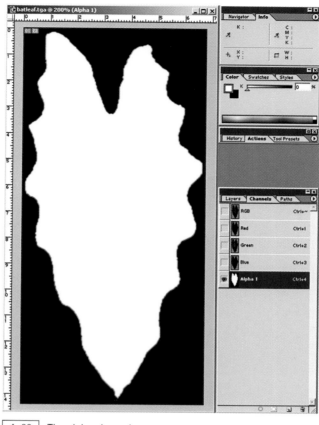

4–66 | The alpha channel

Bump Mapping

Bump mapping is another way to add more detail to a model without adding more polygons. Many modern game engines perform bump mapping, including the Playstation 2.

Bump mapping performs operations during the lighting of an object to make the surface appear to have detail that is not present in the geometry. Bump mapping uses a grayscale image, like the one shown in Figure 4–67. If you had a gray bump map image, a white dot would appear as a bump, while a black dot would appear as a dimple. The bump map in Figure 4–67 is white on black to make the veins of the

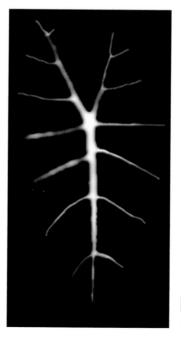

4–67

Bump map for the plant

More on bump mapping

For more information on using bump mapping, choose **User Reference** under the **Help** menu in 3D Studio MAX. In the Search panel type "bump map" and press **Enter**. A list of topics will appear; double-click on the topic titled "Bump Mapping."

plant appear raised from the leaf as much as possible. Figure 4–68 shows the plant model with the texture map turned off, so that the effect of bump mapping is clear. Figure 4–69 shows the plant without bump mapping, and Figure 4–70 shows it with.

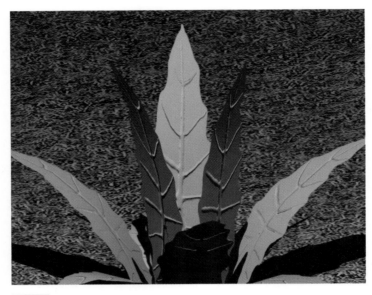

4–68 | Bump map applied to the plant, no texture map

4–69 | Plant without bump map

4–70

Plant with bump map

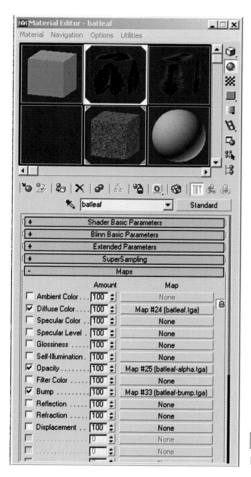

As you can see, bump mapping provided highlights on the raised areas, including on the darker undersides of the leaves. The effect of bump mapping is turned up to its highest extreme in Figures 4–68 and 4–70. The effect of the bump map can be adjusted. Figure 4–71 shows the Material Editor with *batleaf-bump.tga* loaded into the **Bump** channel (it is available on the CD-ROM; try it in plant.max as a bump map to study the effect). The figure shows that the effect of the **Bump** channel is 100%, as are all map channels. These numbers can be turned down for a more subtle effect, or in some cases turned up for enhanced effect. Note that bump mapping will almost certainly be set up differently in any game engine you encounter; this is the way it is done in MAX.

4–71

Bump channel in the Material Editor

For one more example of the use of bump mapping, consider the brick texture in Figure 4–72, and the bump map for it in Figure 4–73. Figure 4–74 shows the bump map set to 25% in MAX. With bump mapping, subtle is often better. Compare it with Figure 4–75, in which bump mapping is not used.

4–72 | Brick texture

4–73 | Bump map for brick texture

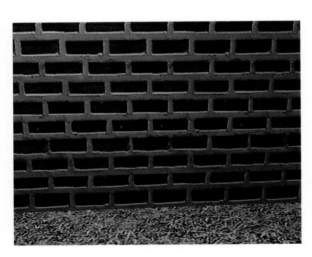

4–74 | Render with bump mapping

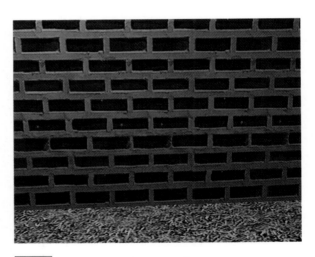

4–75 | Render without bump mapping

:::CHAPTER REVIEW QUESTIONS:::

1. Name some 3D Studio MAX features that are useful when you are starting with a reference map.

2. What makes a model suitable for modeling from primitives?

3. What are U, V, and W?

4. What is the function of Unwrap UVW?

5. How is a texture with transparent pixels created?

6. Discuss the advantages and disadvantages of 100% transparent pixels.

7. How is bump mapping useful to the artist?

You have now learned the basics of box modeling and texture mapping; to load an image into the background of a viewport and to use it as reference while modeling; to modify primitives to model certain shapes; the function of Unwrap UVW to manually adjust texture coordinates; and how to create opacity maps and alpha channels. You have also learned to create and use bump maps.

The next chapter begins to teach a procedural approach to modeling, and expands on box modeling.

In this chapter you will learn a procedural approach to modeling that gives you control over the modeling process and flexibility in the number of polygons in your models. You will build the sword model shown in Figure 5–1.

5

MODELING WITH THE PROCEDURAL APPROACH
CONTROL AND FLEXIBILITY IN POLY COUNT

OBJECTIVES

+ Create and edit splines

+ Learn the advantages of a procedural approach to modeling

+ Learn to use the modifier stack

+ Make models using extrusion

+ Learn about box modeling

+ Learn the basics of texture mapping

5–1

Low poly model created in tutorials in this chapter

The Value of Reference in 3D Modeling and Texturing

The value of reference in art is discussed in Chapter 2, but it has extra benefits in 3D modeling. It certainly is the case that it pays to look at examples from the real world of anything that you plan to build in 3D. In a 3D system such as 3D Studio MAX, you can load a digital image into the background of any viewport, and trace the outline with a **spline** (a curved line), making it a very literal reference for the proportions of your subject. While this is not helpful with all types of models, it is with many. With some work, a reference image can often be turned into an effective texture map for the model. The next tutorial shows you how to build one example of such a model.

The Right Modeling Approach

To model efficiently you have to make a good start. This involves choosing the right modeling approach, that is an approach that will get you closest to your final model with the least effort. Often this means using available tools that provide a procedural approach, those that allow the user to create and control the entire surface of the model at once, rather than individual vertices or polygons. This is also referred to as **parametric modeling**, because the model can be altered by simply changing various parameters. It also means that changes can be made to any aspect of the model without repeating the entire building process. Using a procedural approach can also help speed up the creation of Level Of Detail models. With many models, possibly most, you will need to take a very manual approach (like that used in Chapter 4) at some point in order to reach a finished

state. Using only a manual approach (box modeling) you can create any model, but it is definitely not the most time-efficient method in most cases. There are a variety of polygon modeling tools that have been around since the early days of computer graphics and are still in use today. In many cases they have been updated, made more powerful and easier to use, and provide a more efficient approach to modeling. They exist in a large quantity because models of different shapes require different tools.

The remaining tutorials in this book will show you various procedural polygon modeling tools and how to use them to create low poly models. Through examples and discussion you will begin to learn how to choose the best approach for any given model, how to determine the optimal point at which to switch to a manual approach to finish the job, and what precautions to take before making any strategic changes. You will continue to learn these lessons through experience.

The tutorials in this chapter introduce a simple procedural modeling tool, **extrusion**. You will build a model of a broadsword, but in order to finish it you will need to use box modeling methods. You will learn a new way of box modeling.

Using Splines

Splines are curved lines, using certain associated tools to define and refine those curved lines. The types discussed in this chapter are commonly called **bezier splines**. With bezier splines, the shape is controlled by vertices placed by the user and "handles" that can be adjusted to define the shape of the curves between the vertices. Two-dimensional splines are the starting point of many 3D models, and are an essential part of the modeling process.

Unless you have used splines before, it is strongly recommended that you take the time to do a short tutorial to learn about the use of splines. Under the *Help* menu in 3D Studio MAX, choose *Tutorial* In the Contents panel, click the + next to "Modeling a Chess Set," and double-click on "Modeling a Pawn." This tutorial is estimated to take 15 minutes to complete. It teaches elements of spline creation and spline editing, as well as the *Lathe* modifier and modeling technique. The following tutorial teaches creation and editing of splines as well, but uses a somewhat different approach and covers somewhat different material. Later tutorials expand on the use of splines.

More on splines

For more information on using splines, choose *Use Reference* under the *Help* menu in 3D Studio MAX. In the Search panel type "splines" and press *Enter*. A list of topics will appear; double-click on the topic titled "Splines."

For more information on using NURBS Curves: Under the *Help* menu in 3D Studio MAX, choose *User Reference*. In the Search panel type "NURBS Curves" (include the quotes) and press *Enter*. A list of topics will appear; double-click on the topic titled "NURBS Curves."

Also available for use are **NURBS Curves**. NURBS (or Non-Uniform Rational B-Splines) are two more types of splines available in MAX. Most MAX users find bezier splines the easiest to work with. 3D Studio MAX tends to provide several different ways to do the same thing, and this flexibility makes it likely that at least one way will work in any particular situation. But it also means that there is room for users to choose their own way of working with the software. NURBS Curves can be used to create polygonal models the same as bezier splines. Try all of the splines and decide which work best for you.

Workflow

In this tutorial you will:

- Create a spline shape.
- Use the appropriate tools to refine the shape of the spline.
- Use the **Lathe** modifier to create a 3D model based on the spline.

This is a short lesson in splines and concludes with the creation of a 3D model as an example of using splines to build models.

Before you start, choose **Reset** from the **File** menu to ensure that you are starting fresh. Turn on the **Snap Toggle** button, circled in red in Figure 5–2. By default, snap will add blue crosshairs that will follow your cursor, snapping to the nearest grid point (the crosshairs are visible in Figure 5–2). When the crosshairs are visible, any point you create will be placed on that grid point. The cursor can be set to snap to other entities as well, such as vertices of objects.

In the **Create** panel, click on the **Shapes** button, then the **Line** button. Click and release to place points. Use the snap feature to place points on the grid approximately as shown in Figure 5–2.

5–2

Spline creation

Go to the *Modify* panel, and to sub-object *Vertex*. Select the three vertices shown in Figure 5–3. Right-click on one of the vertices and choose *Smooth* (if you right-click anywhere besides on one of the vertices, you get a different menu). The spline should change to look like Figure 5–3.

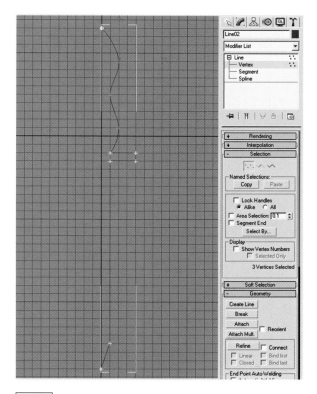

5–3 | Smooth spline points

Select the vertex at the top, right-click, and choose *Bezier Corner*. A line with a green square on the end appears, attached to the vertex. The green square is the handle you can use to manipulate the spline. With the *Move* tool selected, click and drag with your left button, and move it around in order to see the effect on the spline. Place the handle about where it is in Figure 5–4.

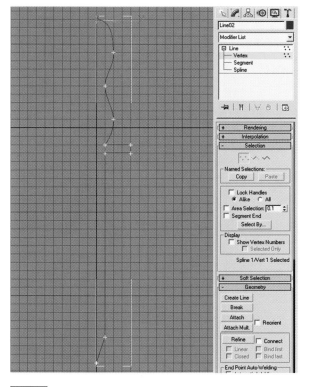

5–4 | Bezier spline point

Select the three points shown in Figure 5–5 again, right-click, and choose **Bezier**. The green boxes which act as handles appear extending in two directions from the vertex. Move a handle around to see the effect on the spline. You'll notice that the two handles move together. A spline always maintains a smooth curve through a bezier point. Adjust the handle attached to the top point to make the curve smoother in that area.

Select the vertex shown in Figure 5–6 and change it to a bezier point (right-click on the vertex and choose **Bezier**). Notice that the two handles are of different lengths. MAX tries to make intelligent decisions when changing the type of vertex, and has in this case gotten you very close to the shape you want.

5–5 | Bezier spline adjustment

5–6 | More bezier spline adjustment

A bezier corner vertex allows you to adjust one handle without affecting the other. Right-click on the selected vertex, and change it to **Bezier Corner**. Move the lower handle down to make the bottom-most curve of the blade more rounded. See Figure 5–7.

Apply a **Lathe** modifier: click on the **Modifier List** menu (see Figure 5–8), and choose **Lathe** from the list. To make the lathed model look as it should, you'll have to click the **Min** button under the **Align** rollout.

5–7 Bezier corner point

> ## More on lathe
>
> For more information on using the **Lathe** modifier, choose **User Reference** under the **Help** menu in 3D Studio MAX. In the Search panel type "lathe" and press **Enter**. A list of topics will appear; double-click on the topic titled "Lathe Modifier."

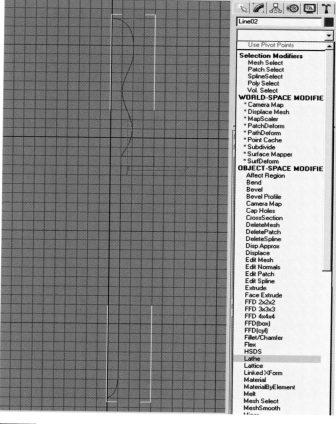

5–8 Lathe modifier

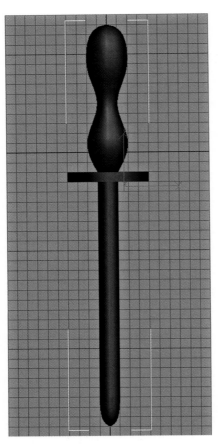

The lathed model should look like Figure 5–9. It looks like one type of knife sharpener.

This concludes the exercise in using splines. Practice using splines to make various shapes in order to test and develop your control over splines. Next you will use splines to build a sword model.

5–9

Lathe model

Procedural and Non-procedural Polygon Modeling

The next tutorial teaches extrusion as an example of a procedural approach to modeling. So that you can finish the model that you start, you will also be introduced to box modeling in subsequent tutorials. You will also learn about texture mapping.

The process you are about to follow is not necessarily the best way to build this sword model. Extrusion produces a finished model, without further modification, in relatively few cases, yet it does have its uses and should be taught—and it is a good way to reveal more of the workings of the **modifier stack** in 3D Studio MAX. The modifier stack is a sort of history of your modeling operations. It will be explained more fully later in this chapter. Although the intention is to provide the reader with the sense of accomplishment that comes from finishing a quality model, the primary purpose here is to teach the reader about modeling. A more flexible way to build the sword model will be revealed at the end of Chapter 6.

::::: Tips for Low Poly Modeling

A good tip for low poly modeling is to use **Facets** rather than **Smooth** for solid shading (right-click in the upper left of any viewport, on the text that indicates which view is shown in the viewport, and choose **Other>Facets**). Smooth shading can hide small imperfections in the surface, while faceted shading will reveal them.

Two keyboard shortcuts will be very helpful as you work in 3D Studio MAX: F3 toggles between shaded and wireframe views, and F4 toggles on and off **edged faces** (polygon outlines drawn over the shaded view).

TUTORIAL 5-2: EXTRUSION:::

An extruded model starts as a two-dimensional shape, and is given thickness through the extrusion process.

In this example, you will use an image as reference—the sword image in Figure 5–10.

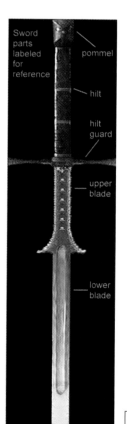

5–10

Sword reference image

Workflow

In this tutorial you will:

- Load an image into the viewport background to use as reference.
- Create a spline to trace the background image.
- Apply an extrusion modifier to make a 3D model based on the spline.

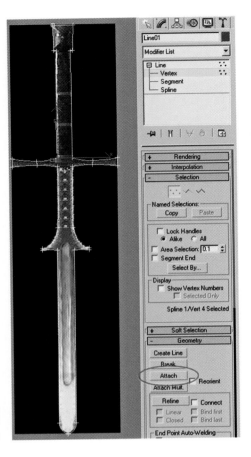

5–11

Spline outline

Start 3D Studio MAX. Select the **Front** viewport. Type Alt-B and load the image titled *sword-01.tif* as a viewport background. Remember to check **Match Bitmap** (under **Aspect Ratio**), and **Lock Zoom/Pan**.

Use **Line** (under **Create>Shapes** in the **Command Panel**) to trace the contour of the shape you want to extrude, as shown in Figure 5–11. You will probably want to switch to **Modify** (in the **Command Panel**), and work in sub-object **Vertex** to fine-tune your outline.

::::: **Tip for Creating Symmetrical Splines**

When creating a symmetrical outline such as the sword, consider creating just half of the outline first (see Figure 5–12). You can then click the **Mirror** button to mirror the first half as a copy. In the **Mirror: Screen Coordinates** window, choose **X** under **Mirror Axis** and **Copy** under **Clone Selection**, and then click **OK**. The **Align** tool can help to place the second half into its proper location: assuming you created the left half first, as in the figure, select the second half, click **Align**, and then click the first half. Choose **X Position**, select **Minimum** under **Current Object** and **Maximum** under **Target Object**. Click the **Attach** button (circled in red in Figure 5–11) and click on the other spline to attach the two halves. At the tip of the sword's blade there will be two points that should share the same location. Select them and click **Weld** in sub-object **Vertex** to weld the points together into a single point. Go to sub-object **Spline** and click **Close** to close the open section at the top of the sword.

Add an **Extrude** modifier to automatically add polygons to your spline shape. Enter a value of 30 under **Amount** for the thickness of the extrusion. Figure 5–13 shows the extruded model.

You now have a basic sword model. There is, however, more work to be done. The model is not really shaped quite like a sword. You will also want to find out how many polygons are in the model, and try to reduce the polycount.

For now, create a material using the image you used for reference, sword-01.tif, and apply it to the model.

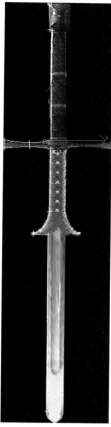

5–12 Starting with half of a symmetrical spline

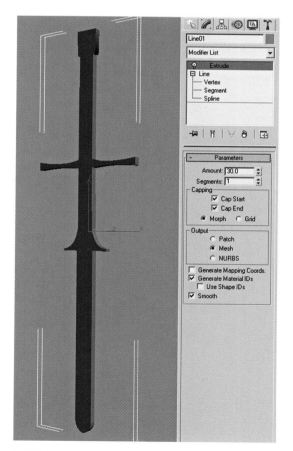

5–13 Extruded sword model

5–14

The Material Editor

5–15 Material using sword texture map

5–16

Texture map displayed in the viewport

Remember to click the ***Show Map in Viewport*** button (circled in blue in Figure 5–15). Now the texture map displays in the viewport, as shown in Figure 5–16.

Note that you have not applied texture mapping coordinates, or UVWs, to your model. In Figure 5–16, you can see that the ***Generate Mapping Coords.*** checkbox (circled in red) has been checked for you by MAX.

Ordinarily, a texture map cannot be displayed if UVW coordinates have not been applied. However, 3D Studio MAX will apply default mapping coordinates, if possible, when a material that requires mapping coordinates is applied.

The default coordinates for an extruded model are usually inappropriate for the edges of the model, as you can tell if you examine your sword model. The texture map aligns properly on the front and back of the model in this case because the texture image itself is cropped perfectly to the edges of the sword image; that is, there are no pixels in the image beyond the outermost parts of the sword itself. If the image had any kind of border, that border would be visible on the model.

The file *sword-16.max*, available on the CD-ROM, contains the sword model at this stage. You can examine it for comparison.

The next tutorial shows how to adjust the number of polygons in the model.

Save your work, and continue when ready.

TUTORIAL 5-3: CONTROLLING THE POLY COUNT:::

Next you will learn to use the stack to control the number of polygons in your model.

3D Studio MAX gives you great control over the number of polygons in a model. This control represents one of the most basic uses of the modifier stack. When building a low poly model, using the stack to control the poly count, as this tutorial will demonstrate, should be among the first approaches you consider. In this case you are dealing with an extruded model. Adjustments to other types of models are not made in exactly the same way, but the process is similar.

> ### Workflow
>
> In this tutorial you will:
>
> • Adjust the parameters of your original spline in order to change the poly count of the extruded model.
>
> • Arrive at a model with minimal polys but sufficient detail.

5–17

Displaying
hidden edges

To see all of the faces or polygons in your model, you will need to go to the **Display** panel, and uncheck **Edges Only** (circled in red in Figure 5–17). Hidden edges will now be drawn, so that you can see every triangular face in the model.

The **Polygon Counter** is extremely helpful. Go to the **Utility** panel, click **More**, and choose **Polygon Counter**. The polygon count displays in a floating window. Leave it open as you return to the **Modify Panel**, and move it around the screen as necessary to keep it out of your way. See Figure 5–18.

You can also press *7* on your keyboard to display the number of faces in the viewport for the currently selected model.

5–18

The polygon counter

In the *Modify Panel*, choose *Line* from the stack (see Figure 5–19). You are returning to the first modifier on the stack, the one you used to make the original spline. The stack is a sort of list of all of the operations you have performed to create your model. More specifically, it is a list of the modifiers you have used. The modifier at the bottom of the list is the first modifier applied (in this case *Line*), and the modifier at the top of the list is the one applied most recently. In most cases you can select any modifier in the stack and make changes within that modifier, and the results will be passed through all subsequent modifiers so that the model is changed appropriately. In this case, you will make changes to your original spline, and the extruded model will be affected.

5–19

The Show End Result Toggle

More on the stack

For more information on using the stack, choose *User Reference* under the *Help* menu in 3D Studio MAX. In the *Search* panel type "stack" and press *Enter*. A list of topics will appear; double-click on the topic titled "Modifier Stack."

The viewport should show only the original spline. Click the *Show End Result Toggle*, circled in red in Figure 5–19. This will cause the model to be displayed as it looks at the top of the stack, with all of the modifiers having their affect. With this button off, the model appears as it would if only the modifiers up to and including the selected modifier were applied.

Your spline should use the points that you placed when creating the spline, plus a number of points in between to make the shape smoother. This is called **spline interpolation**. The user can control the number of points placed between each user-placed point.

Open the *Interpolation* rollout. Dial the *Steps* value up and down, and watch the effect on the model, and on the poly count. The default value for steps is 6; as you can see in Figure 5–19, a value of 3 has reduced the poly count to 304 without much visible difference in the model. You could turn *Steps* down further and further to reduce the poly count, but then the sword begins to lose definition in some areas.

With *Optimize* checked, MAX will not place any extra points between the points you placed where they are not needed, specifically on the straight edges in your spline.

The model as it is now may be useful in some situations. If the player is not able to get very close to the sword, the lack of detail and blunt edges of the blade may not be noticeable. If the player is intended to wield the weapon, or is able to approach it very closely, the problems will be all too obvious.

In the next tutorial you will put the finishing touches on the shape of your sword model. After that, you will finish the texture mapping of your model.

Save your work and continue when ready.

EXERCISE 5-1:::

Select a suitable reference image for a model that you can build, or start to build, using extrusion. Use it to build an extruded model, and use the stack as shown in the last tutorial to bring the polycount to the lowest possible number while preserving the necessary amount of detail.

PLANNING BEFORE MODELING:::

It is usually wise to spend some time planning your model before you begin. When using *Edit Mesh* (or *Editable Poly*, explained in the next section), some cleanup is often required, as you experienced in the last chapter. Careful planning can help you minimize the amount of cleanup required, which can save a lot of time.

Your sword model is currently of equal thickness from a side view. This is a characteristic of all models made using the *Extrude* modifier. One way to make some parts of a model thicker is to extrude selected groups of faces. This is how you will refine your sword model.

The manner in which you extrude faces is important. Consider Figure 5–20. On the left is a simple mesh made up of four quads. The center and right objects show possible results of extruding two of the quads. To create the object in the center, the quad labeled "B" was extruded first, then the quad labeled "C". This has the unfortunate result of creating untidy mesh. The faces shown highlighted in red would be completely inside a closed mesh model, and with backfacing polygons culled, would never be visible. This arrangement of polygons can cause further problems as you work with various box modeling tools.

To create the object on the right in Figure 5–20, the quads labeled "B" and "C" were selected and extruded at the same time, after which C was selected and extruded again. This creates a much more orderly arrangement of polygons.

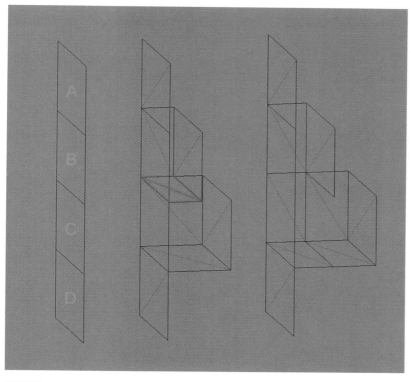

5–20 | Face extrusion

Figure 5–21 shows the extruded sword model beside an outline of the intended profile of the model. You cannot simply scale part of the model, such as the upper blade, because it currently shares vertices with the neighboring faces. For the best results, the parts labeled "A" and "B", the upper blade and hilt guard, can be extruded at the same time. Then the hilt guard (A) can be extruded further. The pommel (C) can be extruded separately. The hilt can be made thicker, as necessary, using scaling.

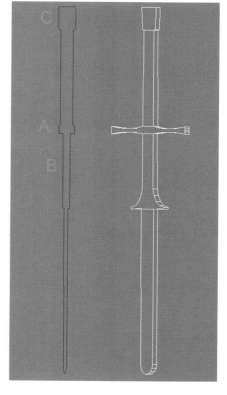

5–21

Planning diagram

MODELING WITH THE PROCEDURAL APPROACH chapter5

Workflow

In this tutorial you will:

- Learn about **Editable Poly** modeling.

- Use the tools associated with **Editable Poly** models to refine the 3D mesh of your sword model.

You have taken the modeling process as far as possible with a procedural approach. As of now, you can easily tune the poly count by changing the path steps. In order to refine the shape of the model from here, however, you need to begin to work with it in a manual, or non-procedural, manner. You will come to this point with many of the models you build.

Editable Poly is relatively new to 3D Studio MAX, and is a new option for use in box modeling. It improves on **Edit Mesh** in various ways, some of which you will see in this tutorial. Like **Edit Mesh**, converting your model to **Editable Poly** will allow you to weld points, divide edges, and extrude faces—but once you have converted to **Editable Poly**, you no longer have access to any modifiers previously in the stack. It is therefore important that you are happy with the model before proceeding—the shape should be what you need, and the poly count should be as low as possible while retaining the amount of detail you need. It is a good idea to save the model in this state, and save to another file name before you proceed.

All faces are still triangles, but **Editable Poly** is designed to manipulate polygons, not faces. No **Face** sub-object is available, thus it is not possible to work on individual faces. The only edges you can work with in sub-object **Edge** are those that define the outline of a polygon; no hidden edges can be selected, whether displayed or not. Although it is possible, and sometimes desirable, to see the hidden edges, **Editable Poly** is intended to be used with display of hidden edges turned off. Thus an edge, in **Editable Poly**, is a visible edge, or the edge of a polygon. If you want to perform an operation, such as extrusion, on just part of a polygon, you must create an edge to divide that polygon—again, any hidden edges that may be present will not help you.

Because **Editable Poly** deals with faces differently than **Edit Mesh**, the polygon counters in MAX will report different numbers. To see the number of triangular faces in your model, you can add an **Edit Mesh** modifier, just to see the polycount, and then delete it from the stack.

Don't worry if the operations in this tutorial have a negative effect on your mapping; the next tutorial will help you to apply more appropriate mapping to the model.

To begin, select the extruded model and right-click on it. In the menu that opens, choose **Convert To>Convert To Editable Poly**. All of the modifiers in the stack will disappear and will be replaced with **Editable Poly**.

The flat surfaces of the sword model consist of one large polygon (see Figure 5–22). To work with an individual part, such as the hilt, you will need to create new edges, dividing the polygon into smaller polygons. In sub-object **Edge**, choose **Create** in the **Edit Geometry** rollout. The vertices of the model are displayed. To define new edges, click on the vertex where the edge should begin, and then on the one where the edge should end. Create new edges as shown in Figure 5–23. Do this on both sides of the model.

More on Editable Poly

For more information on using **Editable Poly**, choose **User Reference** under the **Help** menu in 3D Studio MAX. In the Search panel type "editable poly" and press **Enter**. A list of topics will appear; double-click on the topic titled "Editable Poly."

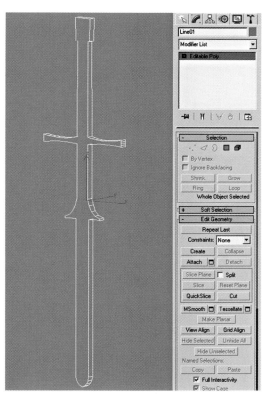

5–22 Editable poly model

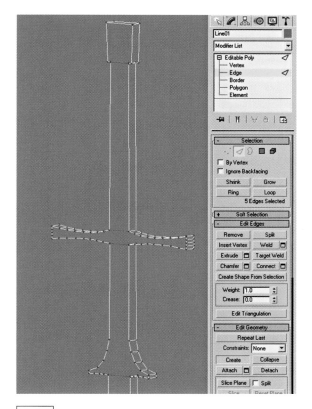

5–23 New edges, new polygons

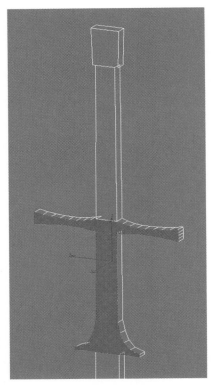

5–24

Polys selected
for extrusion

Switch to sub-object **Polygon**, and select the polygons of the upper blade and hilt guard, as shown in Figure 5–24. If you click to select a polygon and nothing appears to happen, it usually means that you selected or deselected a polygon on the opposite side of the model. It can help to check **Ignore Backfacing**, under the **Selection** rollout, as shown in Figure 5–25.

To the right of the **Extrude** button (and to the right of many tools in **Editable Poly**) there is a button that allows you to enter **Interactive Manipulation** mode. Interactive Manipulation mode allows you to enter various settings and see the results instantly. You can click **Cancel** to close the window and leave the model unaltered, **OK** to accept the current settings, or **Apply** to accept the current settings and see the model as it would be if you applied the same settings again. A small amount of extrusion is

sufficient to make the upper blade slightly thicker than the lower blade, so a low value for **Extrusion Height** is appropriate. Note that both sides of the model—all selected polygons—are extruded simultaneously. See Figure 5–25.

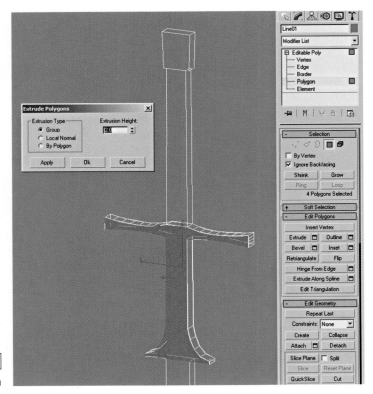

5–25

Interactive Manipulation mode—extrusion

Deselect the upper blade (both sides) and extrude the selected polys again, this time by a larger amount, to define the thickness of the hilt guard. See Figure 5–26.

Select both sides of the pommel and extrude those to an appropriate width, as in Figure 5–27.

5–26

Further extrusion

5–27

Further extrusion

You may have noticed that the extrusion process has added quite a few unnecessary polygons. Since these extra polygons are coplanar, that is they all lie in the same plane, they will not be difficult to remove. In Figure 5–28, the selected polygons are coplanar. The same amount of detail can be created using just a single quad.

Apply an *Optimize* modifier. The default settings are too high and remove detail from the model that you want. *Optimize* works on the angles between faces and edges. Set the *Face Threshold* to 0.1. This low value means that only faces that are coplanar, or nearly so, will be optimized.

Optimize should remove a great many unnecessary polygons from your model. It may seem that *Optimize* would be a very useful tool for low poly modeling, but this is not usually the case, unfortunately. When it is used to do more than remove polygons that are coplanar, or nearly coplanar, it often removes detail from areas where detail is needed. You may well want to experiment with this to see for yourself. See Figure 5–29.

5–29

Optimize modifier

To continue working with your optimized model, right-click on it and convert it to
Editable Poly again.

Now that the various parts of the sword no longer share vertices with their neighbors, as
on the extruded model, and unnecessary polygons have been removed, you can begin to
refine the shapes of individual parts.

Go to sub-object **Edge** and select the edges of the hilt and pommel as shown in
Figure 5–30. Use **Chamfer** to refine the shape of the hilt as shown in Figure 5–31. Use
Interactive Manipulation mode, and drag the spinner up and down to see the effects
of the chamfer operation. The result is a less boxy, more realistic hilt and pommel.

5–30 Selected edges

More on Optimize

For more information on using **Optimize**, choose **User Reference** under the
Help menu in 3D Studio MAX. In the Search panel type "optimize" and
press **Enter**. A list of topics will appear; double-click on the topic titled "Opti-
mize Modifier."

5–31 | Chamfered edges

A close look at the underside of the pommel reveals more unnecessary polygons (see Figure 5–32). These have been created partly as a result of the *Chamfer* operation. You can clean these up using *Optimize* as well. This time, go to sub-object *Polygon* and select just the problem polygons. Stay in sub-object *Polygon* and add the *Optimize* modifier. Only the selected polygons are optimized. See Figure 5–33.

5–32

Extra polygons

5–33

Selected polygons optimized

Convert to *Editable Poly* again to continue.

Next you will refine the shape of the
pommel further, to better match
the shape shown in the reference
image and to allow for better planar
mapping. Go to sub-object *Edge*
and select the edges shown in
Figure 5–34. You will use a non-
uniform scale to bring these edges
together. Be sure you are scaling
about the center of the selection—
set the button circled in red in
Figure 5–34 to *Use Selection Center*
(click and hold the button, and
choose it from the menu). Scale
them until they touch, as shown
in Figure 5–35.

5–34

Selected edges

MODELING WITH THE PROCEDURAL APPROACH

5–35

Scaled edges

There are still polygons between the selected edges. Go to sub-object *Vertex*, and use region selection to select the vertices at either end of the scaled edges, as shown in Figure 5–36. Using **Weld** in Interactive Manipulation mode, you can see the number of vertices before and after the operation, and adjust the **Weld Threshold** as necessary until you see a reduction in the number of vertices.

5–36 Weld vertices

Scale the other edges of the pommel, shown in Figure 5–37, to move them closer together. Be sure you are working with edges on both the front and back of the model.

Now you will refine the lower blade of the sword, to give it sharp edges. You will bring the vertices along the edges together and weld them, but first you will need to use **Slice** to add vertices to the center of the blade; otherwise the blade will become completely flat.

Slice works differently in **Editable Poly** than it does in **Edit Mesh**—the **Editable Poly** version doesn't slice hidden edges. So in order to keep the blade from becoming too flat at the tip, you will need to create edges in that area. See Figure 5–38. Be sure to create new edges on both sides of the blade.

5–37

Scale edges

5–38 New edges

Select all of the polygons of the lower blade. Click the **Slice Plane** button in the **Edit Geometry** rollout to display the slice plane. Rotate the slice plane 90 degrees in z. It is easier to be precise if you use the **Rotate Transform Type-In**. To do so, first choose **Select and Rotate**, then right-click on the **Select and Rotate** button. Type in 90 for z under **Offset: World**. In Editable Poly, the results are shown before you click the **Slice** button. Click the **Slice** button to perform the slice operation. See Figure 5–39.

Go to sub-object **Vertex**. Select the vertices along the edge of the blade, taking care not to select those along the center, as shown in Figure 5–40. The **Front** viewport is good for this.

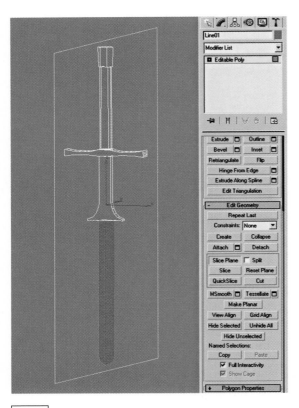

5–39 | Slice plane

5–40 | Selected vertices

Take a closer look at the vertices between the upper and lower blade. You have probably selected the vertices of both the upper and lower blade, as shown in Figure 5–41. Deselect the vertices of the upper blade, as shown in Figure 5–42.

5–41 | Vertices of upper and lower blade selected

5–42 | Vertices of lower blade only selected

Scale the vertices to 0 to move them together. Use **Scale Transform Type-In** (choose **Select and Non-Uniform Scale**, then right-click on the **Select and Non-Uniform Scale** button). The blade should look like Figure 5–43.

Weld the selected vertices. The left view shows that the tip of the blade needs some work. See Figure 5–44.

5–43 | Scaled vertices

5–44 | Tip of the blade

Select the points just above the point at the tip of the blade. Open the **Soft Selection** rollout and check **Use Soft Selection**. Soft selection allows a region of points to be affected by any transformation. There is a smooth falloff between selected points and unselected points in the area, controlled by the settings in the **Soft Selection** rollout.

Points that are red are 100% selected, blue are completely unselected, and the other points can be thought of as partially selected, as indicated by the range of colors. **Falloff** determines the distance between the selected point and the last soft selected point. How much or how little the points are affected by any transformation depends on the **Pinch** setting. Set **Falloff** to 90 and **Pinch** to 1.25. When these points are scaled, the points further from the vertex at the tip will be scaled less than those closer to the tip.

5-45 Tip of the blade

A scale of 30% produces good results. The tip of the sword should look like Figure 5–45.

Now perform a similar operation on the hilt guard. Select the vertices shown in Figure 5–46 and set *Pinch* to 0.0. A scale of 50% produces the results shown in Figure 5–47.

More on soft selection

For more information on using *Soft Selection*, choose *User Reference* under the *Help* menu in 3D Studio MAX. In the Search panel type "soft selection" (include the quotes) and press *Enter*. A list of topics will appear; double-click on the topic titled "Editable Poly (Vertex)."

5–46

Soft selection on the hilt guard

Figure 5–47 shows one more area that needs optimizing. Select the polygons at either end of the hilt guard and apply an *Optimize* modifier. Convert once more to *Editable Poly*. Figure 5–48 shows the improved area, highlighted in red.

You have finished your sword model. Save your work. You can open *sword-49.max*, which contains the sword model so far, for comparison.

At around 342 faces, your sword model is efficient enough for use in most any modern game engine (to see an accurate face count, temporarily add an *Edit Mesh* modifier). It has sufficient detail for most uses, including situations where it can be viewed very closely.

You learned how to use the *Unwrap UVW* modifier in Chapter 4. The next tutorial will provide a little more insight into its use and get you started on mapping your sword model.

5–47 Refined hilt guard

5–48

Optimized hilt guard

EXERCISE 5–2:::

Use *Editable Poly* and the box modeling techniques learned in this chapter to refine the shape of your extruded model (from Exercise 5–1), as necessary.

TUTORIAL 5–5: MAPPING THE SWORD:::

This tutorial will help you improve your ability to texture map using *UVW Map* and *Unwrap UVW* by showing you a few more strategies for mapping.

Apply a *UVW Map* modifier and orient it as shown in Figure 5–49.

Workflow

In this tutorial you will:

- Apply a more economical texture map.
- Apply planar mapping to your sword model.
- Adjust texture coordinates using *Unwrap UVW*.
- Apply new mapping to selected areas, adjusting texture coordinates as you proceed.

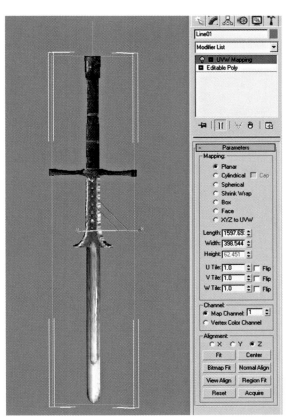

5–49

UVW Map modifier

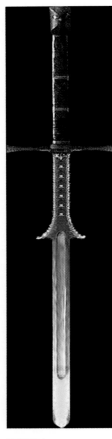

5–50 Sword image for reference

The image used as reference does not make very efficient use of texture memory. Figure 5–50 shows the reference image for comparison. Figure 5–51 is the image provided for use as a texture map, available on the CD-ROM as *sword-map.tif*. This image is more economically arranged—at 128x1024 pixels, it is half the size of the image you used as reference, and contains all of the extra parts you will need. The resolution is still powers of two in each dimension. The texture memory saved by using a texture of half the size could be used to create an alternative texture map for the same model, or for another sword model. Also notice that the various parts are of nearly proportional size in the texture; the parts of the hilt guard, for example, are roughly the same size as they were in the reference image, even though there is more space available in the texture. The texture mapping will usually look more natural this way; if one part has a proportionally higher resolution, it can be conspicuous.

Create a new material using sword-map.tif as texture map, and apply it to the sword model. Then apply an **Unwrap UVW** modifier.

You can turn off the grid in the **Edit UVWs** window by choosing **Options>Advanced Options . . .** , and under **Colors** unchecking **Show Grid**. In the same window, under **Display Preferences**, you can uncheck **Tile Bitmap**. This can help you understand the mapping better in some instances. You may also want to change **Render Width** and **Render Height**; by default, the texture map is made to display at 256x256. The actual size of the image is 128x1024, but settings of 256x1024 can help you see the map better as you work. This texture map is somewhat dark, so you may want to give the **Edit UVWs** window the full screen, or a large portion of the screen, and zoom in to the appropriate area as well.

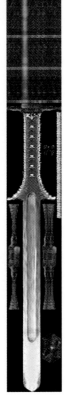

5–51

Sword texture map

In the *Edit UVWs* window, use *Scale Horizontal* and *Move Horizontal* to arrange the texture coordinates as shown in Figure 5–52.

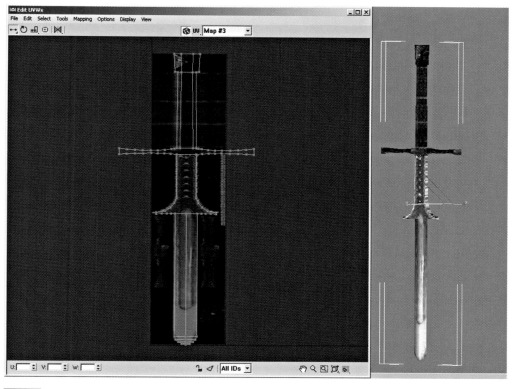

| 5–52 | Editing UVWs |

Figure 5–53 shows the various problems with the mapping that you will need to fix. There is streaking on the top of the pommel, on the edges of the upper blade, and, if you look closely, on the sides of the hilt (you can probably see this best by zooming in for a closer look at your model in MAX). As you can see in Figure 5–52, the UVWs of the hilt guard don't fit to the image of the hilt guard in the texture, so the mapping of the hilt guard needs work as well.

Begin with the top of the pommel. Add a **Mesh Select** modifier, and in sub-object **Polygon** select the polygon at the top of the pommel. Then add a **UVW Map** modifier and orient the gizmo as shown in Figure 5–54.

5–53 Mapping problems

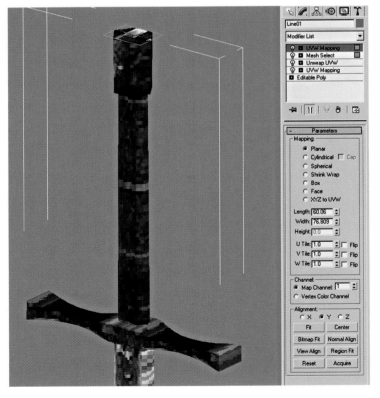

5–54

UVW mapping the pommel

Add an *Unwrap UVW* modifier and arrange the points as shown in Figure 5–55. You will need to rotate the points, and use a combination of moves and scales.

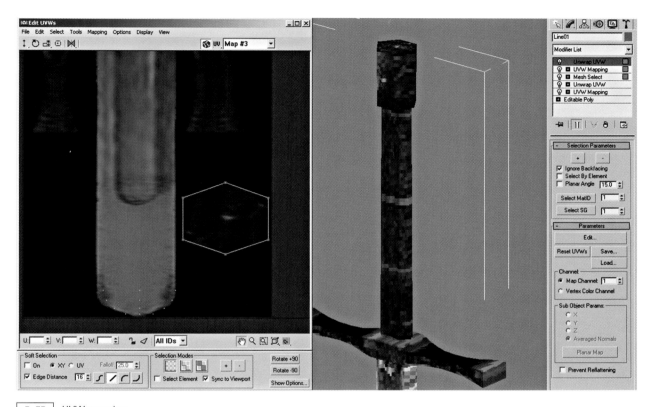

5–55 UVW mapping

Next you will address the mapping of the hilt. Add a *Mesh Select* modifier, but this time do not enter sub-object mode. This effectively selects the entire model. Add a *UVW Map* modifier and choose cylindrical mapping. Use *Alignment* and *Fit* to align the cylindrical mapping gizmo as shown in Figure 5–56.

The actions you were instructed to perform in the last paragraph bear explaining. First, cylindrical mapping is a type of UVW mapping in which the texture map is wrapped around a model. The gizmo shows the orientation of the map; by default, with the gizmo oriented as in Figure 5–56, the texture image is fit with the top of the image at the top of the model, the bottom of the image at the bottom of the model, and wrapped around the model so that the two sides touch. You probably noticed that the mapping of the entire model was affected when you added the last *UVW Map* modifier. In this case, it is

helpful to be able to adjust the gizmo to fit the entire model, rather than just the faces in the hilt. Working with the entire model selected made this simple. You only want to apply the results of the cylindrical mapping to the faces of the hilt, however. This too will be very easy. Select the *Mesh Select* modifier you added most recently, go to sub-object *Polygon*, and select the polys of the hilt. Then move back to the top of the stack. Now only the selected polygons are passed through to the *UVW Map* modifier, and only those polygons are remapped. The advantage of this arrangement is that you can, in sub-object *Gizmo*, rotate the gizmo to place the highlight in the texture map on the appropriate part of the model. See Figure 5–57.

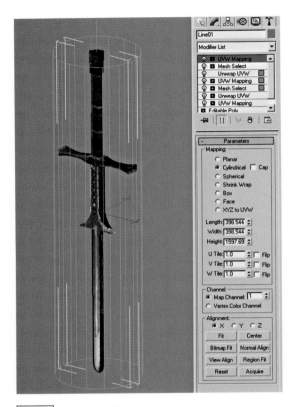

5–56 UVW mapping

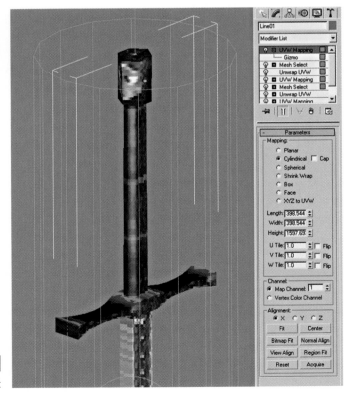

5–57

Cylindrical mapping of the hilt

Add another *Mesh Select* modifier and select the polygons on both sides of the upper blade as shown in Figure 5–58.

Add a *UVW Map* modifier and orient the gizmo as shown in Figure 5–59.

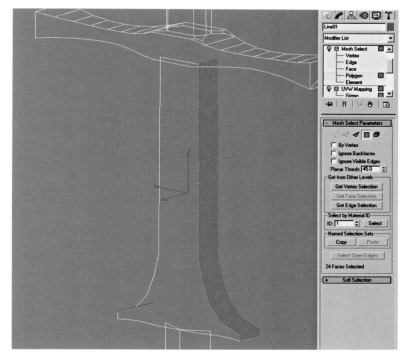

5–58

Polys selected for mapping

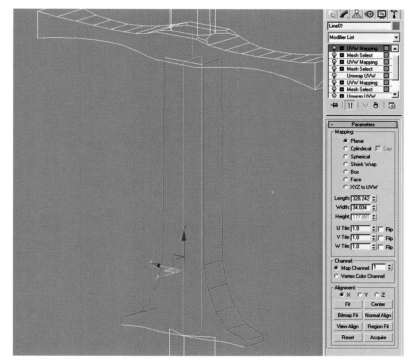

5–59

Polys selected for mapping

More on UVW mapping

For more information on using all types of UVW mapping, choose **User Reference** under the **Help** menu in 3D Studio MAX. In the Search panel type "UVW map" and press **Enter**. A list of topics will appear; double-click on the topic titled "UVW Map Modifier."

Add an *Unwrap UVW* modifier and align the points over the texture as shown in Figure 5–60.

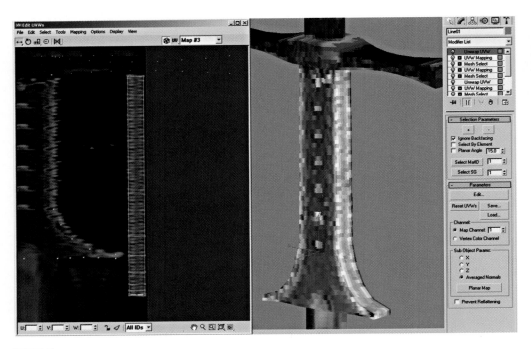

5–60 | Polys selected for mapping

Save your work. You can open *sword-60.max* on the CD-ROM for comparison.

EXERCISE 5-3:::

Use the methods you have learned to finish the texture mapping of the sword model. Map the bottom of the upper blade and the hilt guard.

EXERCISE 5-4:::

Use the methods you have learned to apply texture mapping to your own extruded and box modeled object. If appropriate, use your reference image as a texture map, modifying it in Photoshop. Otherwise, paint a texture map in Photoshop.

:::CHAPTER REVIEW QUESTIONS:::

1. What is the purpose of splines?

2. What are the advantages of a procedural approach to modeling?

3. Why is the modifier stack useful?

4. Name the modeling methods used in this chapter, and state which are procedural.

5. What are the two parts of texture mapping a model?

You have gained a great deal of modeling experience and insight in this chapter. You've learned about the flexibility provided by good use of the stack, and the procedural approach.

You have learned to use splines to build 3D models, and to easily control the poly count of those models. You can also make a model using extrusion in 3D Studio MAX. You learned to control the poly count using the stack. You've also learned more about box modeling and the use of the *Unwrap UVW* modifier for good control over the mapping of your models.

Next you will learn another approach to modeling, which will give you procedural control over the polygon count, using the stack, and a useful way to deal with texture mapping.

LOFTING

OBJECTIVES

+ Make models using lofting

+ Take advantage of the most powerful features of lofting

+ Take advantage of the flexibility of lofted models

+ Learn about a type of mapping unique to lofting

Introduction

Because there are so many ways to change and refine a lofted model, it takes some time to learn, so it's important to spend enough time with lofting to realize what it offers. Like extrusion, lofting is procedural and offers very good control over the polycount, with many ways to control the distribution of polygons as appropriate to the surface of the model. Models of different LOD are easily created. Lofting also offers a very useful type of UVW mapping not otherwise available.

Like extrusion and other polygon modeling techniques, you will frequently need to apply an **Edit Mesh**, convert to **Editable Polys**, or otherwise make changes to the model beyond the lofting process. Many changes that you can make using **Edit Mesh** will result in problems if the vertex count is later changed in the **Loft** modifier. This means that once an **Edit Mesh** is used (or alternatively, the model is converted to **Editable Polys**), the ability to make changes at an earlier stage in the stack is compromised or lost. Thus it becomes important to take the model as far as possible with lofting, and save the model before proceeding to add the **Edit Mesh**. UVW mapping can be compromised using **Edit Mesh** or **Editable Polys** on any model, so as you work it is important to watch the entire model closely for undesired side effects as you make changes. Of course you can always remove the **Edit Mesh** modifier and return the model to its previous state.

TUTORIAL 6–1: LOFTING PART I:::

In this tutorial, you will build the model shown in Figure 6–1 using lofting.

Workflow

To build your first lofted model, you will:

- Choose a straight line as your path and a shape to loft along the path.
- Use a fit curve to refine the shape of your lofted model.
- Adjust the polycount easily for various versions of your model of various Levels Of Detail.

You will work from a MAX file on the CD-ROM. The texture map is also provided. To ensure that the texture will fit the model, you will work from splines in the

6–1 Lofted model created in this tutorial—a pagoda

MAX file. You already know how to make splines, so you can proceed directly to making the model. You will also learn how to make a texture for any lofted model.

Load *Loft-01.max* from the CD-ROM.

A lofted model is created using at least two splines: a path and a shape. You will use the straight spline as your path, and the octagon as your shape. The third spline in the viewport does the most to determine the shape of the model in this case. This spline is called a fit shape. These will all be explained.

Select the straight spline as shown in Figure 6–2. In the **Create** panel, with **Geometry** selected, use the drop-down menu to change **Standard Primitives** to **Compound Objects**. Click the **Loft** button.

Because you created the loft with the straight spline selected, it automatically became the path for the loft model. Click the **Get Shape** button in the **Creation Method** rollout and choose the octagon.

At this point you begin to see the nature of a lofted model. A shape is "lofted" along a path. Later in this chapter you will use a curved path and use multiple shapes rather than just one.

6–2 Spline shapes for creating this lofted model

6–3 Lofted octagon

The loft **Deformations** rollout is only available under the **Modify** panel. Open the **Deformations** rollout and click **Fit**. The **Fit Deformation** window opens. See Figure 6–4.

For more information on using **Loft**, choose **User Reference** under the **Help** menu in 3D Studio MAX. In the **Search** panel, type "loft" and press **Enter**. A list of topics will appear; double-click on the topic titled "Loft."

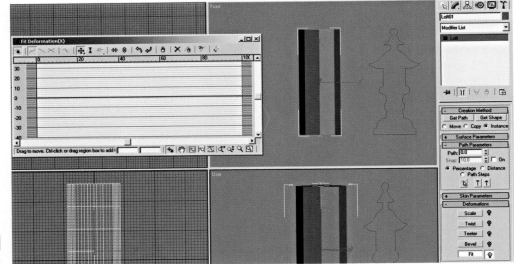

6–4

The Fit Deformation window

Click the **Get Shape** button and choose the spline shaped like a pagoda. The model will change, but not for the better. Click the **Rotate 90 CW** button (circled in red in Figure 6–5) to put the shape into a more appropriate alignment. Click the **Zoom Extents** button (circled in blue in Figure 6–5) in order to see the shape in the **Fit Deformation** window.

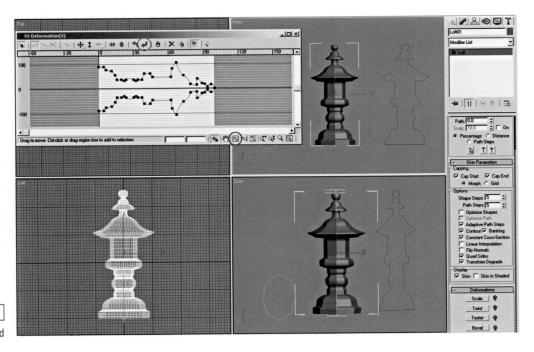

6–5

Fit deformation applied

chapter6 LOFTING

Open the *Skin Parameters* rollout and set both *Shape Steps* and *Path Steps* to 0. These settings mean that there will be no extra points around the circumference of the model beyond the number of points in the shape, and there will be no extra cross-sections along the length of the model beyond those created (in this case) by the fit shape. This is the lowest polygon version of the lofted model given the splines used. Observe the profile of the model and notice that it is not exactly the same shape as the fit shape. Increasing the *Path Steps* setting adds the detail necessary to bring the model closer to the fit shape. For example, set *Path Steps* to 0, 1, and 2, and check the polycount.

Because the model will most likely be used sitting on another surface, it does not need a bottom. You can save a few more polygons by turning off *Cap Start* and *Cap End*.

Save your file. Before you continue working on the model, some important details of the *Fit Deformer* should be explained.

The fit shape is used like a set of curves that determines how the cross-sections along the length of the loft model are scaled to conform to the shape of the fit shape. You needed to rotate the fit shape in the *Fit Deformation* window because the horizontal axis in that window represents the path—and the fit shape was created with a vertical orientation in the viewports.

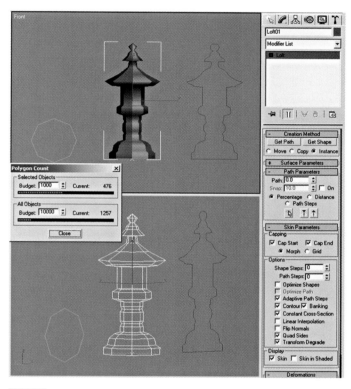

6–6 Adjusting the polycount

When you use a fit shape, you will always add as many cross-sections to your model as there are points along the horizontal axis in the *Fit Deformer* window. Clearly these extra cross-sections mean more polygons, so it is important to be sure that your fit shape is made using the fewest possible points. The fit curve uses beziers to add detail to the shape without adding unnecessary points. At a *Path Steps* setting of 0, the model appears as if there were only straight lines between the points in the fit shape. Higher *Path Steps* settings allow the profile of the model to begin to approximate the curvature of the spline.

If points on either side of the fit shape lie in the same exact vertical axis, then only one cross-section is added to the model for those two points. When making a symmetrical model such as the one you're building now, it is important to be sure that one side of the fit shape is an exact mirror of the other.

As suggested when building the sword, the best approach to creating a spline for a symmetrical fit shape is to create just half of the outline at first (see Figure 6–7). You may want to take the time to try building your own copy of the fit shape. You can load *pagoda.tif*, available on the CD-ROM, into the front viewport background as reference.

Mirror the first half of your spline as a copy. Use the *Align* tool to place the second half into its proper location: select the second half, click *Align*, and then click the first half. Choose *X Position*; select *Minimum* under *Current Object*, and *Maximum* under *Target Object*. Click the *Attach* button and click on the other spline to attach the two halves. At the top there will be two points that should share the same location. Select them, and click *Weld* in sub-object *Vertex* to weld the points together. Go to sub-object *Spline* and click *Close* to close the open section at the bottom.

Create a material using the texture map named *123456.jpg* (available on the CD-ROM) and apply it to the model. Activate the *Show Map in Viewport* button. This will make it easy to see how the default mapping for a lofted model works: the image fits top to bottom along the entire length of the path and wraps around the model so that the left and right edges of the image meet. The *Surface Parameters* rollout provides control over the UVW mapping. For now, just observe that *Apply Mapping* has been checked. See Figure 6–8.

6–7 | Half of a symmetrical spline shape

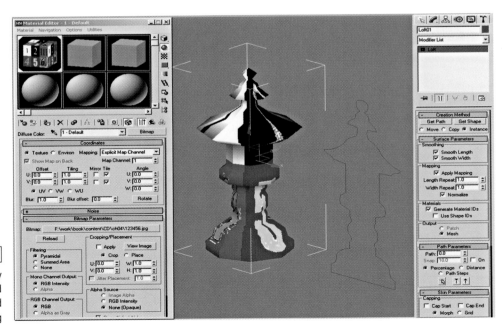

6–8

Arbitrary
texture map applied
to help understand
loft mapping

Replace 123456.jpg with the texture map *loft-map1.jpg* (on the CD-ROM). Study the model and the texture map shown in Figure 6–9.

Again, the texture is fit from the top to the bottom of the model and wrapped once around. This is now a very symmetrical model, and each of the eight sides is exactly the same. The eight identical sides are all represented in the texture.

This is fairly wasteful of texture space. If a texture has eight of the exact same image, it is usually possible to make a texture that includes that image just once, and to tile it around the model eight times. You will do that in a moment, but first let's see how a texture for a lofted model might be made.

Save your work, and close 3D Studio MAX.

| 6–9 | Texture map for the pagoda |

EXERCISE 6–1:::

Choose a model you would like to build that is suitable for lofting. Build it allowing for the lowest possible polycount, while also allowing it to be adjusted to the greatest possible level of detail.

TUTORIAL 6–2: TEXPORTER AND LOFT MAPPING:::

The **Texporter** plugin, written by Cuneyt Ozdas has become a standard tool used widely by anyone who uses 3D Studio MAX. **Texporter** creates an image that is a perfect template of the UVW mapping of a model, ideal as reference on which to paint the texture for your model.

Texporter is available on the CD-ROM. If you haven't installed it yet, you will need to do so now.

> ### Workflow
>
> In this tutorial you will:
>
> • Use **Texporter** to create a template of the UVWs of the lofted pagoda.
>
> • Apply a texture map using the default mapping of a lofted model.

If you are using 3D Studio MAX version 5 or below, open the file *Texporter3_4.zip* and follow the directions in *readme.txt*. To install most plugins, you merely need to place the file or files into the plugins directory beneath your 3dsmax5 directory. In this case, *texporter3.dlu* goes into the plugins directory, and *texporter.chm* goes into the help directory.

If you are using 3D Studio MAX version 6, you need to run *texporter_install_v3.4.6.6.exe*, also available on the CD-ROM. Instructions are provided in the installer. You will be asked to indicate the location of your 3dsmax6 directory, after which the plugin will be installed.

Restart MAX and load your loft model in progress.

To use **Texporter**, go to the **Utilities** panel and click **More**. Choose **Texporter** from the list and click **OK**. Set **Width** and **Height** to 1024. It's a good idea to work at a resolution higher than what you intend to use for the actual texture, so if the model is to be mapped with a texture 512×512 in size, it is recommended to paint the texture at 1024×1024. The other **Texporter** default settings are usually good. Click **Pick Object** and then click on the lofted model. A window will open displaying the resulting image, as shown in Figure 6–10. Click the **Save Bitmap** button and save the image.

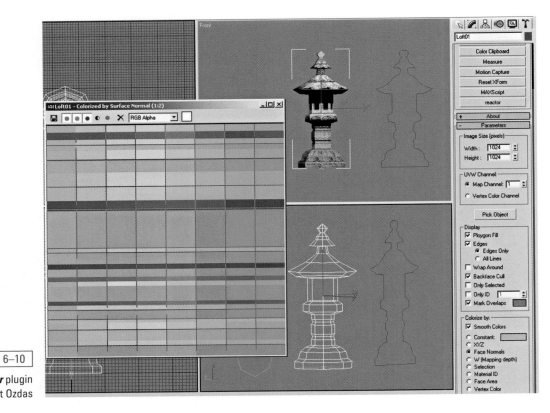

6–10

The **Textporter** plugin
written by Cuneyt Ozdas

Make a new material using the **Texporter** image you just saved as the texture map and apply it to the lofted model. Study the model in order to understand the function of the **Texporter** plugin.

By default, **Texporter** colorizes the polygons according to the face normals. This can help find the part of the texture that is mapped to a certain particular face on the model. Polys that face downward in this map are dark blues and purples.

Figure 6–11 shows the **Texporter** template overlaying the texture map to help explain the relationship.

6–11 Texporter template overlaying the texture map

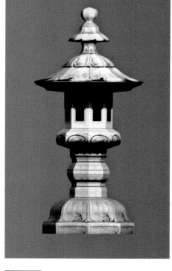

6–12 Mapped pagoda

::::: Reflections on Texture Mapping

This is a good time to reflect on what you've learned about texture mapping so far. To build the extruded sword model, you started with a reference image that is also, essentially, the texture map. It could be said that you built the model to fit the map. The default mapping of an extruded model suits this approach. You could also work from a reference image to create the fit shape for your lofted model (an image such as Figure 6–12, for example). However, such a reference image would not make a very good texture map. Lofting offers useful UVW mapping, but in this case you will have to paint the texture to fit the model (in this tutorial you did not actually create the texture because it was provided for you on the CD-ROM). Another difference is that the UVWs are already applied; after creating a template with Texporter and painting a texture to fit that template, you need only apply the material—no further UVW mapping is necessary.

　　This book teaches two approaches to UVW mapping: making the model for the texture, and making the texture for the model. Being aware of these two methods in the future will help you make informed decisions about how to approach a particular model.

As mentioned, our current texture map is wasteful of texture space. Figure 6–13 shows a better texture map for this model. This image is exactly one-eighth of the current texture. It is available on the CD-ROM as *loft-map2.jpg*. Create a new material using it as a texture and apply it to the lofted model.

By default the texture is wrapped one time around the model, but there is a way to change this. In the **Surface Parameters** rollout (in the **Modifier** panel), set the **Width Repeat** value to 8. Now the texture map is tiled eight times around the circumference of the model. See Figure 6–14.

This completes your lofted pagoda model. Save it. There should be little or no cleanup necessary, but it is good practice to double-check your work.

You may have wondered why you shouldn't use lathe to create a model such as the pagoda. You could in fact make exactly the same model by using lathe, and quite possibly find the process easier and faster and with the same control over the polycount. The goal, however, was to learn lofting. In the next tutorial, you will make a variation on this model that could not be built using lathe. You will accomplish this without much extra work. This flexibility is one advantage of lofting in 3D Studio MAX.

There is much more to learn about lofted models. In the next tutorial, you will use a curved path. You will also get further insight into other functionality of the loft in 3D Studio MAX.

6–13

More efficient texture map

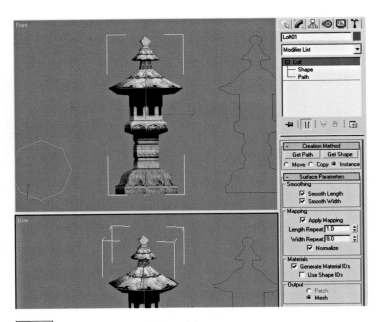

6–14 | Tiling textures on lofted models

Use *Texporter* in the texture mapping of your own lofted model or another model of your own creation.

TUTORIAL 6-3: LOFTING PART II:::

You will now make a variation on your lofted model using the flexibility of lofting.

With the latest version of your lofted model loaded, go to the *Display* panel and click *Unhide All* (under the *Hide* rollout). Select the *Front* viewport and click *Zoom Extents* to reveal all of the splines. See Figure 6–15.

You will be making changes to your lofted model, so to avoid losing the model as it currently exists, save the file now under a new name.

Workflow

In this tutorial, you will:

- Replace the path of your lofted model with a curved spline.
- Use a new fit curve to create a new shape.
- Add detail as necessary while preserving your ability to vary the amount of detail.
- Add a new texture map.

You can replace the path of your loft model, and the shape or shapes as well, at any time. Click *Get Shape* and choose the hexagonal spline (the six-sided purple shape between the path and the pagoda, above the octagon, shown in Figure 6–15). It is applied to the model in place of the octagonal shape. You will want to correct the mapping by setting *Width Repeat* to 6. This gives you a model with 348 polygons (with a *Path Steps* setting of 0). If the polycount was high before, for some particular game engine or application, this version could be used instead and you would still have a very good looking model.

It is common for lofted models to use different shapes at different points along the path. This is not appropriate for this model, but it is useful to know. There is a *Path Parameters* rollout that allows you to set a value for a variable called *Path*. By default, *Path* is set to 0. Also by default, 0 means 0% of the distance of the path, or one end of the path. When you added the octagon to the loft model, it was placed at the bottom of the straight-line path. When you chose the hexagonal shape, it too was placed at the bottom, replacing the octagon.

6–15 | More splines for lofted model

To better see the changes you make, select the **Front** view and work in wireframe, and move in close to the model. Change the value of **Path** to 50 (50% along the length of the path). Click **Get Shape** and choose the octagon. A cross-section is added to the model, and this new cross-section has eight sides. The model is hexagonal at the bottom and transitions to octagonal halfway along the length of the path. An octagon is shown in green at this point on the path for reference, but it is not visible when rendered. Change the value of **Path** to 80 and choose the hexagon. Now the model transitions back to a hexagonal cross-section by 80% of the length of the path and keeps this shape along the rest of the path. See Figure 6–16. Again, there is no particular reason to use more than one shape with this model, and in fact you have added unnecessary polys to your model. But you now know how to add multiple shapes to a lofted model. To remove the extra shapes from the model, go to sub-object **Shape**, select each shape in turn (except the bottom shape), and press the **Delete** button (or the Delete key on your keyboard).

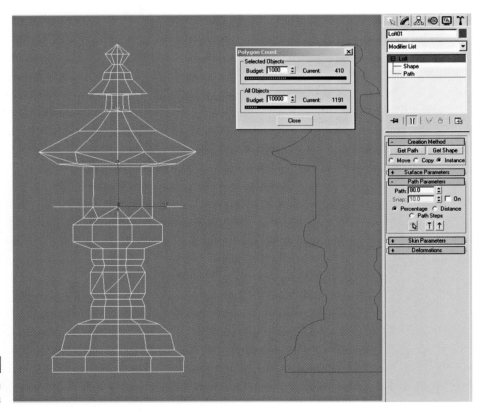

6–16

Lofting with
multiple shapes

Now you will create a new model, a variation on the previous lofted model. Select the curved spline to use as a path, the one named *lamp path*, and click the **Loft** button (on the **Create** panel, under **Compound Objects**). Click **Get Shape** and choose the hexagon. See Figure 6–17.

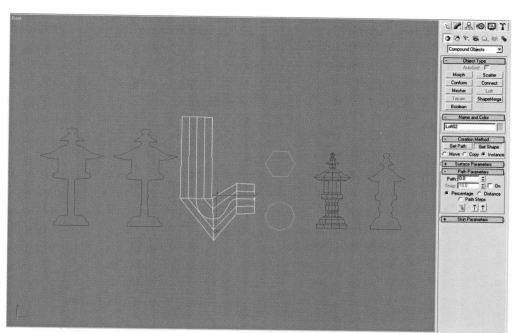

6–17

Hexagon lofted
along curved path

Apply a fit shape to the model. Use the one on the far left, *lamp spline—lopoly*. You will
have to rotate the fit shape. See Figure 6–18.

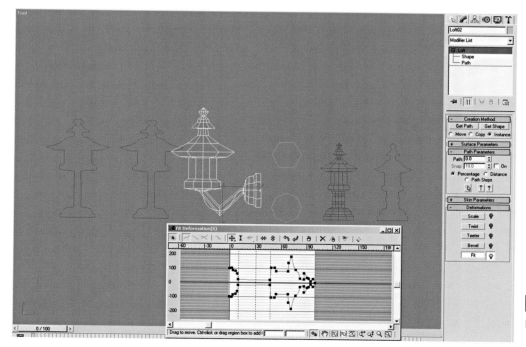

6–18

Fit shape applied

The stem of the lamp is too angular with a **Path Steps** setting of 0. This is because the path itself doesn't have enough points in this area, and the fit shape has no points in this area. You could add points to the curve, but there is an easier way to add extra detail. At 0 **Path Steps**, what you have is probably most suitable as the lowest LOD of the model—but it still needs more definition in the stem area.

The other deformers, like **Fit**, add a cross-section to the model for each point added to their curves. You can use **Teeter** to add detail to the model, and if the teeter curve remains a straight line, as shown in Figure 6–19, then no other changes to the model occur. You can choose the **Move Control Point** option that constrains movement to the horizontal (this button is circled in red in Figure 6–19; click and hold to see a menu of the various options) and easily move the points back and forth in order to adjust the location of the added cross-sections. Figure 6–19 shows three extra points added to the line, resulting in a model with 344 polys.

Figure 6–20 shows the texture map for the lamp model, available as *loft-map3.jpg* on the CD-ROM. Create a new material using it as a texture, and apply it to the model. Under **Surface Parameters** you'll need to set **Width Repeat** to 6. While you're at it, uncheck **Cap Start** and **Cap End** under **Skin Parameters**.

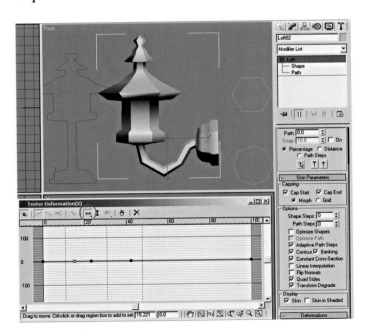

| 6–19 | Cross-sections added via deformer window

| 6–20 |

Texture map for the
new lofted model

With a **Path Steps** setting of 2, polycount of ~996, your loft model should look like Figure 6–21.

There may be no lamps like this in the real world, but it would look quite good in some game worlds. The model shown in Figure 6–21 would most likely be used as the highest LOD, with the lowest LOD being 336 polys, resulting from a **Path Steps** setting of 0. Working carefully with an **Edit Mesh** modifier, you could reduce the polycount somewhat further. You may also want to reduce the size of the texture to 64x512. If this lamp were meant to be lit, you would need to remove some of the shad-

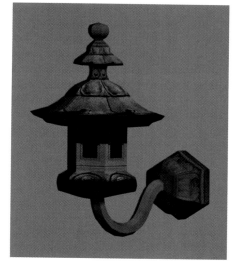

6–21

New lofted model

ows from the texture map. With this model, the area with the most curvature consists of very small polygons compared to the rest of the model, so any detail in the texture in this region becomes a bit blurred. But models with this sort of curved shape are very often difficult to map without the benefit of loft mapping.

EXERCISE 6–3:::

Try building the necessary curves to create the model built in Tutorial 6–3. Use **Instance** under **Get Shape** so that your lofted model is updated as you change your fit curve.

TUTORIAL 6-4: LOFTING THE SWORD:::

Next you will see how lofting can be used to create a lofted version of your sword model, which gives you more control over the amount of detail, and more potential detail than the model you built in Chapter 5.

Lofting is a very flexible, procedural approach to building the sword. The box modeled sword, and box modeling in general, offers little to help generate models of different polygon counts. A procedural approach can make varying the polycount easy. This tutorial will demonstrate how lofting can be a powerful way to build this model, and is a good example of the use of multiple shapes in a lofted model.

Workflow

To build your first lofted model, you will:

- Choose a straight line as your path, and choose a shape to loft along it.

- Use a fit curve to refine the shape of your lofted model.

- Control the fit curve to keep the polycount low.

- Apply various shapes at different points along the path for excellent control over the shape.

- Place the shapes with great precision to keep the polycount low.

- Adjust the polycount easily for various versions of your model of various Levels Of Detail.

Open MAX and load *sword-loft-01.max* from the CD-ROM. Before you begin, try a short experiment that will reiterate and reinforce a point made previously about lofting, fit curves, and polycount.

Select the vertical line, and make a loft model using **Get Shape** to choose the circle. Turn the **Shape Steps** and **Path Steps** to 0. Open the **Fit Deformation** window and pick the light blue hexagon spline as your fit shape. Rotate it 90 degrees clockwise. Use the **Zoom Extents** button (in the **Fit Deformation** window) to see the entire hexagon. You should now have an object like the one shown in Figure 6–22. Press *7* on your keyboard to display the face count.

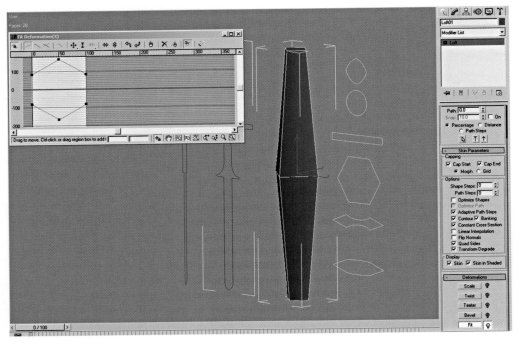

6–22 | Hexagonal fit shape

Your lofted model should have 28 faces, which is more than it needs. Figure 6–23 shows that there is an extra cross-section in the middle.

Figure 6–23 shows the bottom point on the fit shape selected. With a single point selected, the location of that point is displayed at the bottom of the **Fit Deformation** window. The number shown circled in red in Figure 6–23 is the location along the path—in this case 50%.

You may recall that any points in the fit shape add cross-sections to the lofted model. However, points in a fit shape can lie on either side of the horizontal axis in the **Fit Deformation** window and influence opposite sides of the model. If two points on opposite sides of the horizontal axis have exactly the same location on the path, then only one cross-section is added to the model for the two of them. This reduces the number of polygons in the model.

For demonstration purposes, the hexagon used as a fit shape was intentionally made to be not entirely symmetrical. You can fix it in the **Fit Deformation** window. Select the upper point, shown in Figure 6–24. Its location on the path is shown as 50.1. Change this value to 50 (the same value as the point opposite), and you should see the face count reduced to 20.

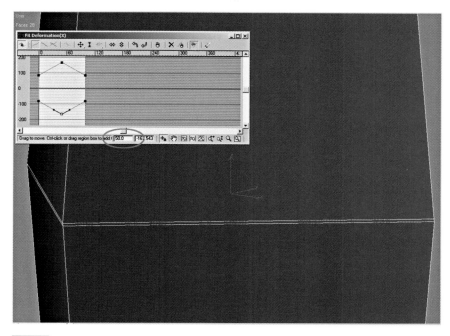

6–23 | Extra cross-section

6–24 | Point at 50.1 on the path

You have been encouraged to make spline shapes that are symmetrical by making one side and mirroring it. When making a fit shape, this ensures that there won't be extra cross-sections. This is especially important in this tutorial, because you will be using two fit shapes. You will also be placing multiple shapes onto the path, which also adds extra cross-sections. To minimize this, you will learn to place shapes on the path at the exact location of the points on the fit shape.

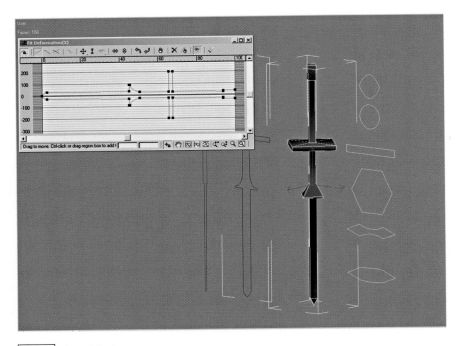

6–25 | Sword fit shape

There are two splines to the left of the lofted model that look like the outline of a sword. The purple shape is the outline as viewed along the narrow axis of the sword; the blue spline is the outline as viewed along the wider axis. It is similar to the spline you extruded previously. Use **Get Shape** in the **Fit Deformer** window to replace the hexagon with the blue sword shape nearest the loft model. Rotate it 90 degrees clockwise. See Figure 6–25.

To load a second fit shape, you must turn off the **Make Symmetrical** button, shown circled in red in Figure 6–26. Click the **Display Y Axis** button shown circled in blue in the figure. Then use **Get Shape** to pick the other sword shape and rotate it 90 degrees clockwise.

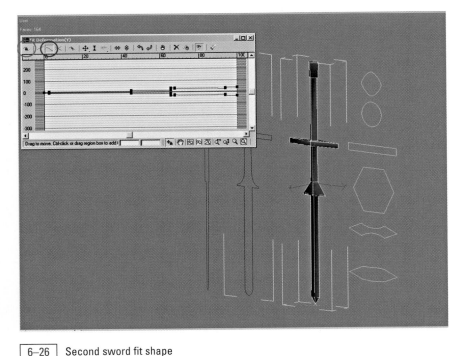

6–26 | Second sword fit shape

To understand the effects of the two fit shapes, toggle between the **Display Y Axis** and **Display X Axis** buttons and study the sword model from the various viewports. Much of the shape of the sword is now present, but there is still more work to do. Expand the **Fit Deformer** window and zoom in on the pommel end of the fit shape. The zoom tools in the **Fit Deformer** window are not especially friendly, so take some time to get a feel for using them.

Set the **Path** value, under the **Path Parameters** rollout, to 100 (indicating 100% along the length of the spline, the pommel end of the sword). The shape for the pommel is the topmost shape to the right of the sword model, a rounded diamond shape. Use **Get Shape** (in the **Modify** panel, not the **Fit Deformation** window) to place it onto the path at 100%.

You want the pommel to be shaped like the rounded diamond, and the hilt to be round. You will place those shapes at the exact location of the points shown in the **Fit Deformer** window in Figure 6–27. At the location of the point selected, you will place another rounded diamond shape to insure that the pommel keeps that shape along its entire length. At the location of the point to the left of it, you will place a circle, so that the transition from diamond to circle takes place between those two points. The points defining the bottom of the pommel and the points defining the top of the hilt cannot have the same location, since there can be only one shape at any one location on the path.

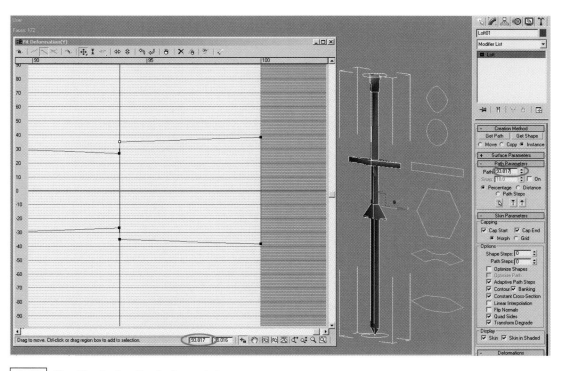

6–27　Checking the location for the next shape

Figure 6–27 shows that the location of the selected point is 93.817. To easily copy that value to the **Path** box, double-click on the number in the **Fit Deformations** window to highlight it in blue, type Ctrl-C to copy it, double-click in the **Path** box, and type Ctrl-V to paste the value. For easy reference, both are circled in red in the figure. A vertical line will appear in the **Fit Deformer** window, indicating that the path is set to that position. Use **Get Shape** in the **Modify** panel to place a rounded diamond shape at this location.

Sometimes, when pasting a value to the path, the selected point in the **Fit Deformer** will move. This would appear to be a bug in MAX. You can usually avoid it by deselecting all points in the **Fit Deformer** window before pasting. If a point does move, you can use **Undo** to reset it (you will find that pasting in the old value doesn't work).

You should check the point opposite the one shown selected (on the fit shape), and be sure that its location is exactly the same. If it is not, you can use cut and paste to reset the location of the point to 93.817. You should also check the values of the corresponding points in the other axis, as shown in Figure 6–28 (Figure 6–27 shows the Y axis, Figure 6–28 shows the X axis).

In the **Skin Parameters** rollout, under **Options**, turn **Shape Steps** up to at least 1 so that you can see the shapes better as you add them. Select the next point to the left (on the fit shape), and note that its location is 93.784. Check the opposite point and the corresponding points in the other axis to be sure that they are all at that location. Then set the path to that location and add the circle to the path at that location. Note the solid vertical line, which indicates the current position on the path, and the dotted vertical line, which indicates the presence of a shape at that location.

Zoom in on the other end of the hilt. Here you will find a problem: in the Y axis, the

6–28 | Checking the location of points

6–29 | Checking the location of points

points at the base of the hilt are located at 67.747 (see Figure 6–30). But in the X axis, the corresponding points are at 67.724 (Figure 6–31). Cut and paste to move the points in the X axis to 67.747.

6–30 | Y axis

6–31 | X axis

Change the current path location to 67.747, and add the circle again to ensure that the hilt remains circular throughout its length.

It is possible to see both axes in the **Fit Deformations** window at the same time. Click the **Display XY Axes** button to do so. Compare the locations of the points that define the top of the hilt guard, shown selected in Figure 6–32. Set them all to 67.597 and set the path to that location as well. Place the rectangle shape at that location on the path. See Figure 6–33.

Check all the points that define the bottom of the hilt guard, and make sure they all have the same location. Do the same for the points at the top of the upper blade.

The rectangle is an appropriate shape for the upper blade as well as the hilt guard. Zoom in on that area in the **Fit Deformations** window. Be sure that the points that define the bottom of the

6–32 | Related points

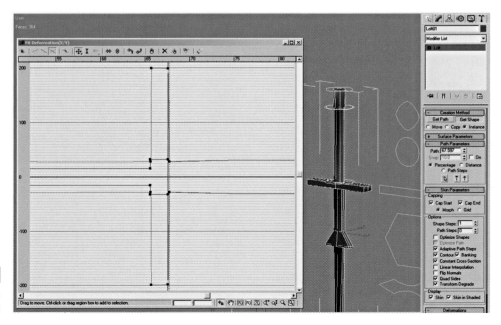

6–33

New shape defines hilt guard

upper blade, shown selected in Figure 6–34, have the same location. At that location on the path, add the rectangle.

The points shown selected in Figure 6–35 define the top of the lower blade. Make sure they are all at the same location, and add the shape below the blue hexagon to the path at that location. This shape creates the groove in the blade that is visible in the texture.

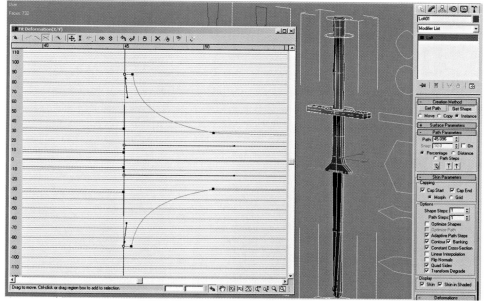

6–34

Defining the bottom of the upper blade

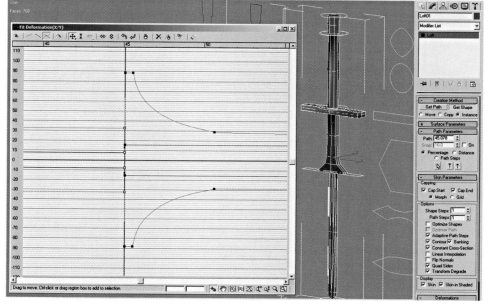

6–35

Defining the groove in the blade

There are no points on the fit shapes to define where the groove in the blade ends. You can choose the location for the end of the groove visually. Add a *UVW Map* modifier and make a material using *sword-01.tif*, available on the CD-ROM. Apply this material to the model.

Move the path location down to about 13. Switch to the *Front* viewport and zoom in on the bottom of the lower blade. If you click on the little arrows next to the *Path* value, the view will switch temporarily from smooth shaded to a wireframe display of the path and shapes on the loft model. When this happens, the little yellow x that shows the current location on the path is visible. Adjust it so that it lies at the point where the groove on the blade begins to narrow (12.929 is a good location). Add the shape below the blue hexagon to the path at that location. Then move the yellow x to the location where the groove ends, about 11.216, and add to the path the bottommost of the yellow shapes, two shapes below the blue hexagon. This shape defines the part of the blade without a groove. Finally, move to 0 on the path and add the same shape at that location.

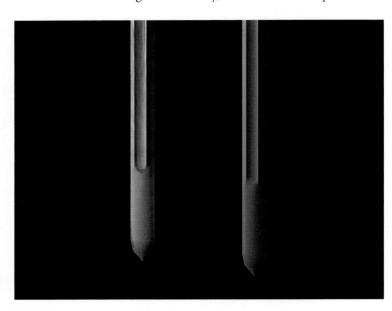

6–36 | The blade with and without a texture

Figure 6–36 shows the shape of the groove in the resulting blade. It is not perfect, but with the texture applied it looks very good.

The hilt guard, in the fit shape, is not the same shape as the hilt guard in the reference image (or in the extruded model made in Chapter 5). This is due to a limitation of the *Fit* deformer. A curve in the *Fit Deformations* window indicates scaling of the cross-sections along the length of the path. In each axis, the curve above the center horizontal line (positive numbers) represents scaling on one side of the model, and the curve below the horizontal line (negative numbers) represents scaling of the other side. A cross-section on one side can only be scaled by one value. Figure 6–37 shows a fit shape that includes the hilt guard as built for the extruded model. The blue vertical line shows that at that location, approximately 32.75% along the length of the path, there are three values (the blue line crosses the fit shape three times). This will not produce a shape like the desired hilt guard in the lofted model. Thus, the hilt guard has been simplified in the fit shape used in this tutorial.

| 6–37 | Invalid fit shape |

If you look closely at the way the hilt guard has been built, even the simplified fit shape, you will see that it has not produced a mesh that can be easily modified to refine the shape of the hilt guard. See Figure 6–38.

| 6–38 | Problem mesh |

Lofting often does not work well with cross-sections that vary greatly in size, especially large variations between axes. Thus, it will be best to build the sword model in two parts.

Remove the hilt guard from the model by removing it from the two fit shapes. You can do this in the *Fit Deformer* window. Delete the vertices shown selected in Figures 6–39 and 6–40.

6–39 Fit shape, X axis

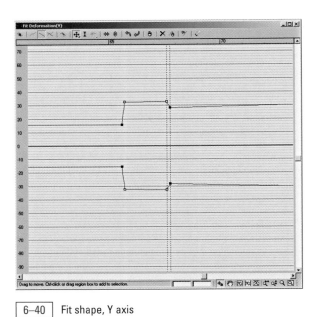

6–40 Fit shape, Y axis

Your model should look like that shown in Figure 6–41.

6–41

Results of the
altered fit shapes

There is still a rectangular shape on the path just below the hilt. This shape no longer needs to be so close to the bottom of the hilt—the rectangle should now start at the top of the upper blade. Go to sub-object *Shape* and select the rectangular shape on the loft model. This can be a bit tricky since the shape is not visible in the viewport. Remember that your cursor will change when placed over something that can be selected. Move your cursor over the area where the circle changes to the square (see Figure 6–41), and when the cursor changes, click the left button. One way to tell if the correct shape is selected (the circle is very close) is to delete the selected shape. It should be clear whether the circle or rectangle was deleted. Undo to restore the shape.

You will now need to move the selected shape to the top of the upper blade. You can check the location in the *Fit Deformer* window, but that will mean leaving sub-object *Shape*. To save you this step, check Figure 6–42; the selected vertex at the top of the upper blade is shown to be located at 65.583. Enter that value under *Path Level* in the *Shape Commands* rollout, under sub-object *Shape* (see Figure 6–43).

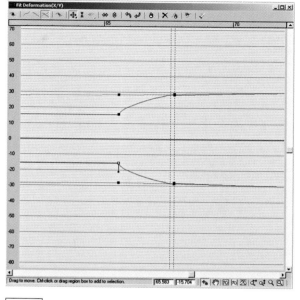

6–42 Both fit shapes

6–43

Altered hilt guard area

Compare the *Fit Deformer* windows shown in Figures 6–42 and 6–44. The dotted vertical lines show the location of shapes on the path. Figure 6–42 shows the location of the shapes before moving the rectangle, and Figure 6–44 shows the location of the shapes after the move.

Figure 6–45 shows the lofted sword without the hilt guard. The faces in the region shown in red will be concealed by the hilt guard you will build and will ultimately be deleted. You should not delete any faces, however, until you have checked the model over thoroughly and decided on the amount of detail, and number of faces, you want the sword to have.

When you have built the hilt guard and deleted the faces mentioned in the previous paragraph, you can attach the two parts as necessary. Many game engines can handle multiple objects in a model. You will probably not need to weld vertices to make a single seamless surface, since most game engines will render interpenetrating polygons without problems.

Now would be a good time to save your work.

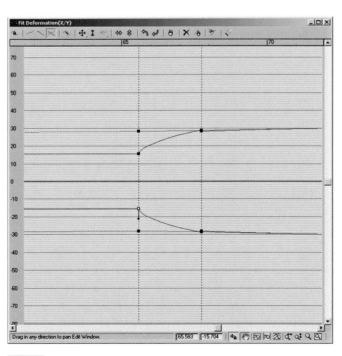

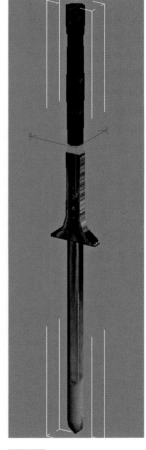

6–44 Shape location after move

6–45 Lofted sword

Turn **Shape Steps** and **Path Steps** to 0 to see the model at the lowest level of detail. It should now have about 194 faces. The sword comes to a point at the end of the blade, so there is no need to cap that end; turn off **Cap Start** to save a few more faces. As you increase the number of **Shape Steps**, you can save more faces by turning on **Optimize Shapes**. With **Optimize Shapes** checked, no points are added to straight line segments of shapes. Study your model to see this effect.

With **Path Steps** set to 2 and **Shape Steps** set to 1, you have enough detail for any modern game. There is plenty of room to adjust this upward and sufficient levels of detail as you turn these down. Since the model can be mapped as you did in Chapter 5, you don't need to rely on the default loft mapping, so you could add an **Optimize** modifier to remove coplanar polys, bringing the polycount down further.

Figure 6–46 shows the sword at four different levels of detail, with the polycount of each displayed to its left. Remember that this is before removing the unneeded faces around the hilt guard and before any further optimization.

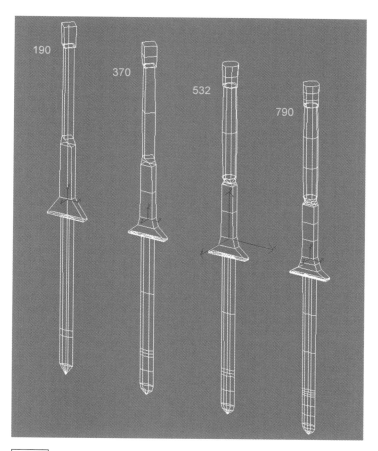

6–46 | Lofted sword, various LOD

You have now used many of the features of lofting in 3D Studio MAX, and learned about its power and flexibility. If you have worked your way through the tutorials in this chapter, you should be able to finish your sword model. This is the goal of the next exercise.

EXERCISE 6–4:::

Use lofting to build a hilt guard for the lofted sword. If you'd like some help, you can load *sword-loft-16.max*, available on the CD-ROM. This file has all the splines necessary to build a hilt guard.

EXERCISE 6–5:::

Use *sword-map.tif* (available on the CD-ROM) to texture map the lofted sword model.

:::CHAPTER REVIEW QUESTIONS:::

1. What are some advantages of loft modeling?

2. What is the minimum number of splines needed to make a lofted model? Name them.

3. What can you do when creating your path and shapes to keep the greatest control over polycount?

4. What can you do when placing your shapes on the path to keep the greatest control over polycount?

5. What can you do when creating your fit curves to keep the greatest control over polycount?

You have gained a great deal of insight in this chapter into the working of loft models. You have seen a variety of ways to allow for the lowest possible polygon count. You've learned about the flexibility provided by lofting and the ways of making a model that can have as little or as much detail as needed, in a way that allows you to easily adjust the level of detail. You've learned to use *Texporter* to help with the mapping of your models.

In the next chapter, you will learn more advanced modeling and mapping techniques.

In this chapter you will learn how to apply UVW mapping coordinates to any model so that you can paint a texture map that fits the model perfectly. You will also learn how to use patch modeling, a spline-based modeling system, to make complex low poly models.

MAKING THE TEXTURE FOR THE MODEL
ADVANCED MODELING AND TEXTURING

OBJECTIVES

+ **Learn to use patch modeling**

+ **Create complex low poly models**

+ **Create patch models of multiple Levels Of Detail (LOD)**

+ **Learn to effectively and efficiently texture map any low poly model**

Patches for Complex Models

Patch modeling in 3D Studio MAX using the *Surface* modifier allows the modeler to use a **spline cage**, or mesh made of splines, to define a model. The system is also called *Surface Tools*. It is an advanced modeling tool, good for complex or organic models including human or animal forms. It gives good control over the shape and polycount of the model.

A simple surface on a patch model (a **patch**) is much like a polygon, except that the edges of a patch can be curved splines. A polygon is always flat, but a patch is not. While spline-based modeling is very different from polygon modeling in many ways, a spline-based model in 3D Studio MAX can be easily displayed as a polygonal model, and easily converted to a polygon model. This is convenient when you need a polygon model and need control over the poly count.

There are not many modifiers used in patch modeling, but it is an entirely new approach and can take as long to master as polygon modeling. While there are many different tools for polygon modeling (lathe, loft, extrusion, etc.), with patch modeling you have a very simple set of tools, but must learn to create and control three-dimensional splines and spline cages. For many modelers this will mean greatly increasing your understanding of the model in 3D, using the viewports, and learning to move vertices and spline handles effectively to achieve the desired results.

One advantage of this approach is that by using splines, the user can make very smooth organic or complex models with relatively few vertices. The approach is similar to the way you can create a smooth curve with very few points using splines. Spline-based modeling is usually thought of as a hi-poly technique, but it gives great control over low poly models as well. Because you have good control over the number of polygons in a patch model, patch modeling can be used to efficiently generate various levels of detail. But perhaps even better, some game engines can actually read and display patch models and automatically generate an appropriate level of detail, based on distance from the viewer, before render time. Software such as some game engines and 3D Studio MAX can generate a polygon model based on a patch model or spline cage, and can create that polygon model with great control over the number of polygons generated. Therefore, the modeler can create one patch model, and the game engine creates LOD models as they are needed.

::::: Surface Tools

Unless you have used *Surface Tools* before, it is absolutely essential that you take the time to read the information available in 3D Studio MAX, and do a short tutorial on the use of the *Surface* modifier. *Surface Tools* and the *Surface* modifier are advanced tools used to create and manipulate patch models in 3D Studio MAX.

To get started, choose *User Reference* under the *Help* menu in 3D Studio MAX. In the *Search* panel type "surface tools" and press *Enter*. A list of topics will appear; double-click on the topic titled "Surface Modifier." Read this entire page, paying special attention to the section titled "Procedures."

To continue, choose *Tutorials* under the *Help* menu in 3D Studio MAX. In the *Search* panel type "surface tools" and press *Enter*. A list of topics will appear; double-click on the topic titled "Modeling a Rhino Head with Modifiers."

TUTORIAL 7–1: MODELING A BUDDHA WITH PATCHES:::

In this tutorial you will use reference images to model a stone buddha using *Surface Tools*.

Load *buddha-front.tif* (from the CD-ROM) into the **Front** viewport as a background image, and *buddha-left.tif* (from the CD-ROM) into the **Left** viewport as a background image.

Start by creating a spline that conforms to the outline of the buddha in the left viewport, as shown in Figure 7–1. At this stage it is best to work with straight line segments and toward the lowest polycount you need—or to put it another way, the minimum detail you think you need to make the model look good. Working with straight line segments makes it easier to imagine the polygons that will result from the line segments you draw. You may find it helpful to set *Steps* (under the *Interpolation* rollout) to 0—this will ensure that each line segment is a straight line.

> ### Workflow
>
> To create the buddha model, you will:
>
> • Use two reference images.
>
> • Create spline outlines of the reference images.
>
> • Create a spline cage from the spline outlines.
>
> • Apply a *Surface* modifier to create a patch model from the spline cage.
>
> • Work with the original spline cage to fix problems and refine the shape.

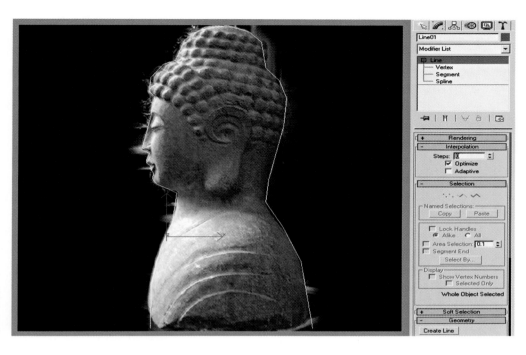

7–1

Spline outline
of side view

Next trace the outline of the buddha in the front view. Since the buddha is bilaterally symmetrical, you need only build half of the model, which you can then mirror to create the other half as you have done previously with splines. The spline shown in Figure 7–2 does not trace the earlobe. The shape of the earlobe will be created in a different way.

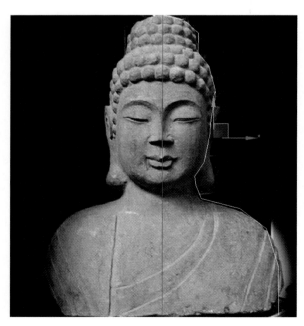

7–2

Spline profile of front view

Switch to the **Left** viewport and move the new spline to a location just in front of the ear, at the back of the jaw. See Figure 7–3.

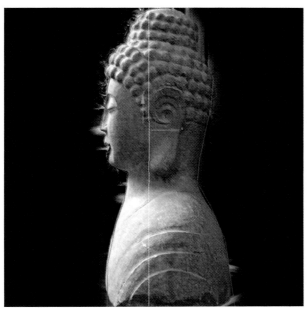

7–3

Adjusting spline location

The splines you are making will ultimately need to form a closed spline cage, so you might as well begin linking the splines now. The **User** view will probably give you the best view of both the front and side profiles; snap the top vertex of the front profile to the nearest point of the side profile as shown in Figure 7–4.

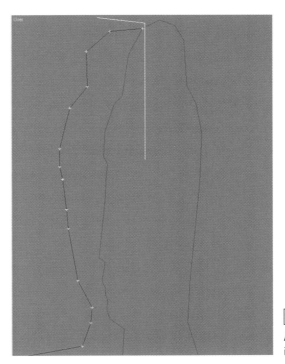

7–4

Aligning points in the two splines

Make a new spline in the shape of the ear, as in Figure 7–5.

When creating a spline cage for the **Surface** modifier, it is not necessary that vertices that touch be welded into a single vertex—in fact, for various reasons it is much better that they remain separate but coincident (occupying the same location).

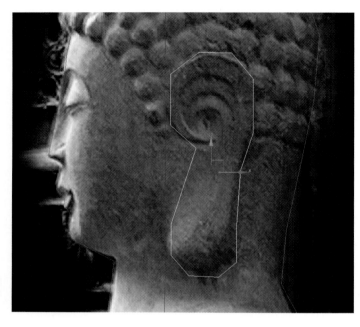

7–5

Spline defining the ear

In the **Front** viewport, move the vertices of the ear spline to match the shape of the ear from the front. See Figure 7–6.

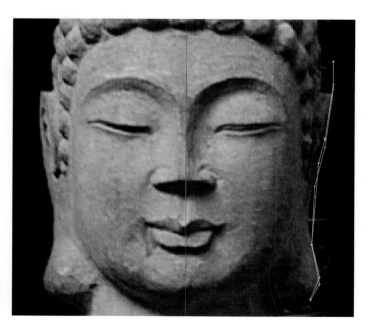

7–6

Ear adjusted for front view

The ear will need some thickness, so copy the ear spline and move the vertices so that it matches the shape of the face and neck, as shown in Figure 7–7.

Snap the vertices of the front profile to the vertices of the ear. Be sure you are snapping to the ear spline closest to the head. See Figure 7–8.

The images you are using as reference are two-dimensional pictures of an object. They have the same vertical resolution, so as you build the model details such as the nose and mouth should line up fairly well with the front view and the side view. Since you traced the side view first, the spline you made should match the buddha from the side—but the points you place around the ear in the side view will not line up perfectly with the ear in the front view. The front view will be very useful as a reference; just don't take it too literally.

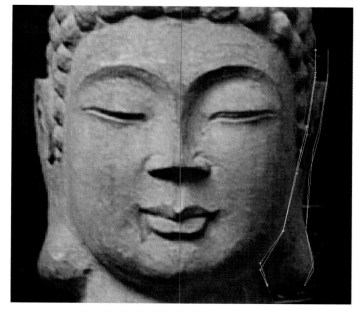

7–7 Second ear spline

7–8

Snapping vertices to other splines

You can make splines display with ticks at each vertex, allowing you to see the vertices clearly even when not in sub-object **Vertex**. To do this, go to the **Display** panel and check **Vertex Ticks** (shown circled in red in Figure 7–8). You will need to do this for each spline on which you want vertices displayed as ticks.

You may as well stitch the ear into a cage at this point. In the **Create** panel, click the **Shapes** button, then the **Line** button in the **Object Type** rollout. Make sure **3D Snap** is on, and vertices are displayed as ticks. To create a line segment, click a vertex on the inner ear profile, then click the nearest vertex on the outer ear profile. Right-click to end the segment before creating the next one. Try to be sure that you are creating shapes that have three or four sides so that valid surfaces will be created when you add the **Surface** modifier. See Figure 7–9.

Copy the front profile and move it to a location just behind the ear. See Figure 7–10.

7–9 | Stitching the spline cage

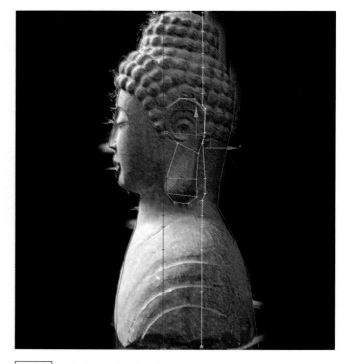

7–10 | Adjusting spline location

Snap the vertices of the new spline to the vertices of the ear, as shown in Figure 7–11. Snap the vertex at the top of the new spline to the nearest vertex at the top of the head. If either spline needs more vertices to match up well, go to sub-object *Vertex* and click **Refine** in the **Geometry** rollout. Then click on the spline where you need a new vertex.

Stitch the back and side of your buddha together to form a spline cage. Remember the rule about three or four sides. See Figure 7–12.

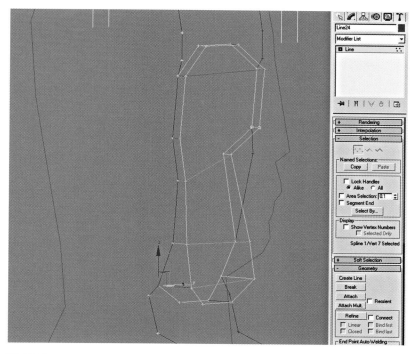

7–11 Stitching the spline cage

7–12 More spline cage stitching

As you can see in the **Top** view (see Figure 7–13), your buddha doesn't have enough detail in the back. His shoulders should be rounded, not so angular. This gives you the opportunity to learn about a tool that is very useful when making spline cages for use with **Surface Tools**.

First, the splines you created in the last step must be attached together to form a single spline object. Select the topmost spline, add an **Edit Spline** modifier, and attach all of the other splines you just created. In Figure 7–14 all of the green splines are part of a single spline object.

7–13 | Top view of spline cage

7–14

Attaching splines for further editing

Go to sub-object *Vertex*. In the *Geometry* rollout, check *Connect* beside *Refine*, and then click the *Refine* button itself (see Figure 7–15). Click on the middle of each spline segment in sequence where you want to add a new vertex. When you are finished, click the right mouse button and the new vertices will be connected for you.

If you have left a five-sided spline shape at the top of the head, add a new spline to divide it into one three-sided and one four-sided spline shape. See Figure 7–16.

7–15 Refining the spline cage

7–16

Ensuring correct spline cage structure

To take advantage of the extra vertices you added you will need to move them. First, though, attach the new spline you just added to the top of the head to the splines that form the horizontal lines of the back. Then use region select to select the newest vertices and move them to round out the back, as shown in Figure 7–17 (compare with Figure 7–15). The vertices shown selected in Figure 7–17 have all been adjusted, but not all by the same amount. You will need to adjust these vertices individually or in small groups.

Working with spline cages

Because you are often dealing with two or more vertices occupying the same location, it is good to get in the habit of using region selection when adjusting spline cages. A simple click and drag will move one point, but leave the others behind, breaking your spline cage. Don't worry about getting it perfect right now; very soon you will apply a **Surface** modifier, which will allow you to see how your changes affect the surface of your model.

Another tip for working with vertices in spline cages: it is often easier to make the adjustments you want using the **Perspective** or **User** viewports. In such cases, use the axis gizmo to constrain movement to a single axis. This will help you to understand the changes you are making and to avoid misplacing vertices.

Also, it will often be wise to turn off snap when moving vertices in the **Perspective** or **User** viewports.

7–17 | Moving vertices to refine shape of spline cage

There is much more detail in the face than in the rest of the body. You will now begin to add that detail. The splines you just created on the back can be hidden to get them out of your way while working with the front.

First add a spline to define the eyebrow, as shown in Figure 7–18.

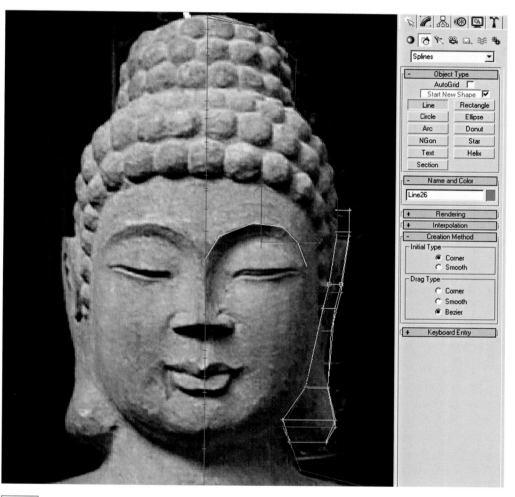

7–18 Defining the eyebrow

Move this spline in the side view to the appropriate location. Choose the side-profile spline and snap the vertex at the top of the nose to the nearest vertex of the eyebrow, as shown in Figure 7–19.

The eyebrow should not be flat of course, but should curve with the contour of the face. See Figure 7–20.

7–19

Snap vertex to existing spline cage

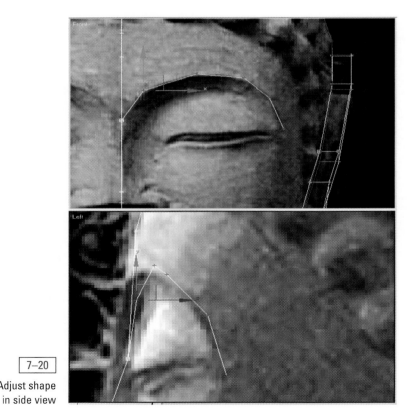

7–20

Adjust shape
in side view

Create splines to define all the important details of the face, adjusting them to fit the face as closely as possible, as shown in Figure 7–21. Remember that you have used the side view as a reference first; in the fine detail of the face you will see more clearly how splines built in the side view do not necessarily line up in the front view.

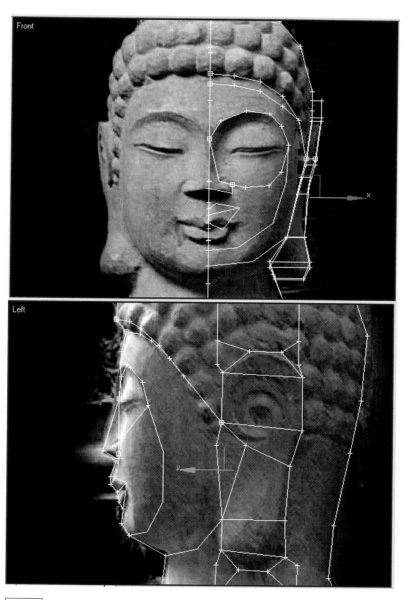

7–21 More work on spline cage

7–22

Continuing to stitch
the spline cage

Stitch the face splines together to form a spline cage. Take your time, think about the contours of the face, and try to build the cage in such a way that it takes on the shape you want. Don't worry too much about it though; you will need to go back and make adjustments after you've applied the surface in any case. See Figure 7–22.

7–23

Stitching the head area

You can approach the top-front of the head in the same way as you approached the back—connect the front and side directly, **Attach** the new splines to form a single spline object, then use **Refine** with **Connect** to add vertices. See Figure 7–23 and Figure 7–24. Adjust the new vertices as necessary.

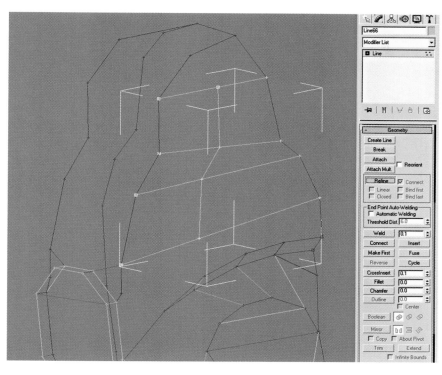

7–24
Refining the head
area

Use the same approach on the front of the torso. See Figures 7–25 and 7–26.

7–25
Torso area

7—26

Refining torso area

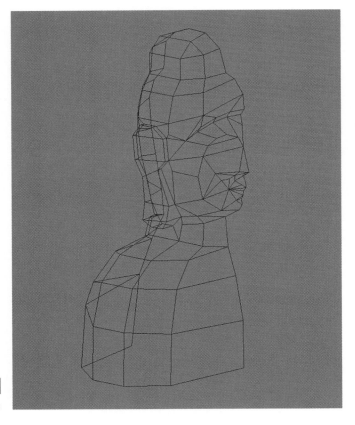

7—27

Finished spline cage

There will still be some openings in your spline cage; add the appropriate splines now.

This would be a good time to save your file (using **+** instead of **Save** to preserve versions of your work at various points in the process).

Unhide the splines of the back, and attach all of the splines together to form a single spline object. You can use **Select by Name** to attach, choosing the spline you wish to attach by name rather than clicking it in the viewports; this approach can help you be sure that all of the splines have been attached to the spline cage object.

Now you should have a spline cage that is more or less complete. It is time to apply a surface, so that you can evaluate your spline cage and make adjustments.

Clone your spline cage, making a **Reference** rather than a **Copy** or **Instance**. This will allow you to make adjustments to your original spline cage and to see the results on the reference, which will have a **Surface** modifier applied. See Figure 7–28.

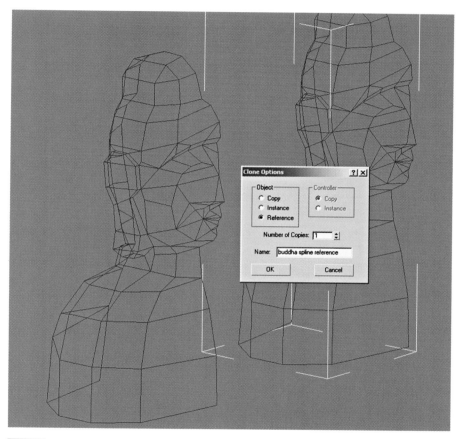

7–28 | Reference of spline cage

Apply a **Surface** modifier to the reference object now. Under **Patch Topology**, set **Steps** to 0. Set the **User** viewport to display **Facets**, so that you can best see the polygons of your model. Open the **Polygon Counter** and check the number of polygons in your model so far. 3D Studio MAX always display models of any kind, including spline-based models, as polygons—and always as the model will look if converted to polygons. Figure 7–29 shows 235 polys; with the other half added this would make a complete model of less than 500 polygons.

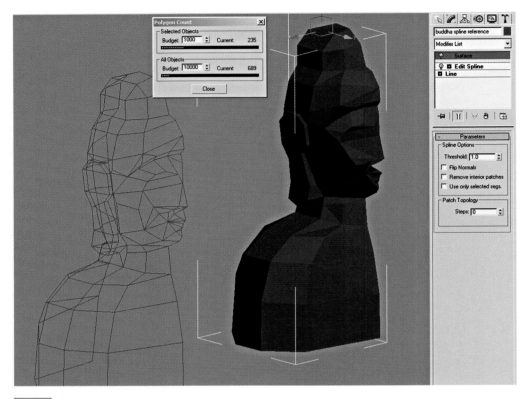

7–29 | Surface modifier applied

Another type of spline model

To see polygons on NURBS models (one type of spline modeling available in 3D Studio MAX), in a wireframe view, you may need to change certain settings. For more information on NURBS, choose **User Reference** under the **Help** menu in 3D Studio MAX. In the **Search** panel type "nurbs" and press **Enter**. A list of topics will appear; read the various topics on NURBS curves and models.

Like all art creation processes, finishing and optimizing patch models is an iterative process of refinement. Check the surface for any holes, and stitch your original spline cage as necessary to close them. Figure 7–29 shows a hole under the nose. Some holes in the mesh are a result of shapes in the spline cage that have more than four sides, or that are simply not closed. Create new spline segments as necessary to fix these problems.

Another possible reason for holes in your surface is that you failed to snap one vertex precisely to another when stitching the spline cage. In the **Surface** modifier, under **Spline Options**, the **Threshold** value indicates how far apart vertices can be while still being treated as if in the same location for purposes of defining the patch surface. Increase this value. If holes in the surface close, you should zoom in for a closer view and snap to the

same location any vertices that are too far apart. You want to have vertices on your spline cage that are fairly close to one another but not treated as one single vertex. So, you should set the **Threshold** back to 1.0.

Faceted shading reveals polygons that could be improved by turning edges. It is not necessary to convert your patch model to a poly model to effectively turn edges; you can do this by adjusting or adding splines to your spline cage. Figure 7–30 shows a quad that may look better with the center edge turned, and also the splines in the spline cage that form this quad.

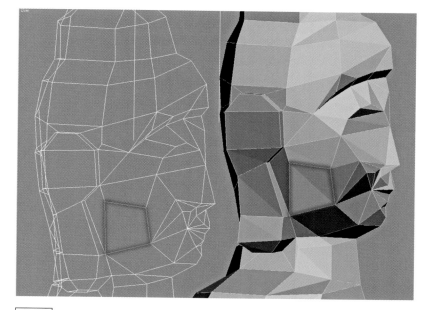

7–30 Problem with center edge

Because these splines form a four-sided shape, the software is left to decide how it is divided into triangles. If you don't like the choice 3D Studio MAX has made, you can explicitly define the center edge by adding a spline so that the quad is divided into two triangles (See Figure 7–31). Sometimes you will have created triangular spline shapes that cause shading problems, and you'll need to delete a spline segment and stitch your cage in a different fashion to fix the problem.

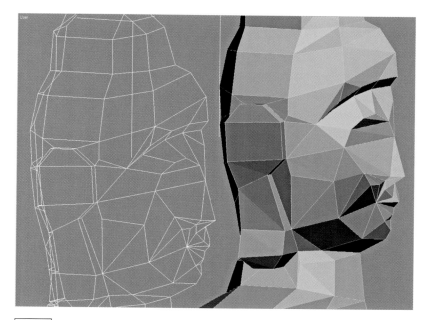

7–31 Better orientation of center edge

The splines and vertices you create during construction will not necessarily be perfect, or even necessary. Figure 7–32 shows a point that is not really needed, which creates unnecessary polygons, one of which causes undesirable shading in front of the top of the ear. Keep in mind that there are almost certainly two or more vertices there; use region select to select them, and snap to place them in the same location as the nearest vertex of the ear. Observe the improvement in Figure 7–33. Don't worry about the extra vertices in your spline cage; vertices that are coincident make only one vertex in the patch surface.

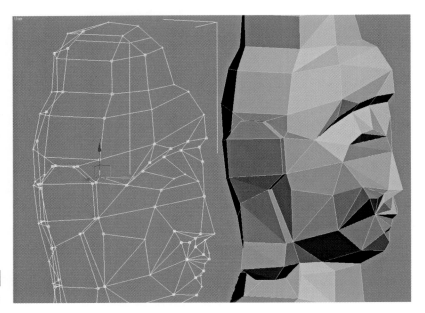

7–32

Remove unnecessary points

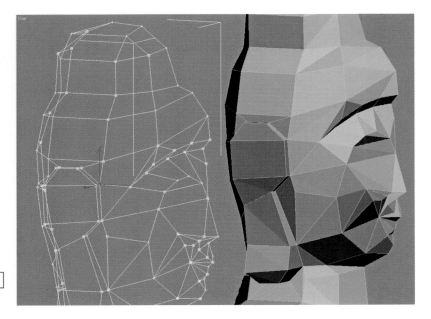

7–33

After removing unneeded point

Figure 7–34 shows one face shading conspicuously darker than its neighbors above the eye. This can often be improved by making adjustments to the locations of one or more vertices. By moving the vertex shown selected in Figure 7–34 very slightly in y, in the negative direction, the shading is improved as shown in Figure 7–35 (more adjustments in this area would further improve the model).

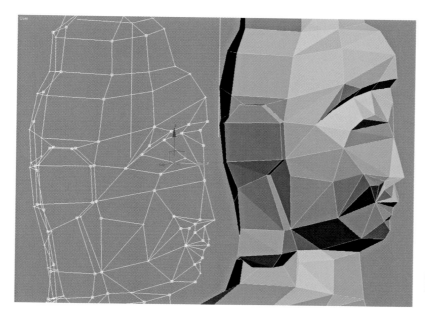

7–34

Shading problem in the eye area

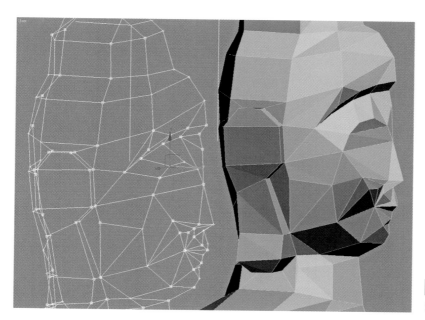

7–35

Shading improved

When you have fixed all the problems that are obvious in the faceted view, you can apply the texture map to get a better idea of how the final model will look, and mirror the reference model so that you are looking at a complete buddha.

Make a material using *buddha-map.tif* (available on the CD-ROM) and apply it to the patch model. Apply a **UVW Map** modifier, align and fit the gizmo. Apply an **Unwrap UVW** modifier, and make the necessary adjustments so that the face fits reasonably well. The final mapping will come later, so it's not important that the mapping is perfect at this stage; it just needs to be good enough that you can tell how your model looks. See Figure 7–36.

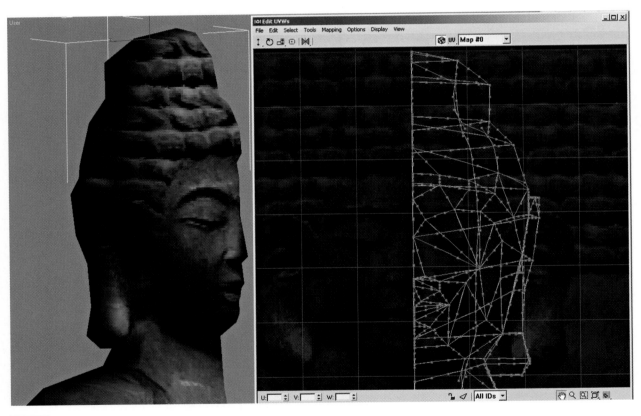

7–36 Checking the model with texture applied

To mirror the patch model, click **Mirror**, and choose **Reference** under **Clone Selection**. You can use **Offset** to position the mirrored model right next to the other half. See Figure 7–37.

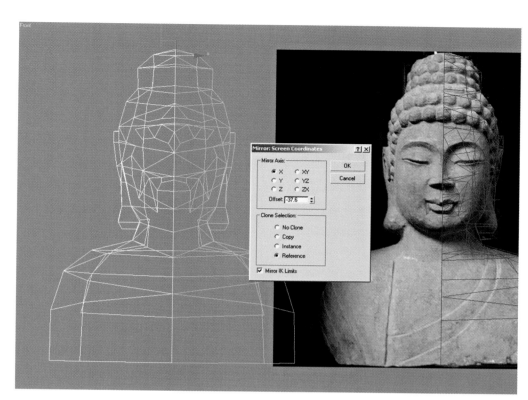

7–37

Mirroring the patch model

Study the results and make adjustments as necessary to the spline cage. When you are satisfied with the appearance of your buddha, you can proceed to make the finished mesh.

7–38

Model in progress

Low poly buddha model

To make your buddha a single, solid mesh, you can select the mirrored half, select the modifier at the top of the stack (*Unwrap UVW*), and click the *Make Unique* button just below the modifier stack window. This makes the object a copy, and no longer a reference of the other half. This is necessary to allow you to attach one half to the other. Select the original half, add an *Edit Mesh* modifier, and attach the mirrored half. When an *Edit Mesh* is applied, the model is converted to a polygon model. Select all the vertices along the vertical center of the model and weld them to create a seamless model.

If you have worked through the previous chapters you should have the skills necessary to apply UVW mapping to finish your buddha model. Figure 7–39 shows a finished buddha model.

EXERCISE 7–1:::

Choose a simple model to build using patch modeling and *Surface Tools*. Build it with the lowest polycount you can.

TUTORIAL 7-2: HIGH-RESOLUTION PATCH MODELS:::

Workflow

In this tutorial, you will:

- Use the functionality of the surface modifier to smooth the buddha model.

- Create a version of the buddha model with a higher LOD.

- Learn to fix problems and refine the shape of patch models.

Patch modeling allows creation of extremely smooth surfaces.

It takes practice to model well with patches. You should probably build six to ten models for practice before you attempt to build a model for any real use. At this point, your buddha model most likely still needs additional work. For this reason, a MAX file for this tutorial has been provided. Open *buddha-20.max*, available on the CD-ROM.

To approach this model as a low poly model, you were advised to work with straight line segments. To make a more detailed version, you will need to smooth your splines. To see the model in its lowest poly form, you were advised to set **Steps** to 0 under **Patch Topology** in the **Surface** modifier. To see the changes you make to the spline cage on the patch surface, you will need to set **Steps** to at least 1 under **Patch Topology** in the **Surface** modifier. This will increase the number of polys in the model. As long as your spline cage consists of straight line segments, however, your model will not be any smoother.

Select all the vertices of your model and right-click to convert them to **Smooth** points. As you work to refine the model, you will convert certain vertices to **Bezier** points in order to adjust their shape. **Steps** under **Interpolation** in the original **Line** modifier will need to be set higher than 0, or the spline cage will continue to appear as if it were made of straight line segments. See Figure 7–40.

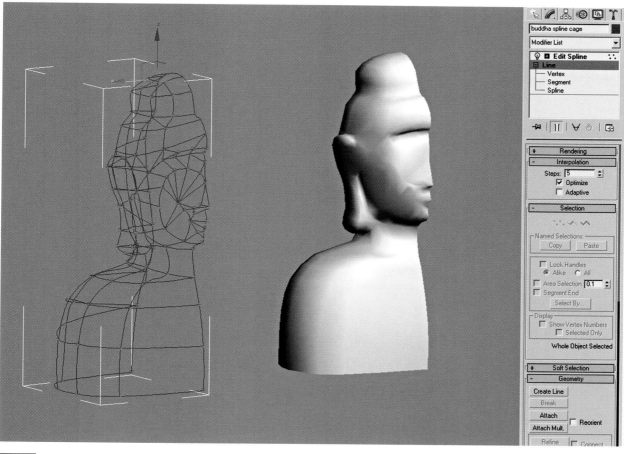

7–40 | Smoothed buddha

An area on the cheek that can be improved is identified in Figure 7–41. Using two views can be a good way to track down the part of the spline cage that relates to a specific part of the surface. The vertex shown selected in Figure 7–41 is in the general area of the problem.

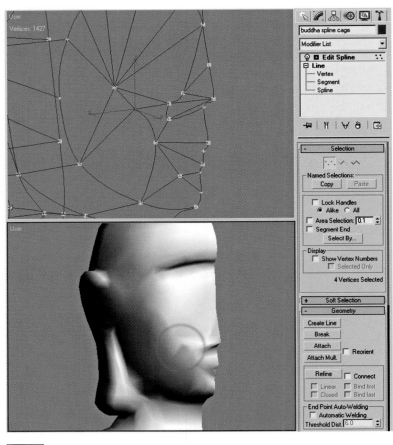

7–41 | Problem area

Triangular patches can often create undesirable shading. This problem can be eliminated by simplifying the spline cage and eliminating some of the triangular shapes in the cage. The selected vertex can be snapped to the vertex above it and still leave valid four-sided spline shapes in the cheek area. See Figure 7–42.

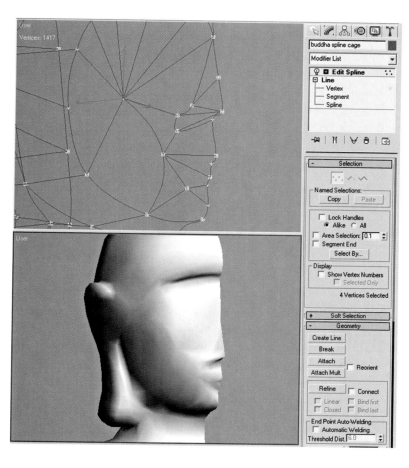

7–42

Improved spline cage

Some spline segments won't take on the best shape by simply being turned to *Smooth* vertices. Figure 7–43 shows that the nose is very narrow. By selecting the segments that seem to contribute to the nose and bringing them to the center in each viewport, you can clearly see their shape from every relevant angle.

7–43

Segments identified

7–44

Segments identified

In this case, the vertices that control these segments can be most easily selected in the *Front* viewport. Selecting them makes them more visible in all views and allows you to turn them to *Bezier* or *Bezier Corner* vertices. Then you can adjust the shapes of these segments to improve the surface. Figure 7–43 shows that the spline segments in question are still straight line segments. Figure 7–44 shows improved spline shapes. This is the sort of operation that you will find quite common when working with spline cages for smooth models.

Moving the vertex shown selected in Figure 7–45 will yield significant improvement of the nose.

7–45

Nose job for the buddha

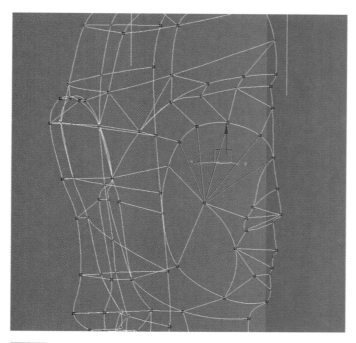

The model is now quite smooth and suitable as a higher LOD model to the original. If greater detail is desired, consider removing the spline segments shown selected in Figure 7–46 and replacing them with splines to define the geometry of an actual 3D eye. The eye is currently represented only in the texture.

7–46 Candidate region for increased detail

When you are happy with the surface, you can mirror the spline cage so that you are working with a complete model. It will save time if you first ensure that all of the vertices along what will become the center lie along the same vertical axis. You can do this by selecting those vertices and scaling them to 0 in the x axis.

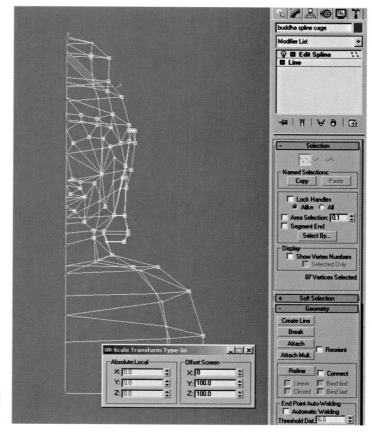

7–47

Aligning vertices

You can then mirror the spline cage, using the *Align* tool to place one precisely beside the other, and then attaching the two together.

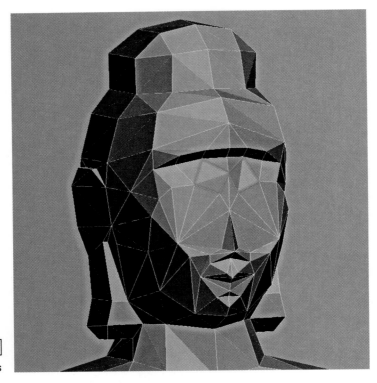

7–48

Different center edges

Working with a complete spline cage can be more difficult, since there are more spline segments displayed. Use extra care when working on the spline cage. Although one half of your model may have no problems, there may be issues to resolve with the new half.

Figure 7–48 shows that the software has decided on different center edges for the two quads highlighted in red. The one on the left side makes smoother mesh, so add a spline segment to the spline cage to turn the quad on the right side into two tris, as shown in Figure 7–49 (To easily identify these problems, the *Step* value has been turned down to 0.)

7–49

New center edge

This process should be familiar. Since you have already done this to one half of the model, this may be a very good case for converting to polygonal mesh before adding the second half.

Adding a texture map will hide the sort of small imperfections still visible in Figure 7–50.

This concludes the discussion of patch models. Next you will learn advanced UVW mapping techniques.

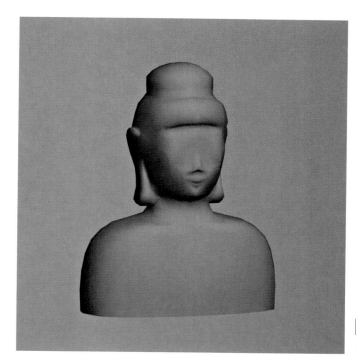

7–50

Smooth buddha

EXERCISE 7-2:::

Smooth your patch model from Exercise 7–2 to create a higher poly version. You will likely encounter many problems. Work with the model to fix the problems, starting with the methods you learned in this chapter. This valuable learning experience will help you avoid extensive cleanup in the future.

Advanced Texture Mapping

While there are times when the approaches to UVW mapping that you have learned so far will be appropriate, they will not enable you to easily map all models. The use of **Unwrap UVW** is impractical in more complex models. The next approach you will learn allows more control.

Workflow

In this tutorial, you will learn to:

- Unwrap the model itself, laying all of the polygons out flat so they can be planar mapped. To do so, you will need to break the model into separate parts.

- Use *Texporter* to create an image template of the UVW coordinates applied to the model. You will use this to paint your texture map.

- Return the model to its original shape with the new texture coordinates. To finish, you will apply your texture map to the model.

This approach can be used to map any low poly model accurately. It is useful in situations where the model is built before the texture image is created. Many modelers and many texture painters prefer to use such an approach most of the time.

This example is intentionally extremely simple, so simple that *Unwrap UVW* would be entirely satisfactory to complete the mapping. The following approach is more complex, however, so it is important to introduce the steps involved using a very simple example first. Although each step may be absolutely clear to you, you are urged to actually go through the process, since doing it yourself will be a valuable learning experience.

Create a box as shown in Figure 7–51 using the following dimensions: *Length* 70, *Width* 30, *Height* 70.

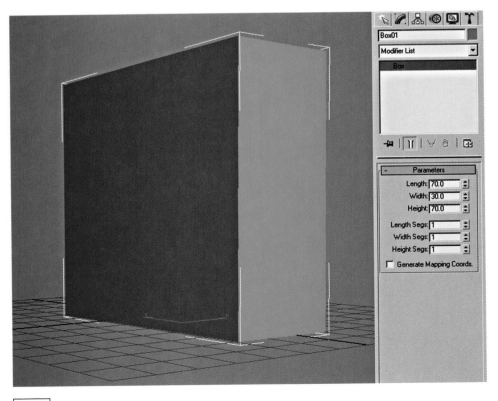

7–51 A box primitive

Add an *Edit Mesh* modifier. Go to sub-object *Polygon* and select one side of the box, as shown in Figure 7–52. Click the *Detach* button (under the *Edit Geometry* rollout), and check *Detach to Element*. The selected side is now a separate element—it is still part of the same object, but shares no vertices with the other parts of the object and can be moved about independently.

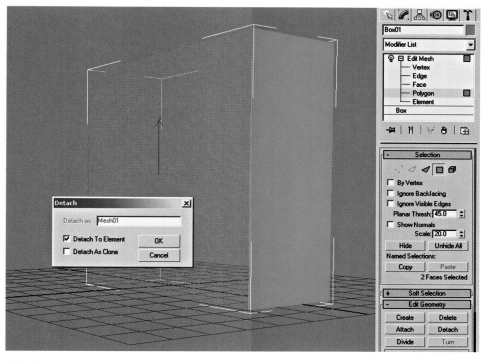

7–52 Detach to element

Now do the same for each side of the box until each side is a separate element. Double check your work; in sub-object *Element*, select each side one at a time, making sure that only the side you click is selected.

The next step is very important and must be performed at the right stage in your process. After the model has been broken into the necessary elements, make a copy of the object. You can hide the copy to keep it out of your way while you work with the original.

It can be easy to forget to make a copy of your object at the right time. The copy will be used with the *Morpher* modifier to reassemble your original object into its proper shape. The *Morpher* modifier is used to cause an object to change from one shape to another. Therefore, you must clone (copy) the object before you begin to unwrap it for mapping. The original object and the copy must have the same number of vertices for the *Morpher* to work, so the clone must be made after the process of detaching is complete.

To avoid a mistake that will result in repeating some part of your process, think carefully about what you are doing at each stage. You should also save frequently, using the **+** instead of *Save* to save your work to different files (rather than overwriting the same file).

Working in sub-object *Element*, select one side of the box. Rotate the selected quad 90 degrees in the z axis. Use the *Rotate Transform Type-In* to be precise. Move it in the *Front* viewport so that it sits right against the front polygon of the case. Do the same in the *Top* viewport. A better approach is to use the *Align* tool to place the side exactly next to the front of the box, as shown in Figure 7–53. Since the elements you are working with are part of the same object, *Align* won't always help you place the elements where you need them.

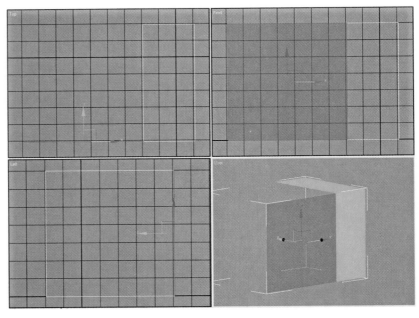

7–53

Aligning element to front view

Now select the top of the box and place it next to the side you have just worked with. Be sure to rotate it in such a way that the vertices of the top and side that originally touched again touch in the same way. To do this you can rotate first in x by 90, then in y by −90 (using the *User* viewport). See Figure 7–54.

Select the back element and rotate 180 in z. Place it as shown in Figure 7–55.

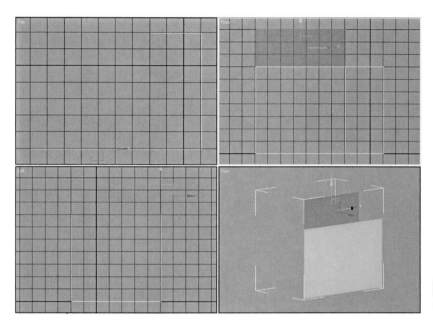

7–54

Top surface aligned to front viewport

7–55

Back surface aligned to front viewport

Next arrange the bottom quad beneath the side, taking care that the edges that were formerly shared between the two touch in the same way they did previously.

To use less resolution in the texture, you can place the last side of the box right behind the first side you adjusted. In this way it can receive the same planar mapping coordinates, and thus the same part of the texture will be shared between the two sides. It should face the opposite direction so that it receives the proper texture coordinates. See Figure 7–56.

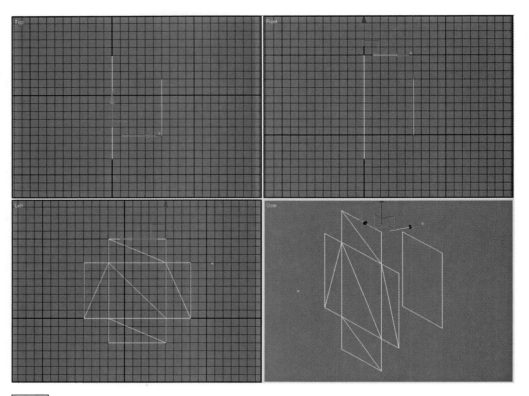

7–56 | One side placed behind the opposite side

Apply a **UVW Map** modifier. Orient the gizmo as shown in Figure 7–57. Click the **Fit** button. Scale the gizmo up slightly, about 2%, so that there is some room at the borders of the texture map, and you won't have to paint right up to the edges.

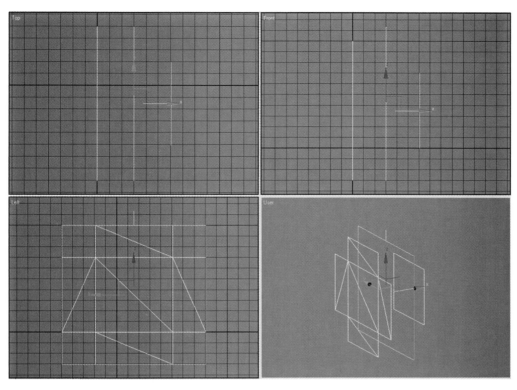

Planar mapping

Set **Texporter** to a resolution of 1024×1024 and choose the unwrapped box. You should get an image very similar to Figure 7–58.

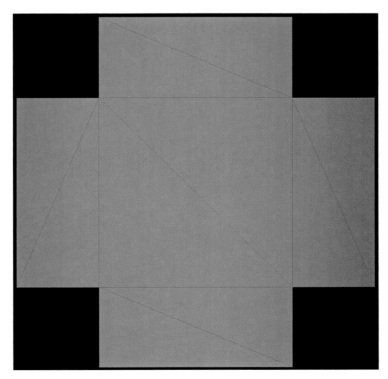

7–58

Template from Texporter

The components of the texture map for the computer case are available on the CD-ROM, titled *case-front.tif*, *case-back.tif*, *case-side.tif*, *case-top.tif*, and *case-bottom.tif*. In Photoshop, arrange them in layers over the template image generated by **Texporter**.

Cut and paste each image into the template image as a new layer. Set the **Opacity** (available in the **Layers** window) of the new layer to about 60%; this will allow you to see the template as you work with the foreground image. Use **Free Transform** (Ctrl-T) to resize the image to fit the template. Once all layers have been fit to the template, and the opacity of each layer is set back to 100%, the texture map should look like Figure 7–59. Save the image as a .psd file so that you have a backup, then flatten the image and save it in another format such as .jpg.

7–59 Texture map

In 3D Studio MAX, make a material using your new texture map and apply it to the box. Unhide the copy you made earlier. Apply a **Morpher** modifier to the unwrapped box. Under the **Channel Parameters** rollout, click **Pick Object from Scene** and click on the copy of the box. The name of the copy object should appear in the first slot in the **Channel List** rollout. See Figure 7–60.

7–60 | Morpher modifier applied

Next to the name of the copy object in the first slot in the **Channel List** rollout is a spinner. Dial this spinner to 100, and you should see the unwrapped model reassemble itself into its original shape.

If you have followed all the steps in this tutorial carefully, your computer case is now complete. See Figure 7–61. If you know that the game engine you are using can handle multiple texture coordinates for a single vertex, then you can add an **Edit Mesh** modifier and weld all of the points back together. If you aren't sure, leave the model as is.

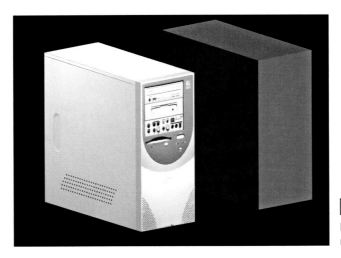

7–61

Finished,
mapped model

This concludes the tutorial, but this process warrants further discussion. Save your work, take a break, and continue when ready.

STRATEGIES AND CONSIDERATIONS FOR UNWRAPPING MODELS FOR TEXTURING:::

There are some things you should keep in mind while working to unwrap a model for planar mapping. One thing to consider is the painting of the seams. Related to this is placing all the parts of the model in such a way that you can clearly recognize them. The model should usually be left as intact as possible, while still causing all the surfaces to face in a direction appropriate for planar mapping.

Consider Figure 7–62. This is one possible way to unwrap the polys of the computer case. To some extent this is efficient use of the texture space—there is relatively little unused space. The disadvantages, however, are significant. First, it will be difficult to remember which part is which—each of the tall, narrow quads could be the front, back, etc., and it will likely require a lot of trial and error to get the right part of the case onto the right part of the map. The way you laid out the polys in the previous tutorial made it very clear which part was which.

7–62 | One possible layout of elements for mapping

Another problem is that each part of the computer case is separated from the others in the texture. To put it another way, the texture is discontinuous. In Figure 7–63, two edges that touch on the model have been highlighted in red on the texture. The challenge for the artist is to paint these two edges so that they have exactly the same color information. In this case the task is relatively trivial; one could simplify it by selecting a pixel-wide piece of the front and pasting it onto the very edge of the side (this is just one possibility). But on a more complex model, leaving as many of the parts connected, making the texture as continuous as possible, can save a lot of time and effort.

The computer case is also a very simple object. With sides at 90 degrees to one another, slight differences in color can be interpreted as differences in light and shading. However, parts of this box do wrap from one surface to another; the top, for example, attaches to the sides not at the edge between the side and top, but slightly below the top. Thus, the more the top looks like a continuous piece of metal,

wrapping from the top onto the sides, the more realistic the case will look. Later, you will look at a simple trick to help with this illusion, and also help to make the edges look less sharp, less like a computer model.

There will necessarily be some parts of the texture that are discontinuous in all instances. When deciding how to unwrap your model, you should carefully consider factors such as which parts will be easiest to paint if discontinuous, and which most need to look their best. For example, the bottom of the case is a separate piece and shares very little of the metal, or color, of the sides. Therefore, the bottom can most easily be painted without touching any of the other parts.

7–63
Touching edges identified

It seems likely that the part of the computer case that will receive the most attention from the viewer will be the front. You could, therefore, decide that the front panel should be left touching the sides and top. As you can see in Figure 7–64, however, this option requires a relatively large texture resolution and leaves much space in the texture map unused. Even with the bottom moved up to occupy one of the empty spaces at the top of the texture map, this is a relatively inefficient use of the texture space.

7–64
Adjacent edges left touching

The manner in which you arranged the sides of your computer case in Tutorial 7–3 is a compromise; the image space is used fairly efficiently, and one entire side of the case is left in such a state that the texture is continuous for its edges.

As these considerations demonstrate, it is important to plan your strategy very carefully and thoughtfully before unwrapping your model.

"BEVELED" EDGES:::

There is a simple trick to help make the edges look less sharp, less like a computer model, and paint discontinuous parts of a texture effectively.

Modelers who have fewer concerns about polycount (such as those who work in computer graphics for film and television, in which there are limits, although much higher) often "bevel" or "chamfer" the sharp edges of their models so that they catch some light, making the edges look more rounded, more natural, and less computer-generated. Figure 7–65 shows a chamfered edge on the computer case.

7–65 | Chamfered edges

This approach adds polygons, and is therefore inappropriate for most game engines today. It can, however, be faked fairly effectively.

In Photoshop, load the .psd file containing your computer case texture map. Hide all the layers except the template. Select the line tool and set the **Weight** to 3 px (pixels). Set foreground color to white, and trace the outline of your template, avoiding the center edges, as shown in Figure 7–66. The line tool will make a new layer for each line segment you draw; when finished, link all the line layers and merge them into a single layer. Move this layer to the top. Name it "highlights."

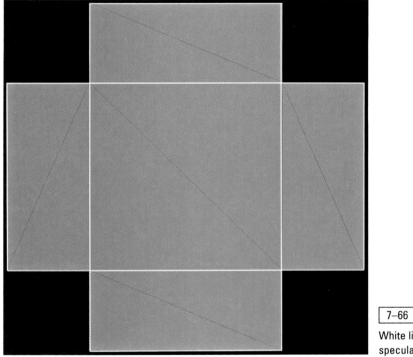

7–66

White lines for faked
specular highlights

Unhide the layers containing the computer case. Blur the white lines as you feel appropriate, and darken them until they are just lighter than the paint of the case. The front is darker than the sides, so you will want to cut and paste the appropriate portion of the highlights into a new layer and adjust its color separately. You will also probably want to remove the highlights from the bottom. After some work, your new texture map should look something like Figure 7–67. This example is fairly exaggerated, to make the effect obvious and easy to see. You may want something more subtle in actual use. It would also look better if the highlights were worked to match the varied color of the case sides.

7–67 | Faked chamfered edges

The effect might be better appreciated as applied to the model shown in Figure 7–68. This is the minegun (minus the clip) from the *Quake III Arena* mod *Political Arena* (http://planetquake.com/politicalarena). The .max file and .psd file (as well as the .tga texture map) are available on the CD-ROM. Look at the .max file to discover how the model was unwrapped for mapping. Study the .psd file, turning the various layers on and off for insight into how the texture map was painted.

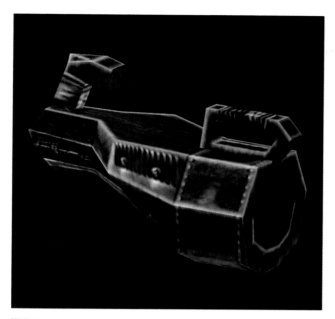

7–68 | Minegun (from *Political Arena,* © 2001 Todd Gantzler)

So far this chapter has introduced you to a basic approach to unwrapping a model for planar mapping in 3D Studio MAX. Fortunately there is a tool, or rather a set of tools, which makes this process much easier. When you are ready to continue, you will be introduced to ChilliSkinner, a set of tools for mapping created by Colin "Chilli" Semple.

In your favorite web browser, go to http://www.chilliweb.co.uk, and click on the ChilliSkinner link. You will find all the tutorials and information you will need to learn and use ChilliSkinner. These tutorials reveal less concern about the issues stressed in the section of this chapter, "Strategies and Considerations for Unwrapping Models for Texturing." You will of course develop your own technique. Fortunately, ChilliSkinner is flexible enough to allow for various working styles.

The following tutorial will show you the power and advantages of ChilliSkinner, demonstrating the most powerful tools and contrasting the ChilliSkinner approach with the approach you learned in Tutorial 7–3. You will unwrap the computer case again, using ChilliSkinner, and this time much more quickly and easily.

The file *CSv3.0.2.zip*, available in the Tools folder on the CD-ROM, contains the ChilliSkinner software. If 3D Studio MAX is running, shut it down and unzip the entire contents of CSv3.0.2.zip to your 3dsmax#\scripts folder.

Restart 3D Studio MAX to begin.

Workflow

In this tutorial you will:

- Learn to use ChilliSkinner.
- Unwrap the model using tools offered by ChilliSkinner.
- Planar map the model.
- Use *Texporter* to create an image template to use in painting your texture map.
- Return the model to its original shape.

Create a box as shown in Figure 7–69 (use the following dimensions: **Length** 70, **Width** 30, **Height** 70). To run ChilliSkinner, go to the **Utilities** panel and click **MAXScript**. In the **MAXScript** rollout, click **Run Script**. A file browser will open; choose *CSv3-0-2.ms* (this should be in a directory called CSv3.0.2), and click **Open**. The ChilliSkinner interface will open. Move the ChilliSkinner window to a convenient location, and resize so that you can see all of the buttons.

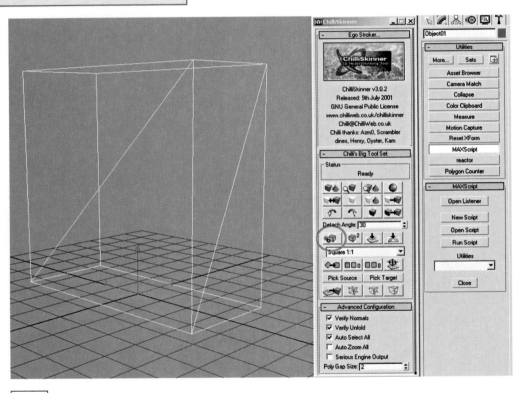

7–69 Auto-detach in Chilliskinner

Working with ChilliSkinner is best when you work in a file that contains only one object. Many of the buttons perform functions that are already available in 3D Studio MAX, but that are added to the ChilliSkinner interface for your convenience. Placing the cursor over a button opens a small rollover window that reveals the purpose of the button.

Select your box in the usual way, or use the **Select All** button in the ChilliSkinner interface (the top left button).

Click the **Auto Detach** button (circled in red in Figure 7–69) to automatically detach the sides of the box. **Auto Detach** works based on the angle between neighboring faces. The **Detach Angle** is set to a default of 30, which means that faces which join at an angle of 30 degrees or more will become separate objects. **Detach Angle** can be set by the user. Since the sides of the box join at angles of 90 degrees, the default setting of 30 will cause each side to become a separate object. In Tutorial 7–3 you detached the sides as elements of the same object. You will probably find it easier to work with the parts as separate objects, and ChilliSkinner provides a simple way to reattach the parts again when you are ready.

ChilliSkinner will unwrap (or unfold, the terminology used by ChilliSkinner) your model for you, and orient the polygons so that they face the same plane for mapping. If you want part of the model to be left touching, however, you need to take certain steps.

Ctrl-click to deselect the far side of the box (one side of the computer case). In Tutorial 7–3 you saved texture space by arranging this polygon so that it received the same mapping as the opposite side; you will do this again.

With all of the box parts selected except for the one side, click the **Attach Polys** button in the ChilliSkinner interface. All of the selected objects are attached into one.

To control the way ChilliSkinner unfolds your model, you must reconnect the edges that you want left touching. ChilliSkinner provides a **Weld Selected Edge(s)** button to make this a simple task. The edges that you weld together act as hinges about which ChilliSkinner will unfold the object.

Go to sub-object **Edge**. Remember that the sides of the box have been detached, and although they are once again a single object, they are still separate elements, so each edge that you see is really two edges. If you select an edge by simply clicking on it, you will only select one of the two edges at that location. Use region selection to select all edges of the near side of the box, as shown in Figure 7–70. Click the **Weld Selected Edge(s)** button. The edges will be welded, and the sub-object selection will be turned off.

7–70 | Welding selected edges

Now you come to that very important step—with the model ready for unfolding, you must first clone it. Click the **Select All** button to be sure that all parts of the model are selected, and then click the **Clone** button. The **Clone** button creates a copy of each selected object and hides the clones.

Deselect all objects, and select just the one with five sides of the box. Click the **Unfold Poly(s)** button. The selected object should be unfolded as shown in Figure 7–71.

7–71

Checking that the model unfolds as desired

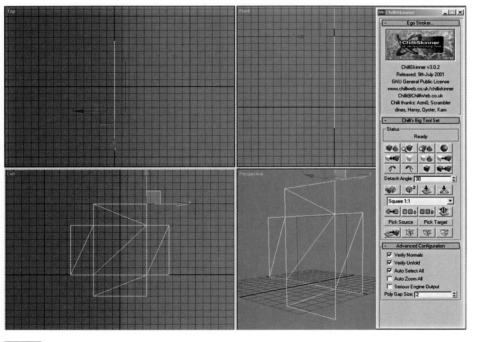

The unfold operation finishes by selecting all of the visible objects. Deselect the object with just one side of the box. Use **Optimize Poly(s)** to return the unfolded object to a state in which its edges are parallel to the major axes. Then rotate and move the object so that the side of the box lines up with the other side (the **Align** tool can be used for the latter). See Figure 7–72.

7–72 Align side face to take same mapping as opposite side

You now need to attach the two objects into one. ChilliSkinner automates this process. Select all the visible objects and click the **Attach Polys** button. Then click the **Toggle Visible** button to hide the unfolded object and unhide the cloned objects. Select all visible objects and click **Attach Polys** button again to make the cloned objects one. ChilliSkinner attaches the parts in a consistent way, so that the **Morpher** will be able to reassemble the unfolded model properly. Click **Unhide All**.

Select the unfolded model and click the **Apply Planar Map** button in the ChilliSkinner interface. You can use a **UVW Map** modifier for more control if you like, but use this option first (the unfold process does things to the model that cause the **UVW Map** gizmo to be applied in an odd and inconvenient orientation; using **Apply Planar Map** in ChilliSkinner fixes the problem).

From here you can use the same approach as in Tutorial 7–3:

+ Use **Texporter** to create and save a template. If you apply a **UVW Map** modifier, orient and fit it properly, then scale it up by the same 2% as in Tutorial 7–3; the map you created in that tutorial should fit the new model. This also assumes that you used the same dimensions for the box as in Tutorial 7–3.

+ Paint a texture map using the computer case images available on the CD-ROM (or use the texture map you created previously), make a material that uses the texture, and apply it to the box.

+ Apply a **Morpher** modifier, choose the clone object as the morph target, and set the spinner value to 100. Your model should return to its original shape.

EXERCISE 7-3:::

Use Chilliskinner to UVW map your patch model from Exercises 7–1 and 7–2. Then paint and apply a texture map.

Painting Texture Maps

Textures can sometimes be even more effective when created using traditional media, such as oil paints on canvas. Some artists are more comfortable working with these media rather than painting in Photoshop. If you do much work in Photoshop it is highly recommended that you acquire and use a pressure-sensitive drawing tablet. Whether it is a painting or a drawing with chalks or pastels, your texture will almost certainly have a look unlike that usually achieved painting digitally. A scanner is a very useful tool for converting traditionally created art into a digital image—but depending on your medium, be sure to protect your scanner from chalk or paint.

Tony Lupidi has worked as an Art Director in the digital games industry and is a great fan of digital games. One of his favorite games is *Gloom* by Team Reaction (http://www.planetquake.com/teamreaction). Tony got tired of looking at the rather bland texture mapping on the alien insect models and decided to paint his own. Making a new texture for an existing model is often referred to in the mod communities of the various *Quake* games as **skinning**. In this case, Tony had to apply new UVW coordinates to the models to get good results.

Tony worked with the UVWs first, laying them out for planar mapping as shown in this chapter. He then exported a template of the UVWs in the form of an image, also like the process shown in this chapter. He printed the images and used pencil to draw the texture maps. These were then scanned back into digital images and manipulated in Photoshop. Color was added and finished textures were the result. This hybrid method, using pencil for initial drawings and Photoshop for final coloration, is just one of many approaches you can take to achieve good results.

The images that follow show samples of the hand-drawn textures, the final texture maps, and the textures as applied to the bug models. "The Drone" is shown in Figures 7–73 through 7–78. "The Stalker" is shown in Figures 7–79 through 7–83.

7–73 | Model Texture Maps—Anthony Lupidi

7–74 | Model Texture Maps—Anthony Lupidi

7–75 Model Texture Maps—Anthony Lupidi

7–76 Model © 1998–2003 Team Reaction
 Model Texture Maps—Anthony Lupidi

7–77 Model © 1998–2003 Team Reaction
 Model Texture Maps—Anthony Lupidi

7–78 Model © 1998–2003 Team Reaction
 Model Texture Maps—Anthony Lupidi

7–79 | Model ©1998–2003 Team Reaction
Model Texture Maps—Anthony Lupidi

7–80
Model ©1998–2003
Team Reaction
Model Texture
Maps—
Anthony Lupidi

7–81
Model ©1998–2003
Team Reaction
Model Texture
Maps—
Anthony Lupidi

7–82
Model ©1998–2003
Team Reaction
Model Texture
Maps—
Anthony Lupidi

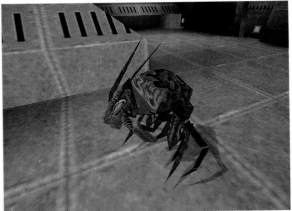

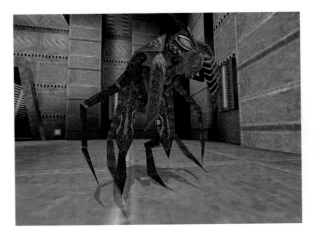

7–83 | Model ©1998–2003 Team Reaction
Model Texture Maps—Anthony Lupidi

:::CHAPTER REVIEW QUESTIONS:::

1. What are the advantages of patch modeling?

2. When is patch modeling a poor choice?

3. What are the advantages of unwrapping the model as described in this chapter?

4. What are the disadvantages?

You have learned to use **Surface Tools** and patch modeling to create complex low poly models. With practice, you can use patches in 3D Studio MAX to make almost any model you need. You have also learned about unwrapping a model for planar mapping, a technique that will allow you to texture map any low poly model.

For many simpler models, you have learned procedural methods that will allow you to build with great control and flexibility in polycount. And you have learned to use **Unwrap UVW** to apply texture coordinates to less complex models. Just as important, you have learned to plan your model and to choose the method most appropriate to the problem at hand.

The most important thing you can do now is practice. Experience will continue to be your best teacher, and by learning from your mistakes, you can continue to improve your modeling skills throughout your career.

CHAPTER

BOX MODELING IN DEPTH

OBJECTIVES

+ Experience box modeling starting with a box

+ Learn a sculptural approach to box modeling

+ Model a complete humanoid character

Introduction

For a true box modeler, most models start as a box. A simple set of tools allows the artist to focus on sculpting the form. For many modelers, this kind of fine control over the modeling process overrides any disadvantages of box modeling.

Mick Lockwood is such a modeler. For Mick, the simplicity of box modeling allows him to forget the tools and focus more completely on the creative process, as in sculpting with clay. A few simple rules are part of a philosophy that guides the modeling process.

One interesting aspect of Mick's approach is that he always makes the most of the polygons currently in the model before adding more detail. Even when the model is still just a box, Mick recommends moving points and edges to best approximate the intended model. Following this approach, and saving different versions frequently, you could, in theory, create many different LOD versions of the model as you progress.

Mick's approach to box modeling involves working in such a way that the model is always made up of quads. As mentioned in Chapter 5, the **Editable Poly** object, or **Poly Object**, doesn't provide for manipulation of hidden edges, and therefore encourages the user to work with quad polygons. It also makes it easier to work with a model as quads. Figure 8–1 shows two box primitives, one converted to **Editable Mesh** and the other to **Editable Poly**. Figure 8–2 shows the result after a slice operation has been performed on each box. **The Editable Poly** object is still made up of quads, while the **Editable Mesh** object has a much less convenient arrangement of triangular polygons. This is a key advantage of the **Editable Poly** object.

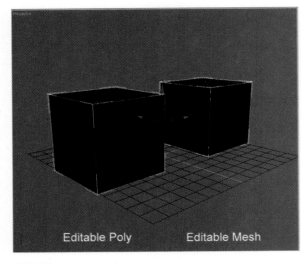

8–1 Editable Mesh vs. Editable Polys

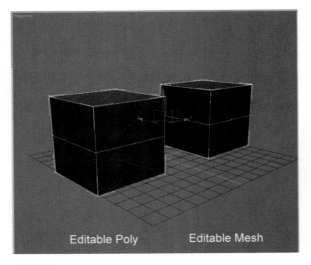

8–2 Editable Mesh vs. Editable Polys

The rest of this chapter was written by Mick Lockwood, and reveals his approach to, and philosophy of, box modeling. (It has been edited to fit the style of this book.) You will be led through the process of box modeling a complete, animatable game character.

Flow, Structure, and Quads

Polygon modeling demands that geometry be created in a clean, flowing, economic manner. It is the goal of the modeler to produce the best possible form using the least amount of geometry. Every time the modeler splits an edge and adds another polygon the data must be justified. It's too easy to get carried away and add unnecessary polygons to try and quickly describe a new area. Each time you create a vertex it should be placed in its optimum position before any more detail is added. The whole process becomes a geometric puzzle; you know that the optimum topology is possible—it's up to you to create it.

There is great satisfaction in looking at a model you have built that has real beauty in its natural flow (Figure 8–3).

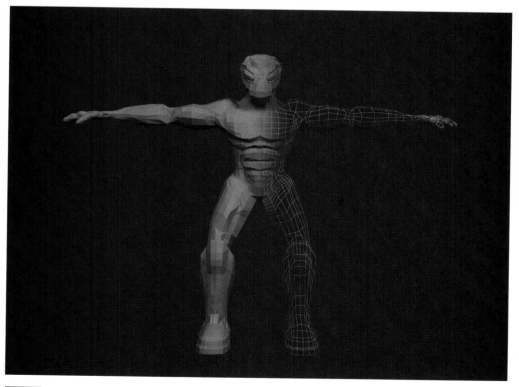

8–3 Flow and structure

MODELING IN QUADS:::

There is a school of thought that says that all models should ideally be constructed solely from quads, and that isolated triangles within a mesh should be avoided. There are a number of very good reasons why you should try to always work in quads. There will undoubtedly be areas within a mesh where including triangles is unavoidable, such as in shoulders, which are complex areas within character models.

Modeling in quads allows you to lay out the structure of your geometry neatly in rows and columns. Constructing topology in this uniform manner allows detail to be added quickly. Rings and loops of additional geometry can be added with great ease, a fact that will become apparent in the tutorial in this chapter. This uniform structure also helps if the model is being split to be laid out for texturing.

PROGRESSION OF DETAIL:::

A quad model, as described in this chapter, is a progression from low to high detail. The same low poly model can evolve, if required, into a highly detailed model (see Figure 8–4). With this in mind it is important to save a version of your model each time you define a new major area of detail. This gives you a range of meshes at various stages.

8–4 Progressive Levels of Detail

SUB-DIVISION:::

Quads work better than triangles with sub-divisional algorithms. A quad model will produce a far cleaner sub-divided surface than a model constructed from triangles. **Sub-division** is a process whereby a high poly model is derived from a low poly mesh. The software achieves this by actually dividing each polygon into two or more new polygons. The result is a more detailed, smoother surface (see Figure 8–5). In game production, a high-poly model may be required for a cut-sequence, pre-rendered animation, or still artwork for marketing purposes.

8–5 Sub-division of a model

Modeling with quads will give far better results when it comes to animating the model. If the topology is created in this way it is far more likely to look natural when moved and repositioned. This is very much the case even in very low polygon models. See Figure 8–6.

8–6 Geometry deformed for animation

It is important for facial animation to have the geometry of the model follow the form of the muscles of the face. Having a uniform quad layout allows the user to easily define useful **Edge Loops**. Edge Loops are circular patterns in the geometry that can be used in some software to aid in animation (see Figure 8–7). Once the edge loops have been defined, adjusting them lets you manipulate the model as if you were moving the underlying muscles.

8–7 Edge loops

CONTOURS AND SILHOUETTE:::

A model's structure is made up of many edges, which in turn create contours. Various contours are highlighted in red in Figure 8–8. The shape and relationship between these contours is what defines the 3D form. As the model is rotated, these contours produce silhouettes. To understand the form as you model, you will likely rotate the model and observe and adjust these silhouettes from every angle. Once these contours and silhouettes begin to look right from all points of view you know you're heading in the right direction.

8–8 Contours and silhouettes

ECHO:::

There is echo in form everywhere in the natural world, and as you create natural form in the digital world you find it here as well. It's important to look at and develop the rela-

tionship between the contours that form the model. Step back and look for the echo of form that should flow though the model. When you find yourself lost and begin to feel as if you're losing control of the mesh, stop looking at the model as a whole and just spend some time developing the echo and relation in the contours; in no time you'll be back on track.

8–9 Echo in contours

Getting into the Zone

Modeling with the aid of Meshtools offers a real opportunity to work in a fashion more like that of a traditional sculptor. In addition, there are options in MAX that can help. By switching to **Expert Mode** (Ctrl-X) you can remove the toolbars, menus, and icons, relying instead on **quad menus** and keyboard shortcuts. Quad menus open when you right-click in a viewport. Working without the toolbars, menus, and icons reduces potential distraction and makes a larger workspace available, allowing you to get into a natural work flow and really focus.

For the newcomer the thought of learning shortcuts can be daunting, but the truth is there's very little to learn. If you set your mind to it you can be working in a fluid expert manner in a short time. A good way to learn is to buy a second keyboard and paint the keys or stick markers onto them. This process alone will probably be enough to teach you what you need to know.

The first step is to become familiar with navigating using the keyboard shortcuts. Create a simple object like a cube and spend half an hour zooming, rotating, and panning the camera in the viewport until it becomes second nature. Not having to rely on the icons at the bottom right of your screen each time you switch between zoom, rotate, and pan really gets things flowing. Try using **Zoom Extents** as well. These four shortcuts will likely be among the most used:

> Pan = Ctrl + middle mouse button
>
> Zoom = Ctrl + Alt + middle mouse button
>
> Rotate = Alt + middle mouse button
>
> Zoom Extents = Ctrl + Alt + Z

When you've mastered these shortcuts in **Expert Mode**, try selecting the object in the viewport, manipulating and repositioning it. To do this select **Move**, **Rotate**, or **Scale** from the quad menu (Figure 8–10).

Once you have installed the plugin, Meshtools options will also appear with the quad menu. Instructions for installing Meshtools will be provided later in this chapter.

8–10 The quad menu

Later in this section you will find a list of shortcuts that will need to be configured to effectively work in Expert Mode with Meshtools. These shortcuts are used in the tutorial in this chapter. Some of these shortcuts are assigned by default and others are not. Use the following steps to configure shortcuts, going through the list checking and assigning each one in turn.

8–11 The Customize User Interface window

From **Customize**, select **Customize User Interface**.

The **Customize User Interface** window will appear. There are five tab selections running along the top of the window. By default it will open with **Keyboard** selected. From here you can assign keyboard short cuts. The actions associated with the short-cuts are listed in the left-hand window. These actions can be filtered by **Group** and **Category**. In this case just leave the default **Main UI** and **All Commands** selected.

Shortcuts can be assigned or removed by typing the desired hotkey next to **Hotkey:**. If the key is already assigned to an action, that action will appear under the **Assigned to:** window. If you wish to remove this shortcut, scroll down in the **Action** list, select the assigned action, and click the **Remove** button. To assign a different action to that hotkey, select the new action from the list and click **Assign**. Once all the shortcuts have been configured, close the **Customize User Interface** window and test them.

Within the **Customize User Interface** window you also have the option to save your shortcut configuration; to do this select **Save** at the bottom of the window. If you have any problems with your shortcut configuration, you can click **Load** and choose "DefaultUI.kbd". This will get you back to the default settings.

In 3D Studio MAX version 5, these shortcuts are assigned by default.

Ctrl + X = expert mode toggle

F2 = toggles shade selected faces
F3 = toggles shaded/unshaded
F4 = toggles show edges

1 = sub-object level 1 (vertex)
2 = sub-object level 2 (edges)

3 = sub-object level 3 (border)

4 = sub-object level 4 (polygon)

5 = sub-object level 5 (element)

F = front view

L = left view

R = right view

T = top view

K = back view

B = bottom view

P = perspective user view

Space = maximize viewport toggle

Ctrl + Alt + Z = zoom extents

W = weld vertex (poly)

N = NURMS (toggle poly)

X = transform gizmo toggle

Meshtools

Meshtools is a plugin offering a set of additional tools, created by Laszlo Sebo. This toolset complements the existing tools associated with Poly Objects in 3D Studio MAX. The tools mimic those found in other packages such as Nichimen's Mirai. The toolset is made up of a number of selection and geometry editing tools. All of these additional tools can be assigned to the quad menu and quickly accessed while modeling simply by right-clicking within the viewport.

The most useful tools I find are the *Edge Ring* selection tool and the *Connect* tools. *Edge Ring* allows selection of edges as shown in Figure 8–12. This group of selected edges can then be split using the *Connect* tool. Having these two tools on your quad menu allows for geometry to be split and divided very cleanly and quickly.

8–12 | *Edge Ring* selection and *Connect* tools

There are many other powerful tools in the set. The best way to understand them is to read the documentation and install, configure, and use them. The following section describes how to install these tools and assign them to your quad menu.

CONFIGURING MESHTOOLS:::

The following steps describe the process of installing and configuring the tools so they become accessible in the quad menu.

If you have installed any version of Meshtools before, follow the installation instructions which can be located in the form of a readme file that comes packed in the Meshtools zip file (*Meshtools_2_5.zip*), available on the CD-ROM. If you have never installed any version of Meshtools, do the following:

+ copy "Meshtools-Functions.ms" to 3dsmax#\stdplugs\stdscripts (where 3dsmax# is your 3D Studio MAX directory)

+ copy "Meshtools-Macroscripts.mcr" to 3dsmax#\ui\macroscripts

+ copy the new icon files (all .bmp s) to 3dsmax#\ui\icons and 3dsmax#\ui\discreet

Select *Customize>Customize User Interface*. The *Customize User Interface* window will open. Select *Quads* from the five tab options along the top. The quad configuring panel will now open. Here you can configure all the quad menus.

Within the *Category* pull down menu, scroll down and click on *Meshtools*. A list of the Meshtools will now appear in the *Action* window. See Figures 8–13 and 8–14.

8–13 | Customizing menus for *Meshtools*

8–14 | Customizing the quad menu for *Meshtools*

The next step is to select the correct quad menu on the right-hand side of the configuration window. First highlight the bottom left square of the four available so it is illuminated in yellow (as in Figure 8–15). All the sets of tools associated with the various modeling techniques appear in the window below.

Open the list titled **Context Edit Poly Tools** by clicking the small **+** in the box next to it.

The tools now displayed in the list are those that appear in the bottom left corner of the quad menu when editing an Editable Poly object.

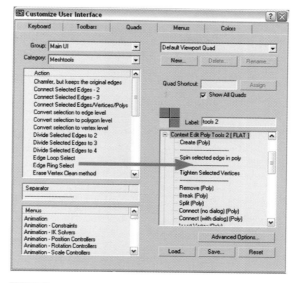

8–15 Customizing the quad menu for **Meshtools**

To add the new Meshtool to this quad menu simply drag and drop them from the Action Window on the left-hand side into the window on the right. The tools can be arranged in any order and separated with a line by adding a separator (Figure 8–16), found directly under the **Action** window.

8–16 Customizing the quad menu for **Meshtools**

It is up to you as to which tools you want to use and the order in which you want to use them. The first time you install the tools, drop all of them into the quad menu in the order they appear in the **Action** window, separate them by category (for example, selection tools/geometry changing tools) with a separator. Over time you will discover which tools you use the most, and you can then go back and reconfigure the setup.

When your menu has been configured, close the **Customize User Interface** window, create a Poly Object, and try your new menu to confirm that your quad menu is set up correctly.

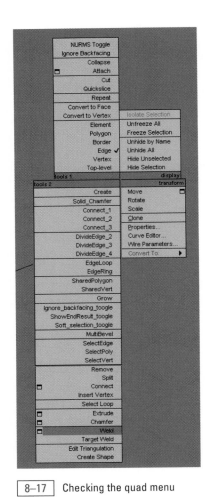

8–17 | Checking the quad menu

Create a Standard Primitive Box: **Create Tab>Geometry>Standard Primitives>Box**. Convert this geometry into an **Editable Poly** object.

Move over to the **Modify** panel and select **Edge** sub-object.

In the viewport, right-click and you will see all the Meshtools displayed in your quad menu.

Take some time to experiment with the toolset to get some initial insight as to how each one functions.

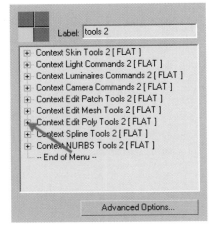

8–18 | Checking the quad menu

TUTORIAL 8–1: BOX MODELING WITH MESHTOOLS:::

Workflow

In this tutorial, you will:

- Use familiar tools such as extrusion of polygons to build your model.
- Learn to use new tools provided by Meshtools to build and refine the shape of your model.

In this tutorial you will experience Meshtools, learn some of its features, and model a game character.

Before you begin modeling the character you first need to set up a number of reference images within the scene. These will act as a visual guide as you begin to model. In this case you will be using a front and side view sketch of the character. Each image will be mapped onto a thin plane of geometry, one of which will lie on the x axis and the other on the y.

The two reference images are available on the CD-ROM as *TROOPER FR.jpg* and *TROOPER SD.jpg*.

The images in Figure 8–19 started out as a rough sketch. I took a male reference image to ensure scale and designed some armor around it. When I was happy with the results I scanned the image and vector traced it in Adobe Illustrator to tighten it up. This step isn't strictly nec-

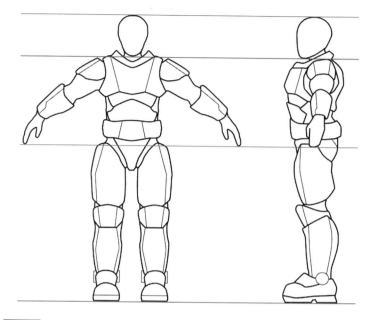

8–19 Reference drawings

essary; you could opt to use original sketch. I simply prefer a cleaner image to work with. From Illustrator I pasted the vector lines into Photoshop and cut, cropped, and sized them to create the two finished images needed. The important thing here is to ensure that each image is the same height and that each is lined up and to the same scale. When you're ready to save your images for use in 3D Studio MAX, make a note of their dimensions, as you'll need this information for the next step.

Setting Up Reference Objects Within the Scene

Now that you have two reference images, you will create geometry onto which they'll be mapped and made visible within the viewports. You must first create two pieces of geometry sized relative to the dimensions of each image.

Open 3D Studio MAX and set the working units to generic: ***Customize>Units Setup> Generic Units.*** Then select the top viewport and make a box.

You will now adjust the size to match your front reference image. The front reference image is 250mm × 185mm. The proportion of width to height is what is most important, so a box of 185 units wide by 250 units high will do.

Switch to the front viewport and toggle on the grid, if it's not already visible, by using the keyboard shortcut G. Center the box by eye, and move over to the **Modify** panel. Resize the box in the **Parameters** rollout to match your front reference image, 250 units in height and 185 units in width, as you only require a thin plane to give the object a length value of 1.

8–20 Adjusting reference geometry

Next add a **UVW Map** modifier, and use planar mapping to insure correct alignment of the reference texture. Select Y under **Alignment** and click **Fit**.

8–21 Mapping reference geometry

In the **Material Editor** create a new material using the front reference map and apply it to your reference box.

8–22 Assign Material to Selection

Be sure that **Show Map In Viewport** is activated.

8–23 Show Map In Viewport

You should now see something like Figure 8–24 in your perspective viewport.

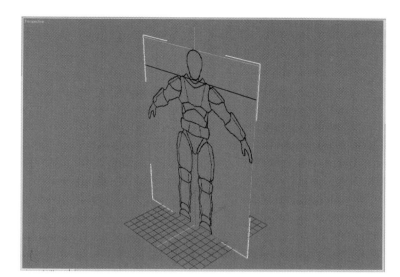

8–24 │ First reference geometry

Now that the front reference image is set up in the scene, you need to go though a similar process to bring in the side reference image. Set your rotational snap to 90 degrees by right-clicking the rotational snap icon on the main tool bar (see Figure 8–25) and setting the **Angle (deg)** to 90 (see Figure 8–26).

8–25 │ Setting angle snap

Close the dialog box and activate the snap by clicking the snap icon with the left mouse button.

Move back to the perspective window and select the front reference geometry. Right-click and select **Rotate**. Hold down shift and rotate the geometry 90 degrees in the vertical axis, creating a copy of your geometry. A **Clone Objects** dialog box will appear; select **Copy** and click **OK**.

8–26 │ Activating angle snap

You now need to resize the newly created geometry to match your side reference image. Go to the **Box** level underneath the **UVW Map** modifier in the stack and change the width to 58. Now go back up the stack to the **UVW Map** modifier and click **Fit**.

The side reference geometry is now ready to be textured with the side reference image. You should now see something like Figure 8–27 in your perspective viewport.

Open the **Material Editor** and make a new material using TROOPER SD.jpg as a **Diffuse Color** map, and apply it to your box.

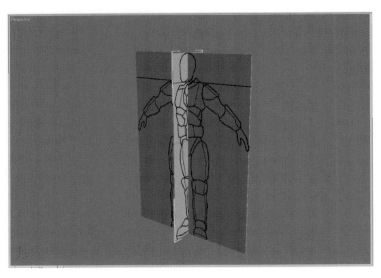

8–27 | Front and side reference

At this point it is worth pointing out a couple of things that will make your life a little easier during the modeling process.

Named Selection Sets

First, you should make these two reference planes into a selection set. This way you can easily select them at any time independent of anything else that might be in your scene. Select both objects and move up to the **Named Selection Sets** tab located on the main tool bar (see Figure 8–28). Simply click in the open space and type "Reference," and hit return to create the newly named selection set. Now at any time you can click the **Named Selection Set** tab and select this named set.

8–28 | Named Selection Sets

Freezing Reference Objects

Once you have the reference placed and textured within your scene you need to freeze it. This prevents you from accidentally selecting and moving it as you work with the other geometry.

Select the geometry and right-click. In the menu that opens, click **Properties**. In the **General** tab, under **Display Properties** be sure that **Show Frozen in Gray** is unchecked. Click **OK**. Then right-click and choose **Freeze Selection**. This object is now frozen in the viewport, and cannot be selected until you either choose it from the **Named Selection Set** menu, or right-click in the viewport and select **Unfreeze All**.

PREPARING THE BOX:::

Select the front viewport and drag out a box from the origin to the right. See Figure 8–29.

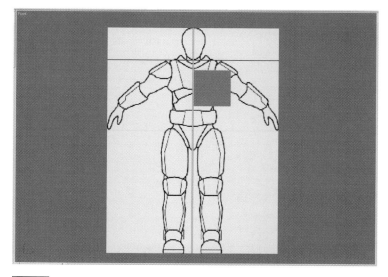

8–29 Starting with a box

Resize the box, giving it dimensions of 40, 40, 40. Position it with its left edge along the vertical axis just over the chest region of the reference plane.

At this stage it's a good Idea to define some color for your geometry. I tend to color the geometry I'm sculpting as gray with green edges. These contrasting colors make it easier to read the form of the model. Change the color of the geometry by double clicking on the colored square next to its name in the **Modify** panel and choosing green from the color menu. Now open your material editor and choose a standard gray material from the next available slot. Assign this material to your box. The geometry color will define the edges while the material will determine the faces.

Now turn the box into an **Editable Poly** object (select the box, right-click, **Convert to Editable Poly**).

In the **Modify** panel go to **Vertex** sub-object and activate **Ignore Backfacing** in the **Selection** rollout.

8–30 Ignore Backfacing

Ignore Backfacing will prevent you from selecting elements behind the ones you intend to select. You can spend a lot of time working with your model only to find later that you've been inadvertently moving vertices behind the ones you meant to.

Go back to the **Perspective** viewport, and with the cube still selected, right-click and choose **Hide Unselected**. This will hide everything but the cube.

8–31 Sub-object Polygon

Go to sub-object **Polygon**.

Select the polygon facing in the direction of –x, and press Delete on your keyboard. As you will be mirroring this piece of geometry you don't need this inner face.

8-32 | Unneeded polygon

HIGHLIGHTED FACES/POLYGONS:::

It's a good idea to configure your viewport so that any selected faces are highlighted in red. The reasons for this are not that obvious at this early stage, but as your model becomes more complex, being able to see your selection clearly is most helpful. To configure your viewport right-click over the word **Perspective** in the top left-hand corner of the viewport, select **Configure** from the bottom of the popup menu. In the **Render Method** tab, under **Render Options** be sure that the **Shade Selected Faces** check box is activated.

REMOVING SMOOTHING GROUPS:::

When you create a new piece of primitive geometry it automatically has a **smoothing group** assigned to it. Smoothing groups allow an object made up of flat faces to be rendered as a smooth surface. Without smoothing groups, all objects would look as if rendered with faceted shading.

It is recommended that you remove smoothing groups before box modeling. This is an alternative to setting your viewport to display **Faceted**, and can be more convenient. Return to the **Modify** panel and uncheck **Ignore Backfacing**.

In **Polygon** sub-object, select all the polygons of the cube. Scroll down the **Modify** panel to **Polygon Properties** and click the **Clear All** button under **Smoothing Groups.** This removes any smoothing groups assigned to your geometry.

8-33 | Clearing smoothing groups

Because the character you will be modeling is symmetrical you need only model half of it. The common practice is to mirror an instance of the geometry you are modeling. As you may recall, with instance objects whatever is done to one instance is replicated in real time in the other.

Select the box and click the **Mirror** icon on the main toolbar. Within the dialog box select **X** for the **Mirror Axis** and **Instance** under **Clone Selection,** and click **OK**. The original geometry will be copied and mirrored along the x axis. **Move** the box over, aligning its right edge with the center axis. See Figure 8–36.

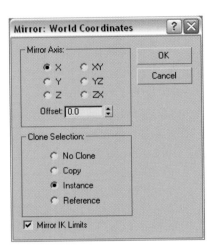

8–35 | Mirror parameters

8–34 | Mirror icon

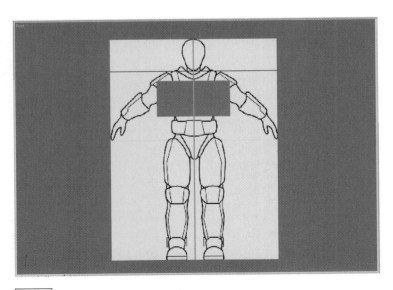

8–36 | Starting box and mirrored instance

MODELING THE TROOPER:::

You will now develop the form of your character step by step using the tools mentioned earlier.

Switch to the front viewport by hitting *F* and select the right-hand box. Right-click and go to: *Properties>General—Display Properties*.

Within the **Display Properties** window turn off **Backface Cull** and turn on **See Through**. Click **OK**.

The box will now become see-through and you should be able to see the backface of the geometry. The front image plane needs to be moved backwards so it's not intersecting with the box. Switch to the **Right** viewport. Right-click and select **Unfreeze All**. You will now be able to select the front reference plane that was frozen earlier. Move the plane back until it is behind the side reference geometry.

8–37 Display properties

8–38

Adjusting reference geometry

Select the selection set named "Reference" established earlier by choosing it from the Selection Set pulldown menu. This will select both reference planes. Right-click and activate **Freeze Selection**.

Move back into the **Front** viewport. Press Ctrl-X to activate Expert Mode. Select the right box and press *1* on the keyboard to go to **Vertex** sub-object. Switching between the **Front** viewport by pressing *F* and the right view by pressing *R*, begin to shape the box to match the basic form of the upper chest region of the character's armor.

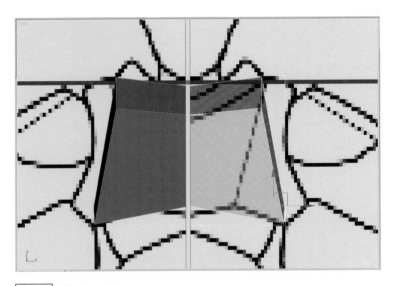

8–39 | Shaping the box

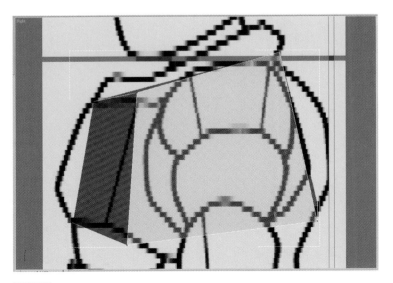

8–40 | Another angle

As you are developing the form of the model, frequently switch to the **Perspective** viewport by pressing *P*, and revolve the geometry to review from every angle until you are sure you have made the most of each vertex.

The next step is to extrude the right-hand face of the box to develop the shoulder area. Press *4* on the keyboard to switch to **Polygon** sub-object. Select the far right-hand face.

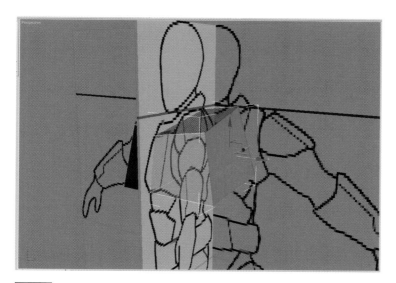

8–41 Polygon selected for extrusion

Right-click and select **Extrude** from the lower right quad menu. Hold down the left mouse button and move the mouse up, extruding the polygon out.

8–42 Extrusion

Return to *Vertex* sub-object by pressing *1*, and switch between the viewports developing the form of this newly created geometry.

8–43 | Adjusting the form

Once the new geometry has been adjusted, switch to the *Perspective* viewport by pressing *P*, and rotate the model around to select the lower left polygon.

8–44 | Next extrusion

Extrude the polygon downward. Again press *1* to activate *Vertex* sub-object. Switch between the viewports and work to develop the form of this new piece.

8–45 | Further extrusion

Repeat these steps to slowly block out the initial form of the character, being sure to make the most of each new piece of geometry before moving on to extrude another. It's always worth just stepping back from the model and looking at its form. As you add more and more geometry you may want to go back and refine early parts, continuously developing the shape. There is always room for improvement.

Work down the model step by step developing the abdominal area. Geometry can also be manipulated using both the scale and rotate tools.

8–46 | Torso progresses

8–47 Torso progresses

8–48 Torso progresses

Save your work frequently.

In Figure 8–48, the model has been developed as far as the groin area and the first section of geometry has been defined for the leg. This would be a good point at which to delete the unwanted polygons that have been created on the inner surface by repeatedly extruding. Hide one half of the model, and remove any internal polygons, as shown in Figure 8–49. You may need to unfreeze and hide one or both reference boxes to see them.

8–49 | Deleting interior faces

Now continue to extrude down the leg, working and shaping the form of the thigh, knee, leg, ankle, and foot.

8–50 | Sculpting the leg

8–51 | Sculpting the leg

When the legs and feet have been blocked out the attention turns to the shoulders and arms. Select the outer polygon protruding from the side of the chest, as shown in Figure 8–52, and begin to extrude, constructing the shoulder and upper arm.

8–52 | Extrusion starts the arms

As you develop the shoulder area remember to keep observing the form and shape from every possible angle. Look at the flow of the geometry; make the most of each vertex. You might want to hide the reference images from time to time and toggle *See-Through* on and off to gain a better view and understanding of the form.

| 8–53 | Shoulders

Work your way down the arm and loosely block out the hands.

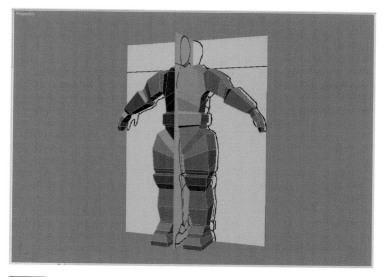

| 8–54 | Forearms and hands

Once the body has been blocked out the attention turns to the neck and head. Select the topmost polygon, extrude it, scale it down, and draw it into the body. The **Scale** and **Move** tools can be accessed in the **Transform** section of the quad menu.

8–55 | Neck

Scaling geometry can draw vertices out from the central axis of the character; it is important to watch for this, and to move them back into line with the center. First, delete the unwanted polygons that have been created during extrusion on the inside edge.

8–56 | Unneeded polygon

Figure 8–57 shows two vertices of the top polygon that have been pulled off-center due to the scale operation.

8–57 | Vertices away from central axis

Meshtools allows you to align all the vertices on the center edge whenever they go astray during the modeling process.

Select **Border** sub-object by pressing *3* on the keyboard, and select one of the central edges, as in Figure 8–58. This will select all of the center edges of the model.

8–58 | Edges selected for alignment

Right-click, and from the lower right quad menu select **Shared Vert**. This will select all the vertices that share this center edge. Right-click once again, and from the same menu select **Flatten X**. All of the vertices will be aligned. Switch back to the **Front** viewport, toggle on the grid by hitting *G*, and move these selected vertices over onto the central axis.

With a series of extrusions, and repositioning of the vertices, block out the head shape.

8–59 | Forming the head

8–60 | Forming the head

At this stage the basic form of the character has been blocked out and it's a good time to step back from the model and look at the overall topology. Before adding any more detail, observe the model from every angle and develop the form as much as possible. Manipulate the vertices until you are sure each one is in its optimum position.

Press *2* on the keyboard to activate **Edge** sub-object, and select the edges down the front of the leg. Release Ctrl and hold down Alt-MMB (middle mouse button). Rotate the model so you can see the underside of the foot, hold down Ctrl, and select the edges that run across the underside of the foot. Hold Alt-MMB and rotate the model around to the back of the leg. Hold Ctrl again and select the edges running up the back of the leg to just underneath the buttocks. See Figure 8–61.

8–61 Edges selected for connect operation

When all of these edges are selected, right-click, and from the bottom left quad menu select the Meshtool function **Connect 2**.

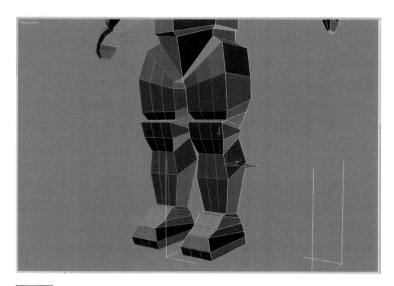

8–62 Result of Connect 2

As you can see in Figure 8–62, the selected edges have been divided evenly with two new edges, creating a number of new polygons. You must now adjust the vertices to form this newly added detail. After a good deal of pushing and pulling of vertices, the legs will begin to take shape. See Figure 8–63.

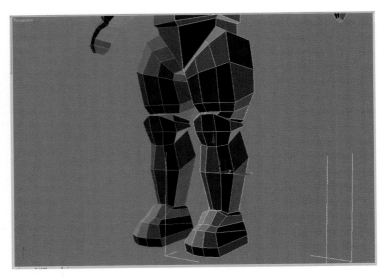

8–63 | Shaping new vertices

You will now add detail to the inside and outside of the leg. Select the right portion of the model, right-click, and choose **Hide Unselected**. Rotate the model so you can see the

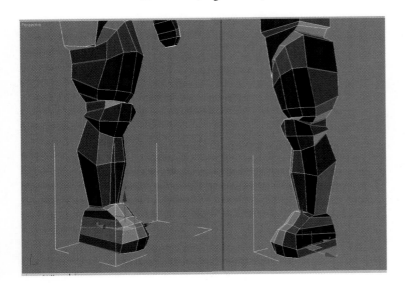

outside edge of the leg. Go to **Edge** sub-object, and while holding Ctrl, select the edges down the side of the leg from were they meet the body downwards. When you have selected all the edges on the outer side, release Ctrl and hold down Alt-LMB (left mouse button) to rotate around to the underside of the foot. Hold down Ctrl once again and select the edges under the foot. Repeat this procedure one more time and rotate around to the inside of the leg, selecting the remaining edges. See Figure 8–64.

8–64 | Preparing for another connect operation

Once all of these edges are selected, choose **Connect 1** from the bottom left quad menu. All of the selected edges will be divided, creating a number of new polygons.

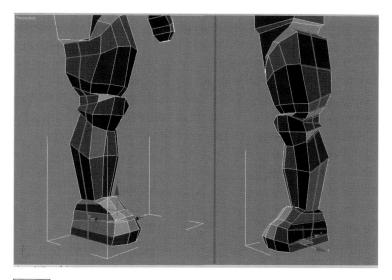

8–65 | After Connect 1

This new geometry should now be shaped to form the body armor plates of the characters' legs and boots. Manipulate the vertices, observing the shape from every angle. After getting the most out of the current level of detail you will discover that in order to define the foot and ankle areas correctly additional detail is required.

Three extra pieces of detail need to be added. The first is a division running around the front of the foot, and up and over the tongue area of the boot. The second is a ring division around the middle of the foot. The third is a vertical division over the ankle area running up into the side of the leg.

First, select the front set of edges on the side of the foot and the top edges in the tongue area, as in Figure 8–66. Rotate the model to the opposite side and select the edges. Rotate the model around once more to select the edges on the sole of the foot.

8–66 | Preparing to add detail

When the full ring of edges is selected, do a **Connect 1.**

8–67 | Result of Connect 1

Work with the new geometry to define the front bulge of the foot and draw the tongue area up a little over the shin.

For the second addition, rotate the foot around and select a front edge.

8–68 | Edge selected

Right-click and select **Edge Ring** from the bottom right quad menu. This will select a ring of edges perpendicular to the original selection. See Figure 8–69.

| 8–69 | Result of Edge Ring operation

Perform a **Connect 1** to split the selected edges.

| 8–70 | After Connect 1

Spend some time working this new geometry into its optimum form before moving on.

Add more detail to the back half of the foot to define the Ankle. Hit *2* on the keyboard to select **Edges**. Rotate around to the back half of the foot and select a horizontal ring of edges from where the foot meets the shin/calf, around and under and to the opposite side.

8–71 | Adding detail

Connect 1 to connect these edges.

8–72 | Connect 1 again

Because the edge division stops at the top of the foot, there is a new vertex in the center of the edge at that point (and on the opposite side of the foot as well). This creates a sit-uation where the polygon above, in the shin, is no longer a quad, but a five-sided polygon. To keep the topology clean and well organized, turning that poly into a quad and a triangle is preferable.

Hit *1* to switch to **Vertex** sub-object and press *R* to move into the **Right** viewport. Hold down Ctrl and select the newly created problem vertex and the one on the left, midway up the shin. See Figure 8–73.

With these two vertices selected, right-click, and from the bottom left quad menu select **Connect 1**. A new edge will be created connecting the two vertices.

At this point introduce a cylinder, which will define the hinge where the foot and the shin and calf armor meet. Press Ctrl-X to come out of Expert Mode. Hit *R* on the keyboard and zoom in on the ankle area in the **Right** viewport.

8–73 | Cleaning up

8–74 | Connecting two vertices

Create a cylinder in the ankle area and switch between the viewports to size and position it. With the cylinder in place, spend some time working on the foot area of the model until you are satisfied with the form.

8–75 | Ankle cylinder

This may be a good time to consider assigning some color to your geometry to aid the development of the form. Breaking up the model by defining areas with color can really help when developing form. Select the polygons of the sole of the foot and shin area, as in Figure 8–76. Open the **Material Editor** and create a new material, in this case a black material with no maps. Assign the material to the selected polygons.

8–76 | Coloring parts

Move up to the knee and add a little detail to help define the top of the knee protector. Select the four edges on the top of the knee, as in Figure 8–77.

8–77 | Defining knee armor

Use **Connect 1** to split the edges.

8–78 | Edges split

Tidy up the topology by splitting the newly formed five-sided poly into a quad and a tri. See Figure 8–79.

8–79 | Splitting a five-sided poly

Select the two vertices shown in Figure 8–79, and choose **Connect 1** from the quad menu.

8–80 | Sculpting the knee armor

Sculpt the knee area using the newly created geometry.

Now move to the chest and arms. Press *F* to move into the front viewport and position the view so the chest and arm are visible. Press *2* on the keyboard to activate the **Edge** sub-object and select the chest plate center edge. See Figure 8–81.

| 8–81 | Selected edge |

Right-click and select **Edge Ring** from the lower right quad menu. This will select the edges shown in Figure 8–82, allowing you to add detail to the arms.

| 8–82 | Edge ring selection |

Use **Connect 1** to split these edges.

8–83 | Connect 1

Adjust the new vertices as shown in Figure 8–84.

8–84 | Using the new detail

Next add some detail into the top of the legs. Rotate the model around so that the top of the leg is visible. Hit *2* to activate **Edge** sub-object and select an edge at the top of the leg. See Figure 8–85.

8–85 | Selected edge

Use **Edge Ring** to select all of the edges around the model, as shown in Figure 8–86.

8–86 | Edge ring

Connect 1 to split the selected edges.

8–87 | Connect 1

Draw the newly created vertices inward to define the top of the leg armor, as shown in Figure 8–88.

8–88 | Vertex adjustments

Select the appropriate edges in the groin area and use **Connect 2** to add new edges, as shown in Figure 8–89. There will be five-sided polygons at the top of the leg armor and at the bottom of the groin. To add edges between them, select the appropriate vertices and use **Connect 1** to create a new edge bridging the open vertices.

8–89 | Added detail

Select the poly shown in Figure 8–90.

8–90 | Poly selected for extrusion

Extrude the selected poly.

8–91 | Extrusion

An extra polygon facing into the center of the model is created. Also select the other two polys shown selected in Figure 8–92. Delete these polys. You will next close the gap created in the groin area.

8–92 | Unneeded polys

Hit *1* to activate **Vertex** sub-object. Right-click and select the small black and gray box next to **Weld** in the lower left quad menu.

tools 2
Create
Solid_Chamfer
Connect_1
Connect_2
Connect_3
DivideEdge_2
DivideEdge_3
DivideEdge_4
EdgeLoop
EdgeRing
SharedPolygon
SharedVert
Grow
Ignore_backfacing_toogle
ShowEndResult_toogle
Soft_selection_toogle
MultiBevel
SelectEdge
SelectPoly
SelectVert
Remove
Split
□ Connect
Insert Vertex
Select Loop
□ Extrude
□ Chamfer
□ Weld
Target Weld
Edit Triangulation
Create Shape

8–93

Opening the Weld Vertices dialog

This will access the **Weld Vertices** settings. Set the **Weld Threshold** to 50 and hit **OK**. If the vertices don't weld, set the value higher and try again.

8–94 Setting Weld Threshold

Select the vertices labeled "1" in Figure 8–95, and press *W* on the keyboard to weld. Repeat the process for the vertices labeled "2."

8–95 | Vertices to weld

8–96 | After the weld

Now use *Edge Ring* to select the edges shown in Figure 8–97, and divide them using *Connect 1*.

8–97 Edge Ring and Connect 1

Rotate the model around and add some further detail to help define the buttocks. Select the edges to be split and use *Connect 1*. Divide the resulting five-sided poly by creating a new edge between vertices shown circled in Figure 8–98. Remember that you need to do this on the other side of the new edges as well.

8–98 Dividing the five-sided polygon

Work to shape the pelvic region to your satisfaction using the newly added geometry.

You can detach the head in order to model it separately—select all the polygons that make up the head.

8–99 | Polys of the head

Hit Ctrl-X to come out of Expert Mode. Scroll down in the **Modify** panel and locate the **Edit Geometry** rollout. Click **Detach**.

The **Detach** window opens; give the detached geometry the name "Head" and click **OK**.

A tutorial on modeling the head is available on the CD-ROM—see *MODELING THE HEAD.doc*.

8–100 | *Detach*

8–101 | Name detached geometry

Reselect the body and move to a closer view of the arm. Select and split edges as shown in Figures 8–102 and 8–103. Tidy up the topology by adding an extra edge connecting the two vertices circled in Figure 8–102 (select the two vertices and use **Connect 1**).

8–102 Tidying up the geometry

8–103 Dividing edges

Add some detail to the chest area to allow it to be shaped correctly. Select the relevant edges and use **Connect 2** to split them. See Figure 8–104. Create edges between vertices as necessary to divide five-sided polygons, and keep the topology orderly.

8–104 | More new edges

Sculpt the chest plate before moving on.

Now move to the shoulder area and add two rings of geometry to define the gap between the chest plate and back plate (see Figure 8–105). Adjust the new vertices.

8–105 | More new edges

To add more detail to make a shoulder pad, rotate around to a top view of the shoulder. Select a ring of edges as shown in Figure 8–106.

8–106 | Edges for shoulder pad

Connect 2 to split the edges as shown in Figure 8–107.

8–107 | New edges

Assign color to the polys to help visualize the shoulder pads, and sculpt the new detail. To keep your geometry quads or triangles, create new edges as shown in Figure 8-108.

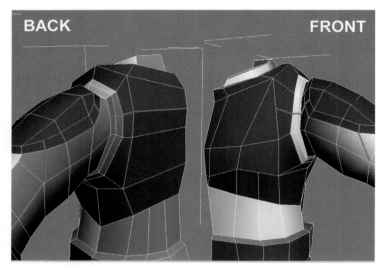

8–108
New edges

You should now have enough vertices. Look the model over carefully, adjusting the form. Pay attention to the hands and the neck opening of the chest plate. Your model at this stage should look something like that in Figure 8–109.

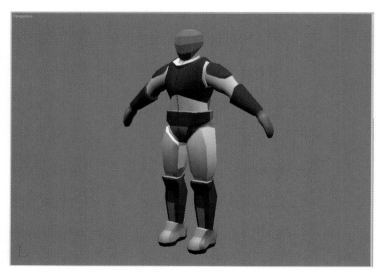

8–109
Trooper model

You can now delete the instance object, and mirror a copy instead. You should then be able to attach the two halves of the body and weld the vertices along the center edge.

:::CHAPTER REVIEW QUESTIONS:::

1. Name a few of the tools offered by Meshtools.

2. What is the function of Edge Ring?

3. What is the function of Connect 2?

You have now built a complex humanoid form using box modeling, and learned about Meshtools and several of the tools it adds to your box modeling arsenal. As with any modeling approach, your box modeling skills will improve with practice.

Mick's tutorial for modeling the head of the alien trooper is available on the CD-ROM. See the file named MODELING THE HEAD.doc.

APPENDIX
CHOOSING THE RIGHT
MODELING APPROACH

Flow Chart—
The Right Modeling Approach

The flow chart in Figure A1–1 shows the decision-making process you may use as a result of what you have learned in this book. You may have all the knowledge necessary to make decisions about the best modeling approach for a particular model, but this flow chart may provide a different way of thinking about the process. It should also be a useful review of what you've learned about modeling in this book.

The flow chart is arranged in columns. To use it, start with the left column and ask yourself the questions posed in that column. The answer should lead you to the appropriate choice in the next column. Every box is footnoted; footnotes with further explanation appear in this text.

The bold black lines represent what will most often be the best choice. The gray lines are also possibilities, but will be the best choice less often.

You should also remember that a model may be better built in parts, like the spider model or the lofted sword. It may be best to build each part using a different method.

1. *Do you have images that could be used to create a texture map with a reasonable amount of work?*

 The spider and the sword are both examples of this. The pagoda reference image required somewhat more work to convert into a usable texture. The buddha reference images demand even more time and effort. Creating the texture for the model, as described in Chapter 7, provides greater control. Answer *yes* to this question when you know it will be very simple to create your texture from available imagery (such as the model reference) and apply it; otherwise answer *no*.

2. *Did you answer no to question 1, or do you simply prefer to work with the form and think about the texture later?*

 You may not be creating an object that exists in the real world, or for other reasons you may prefer to use the modeling process to experiment with the form. Some will simply prefer not to start with the texture.

A1–1 Chart of the process to decide the right modeling approach

3. *Does your model lend itself to planar mapping (possibly with minimal Unwrap UVW work)?*

 Again, the spider and sword models are good examples. Such models are usually fairly simple and low poly. Both the spider and the sword also work because they are relatively flat, and initial planar mapping covers most or all parts of the model. In the case of the spider, only adjustment of planar mapping was necessary; with the sword, planar mapping had to be applied along different axes.

4. *Can your model be built in such a way that it can be mapped with planar mapping (possibly with minimal Unwrap UVW work)?*

 The spider can be adjusted, its legs bent into various poses, but it was built in a way that made the mapping easy. Consider whether you can build your model in such a way that the texture can be easily applied, and, with reasonable effort, change the shape later.

5. *Have you answered no to all of the questions above?*

 Proceed to the next column. Create your model using the most appropriate method, and paint your texture map later, probably using Chilliskinner to apply texture coordinates.

6. *Is your model flat—of even thickness in one dimension?*

 If so, it is probably a prime candidate for extrusion. If it is nearly flat, you might consider starting with extrusion and proceeding to Edit Mesh or Editable Poly.

7. *Does your model consist of shapes that can be created by reasonable alterations of simple primitives?*

 If so, starting with primitives is probably the best approach.

8. *Is your model radially symmetrical?*

 Radial symmetry means that the model is symmetrical about a central point. The pagoda model is an example. Such models are most easily built through lathe or lofting. Lofting becomes the best choice when different cross-sections are of different shapes or the path is curved.

9. *Is your model suitable for lofting?*

 Cross-sections of very different size and shape can cause problems with lofting, as in the hilt guard of the lofted sword model. Often the model can be built in separate parts, with one or more parts lofted.

10. *Have you answered no to all of the questions above?*

 If you have considered the other options as starting points to be followed by an Edit Mesh or Editable Poly approach, and you have ruled out making the model

as separate parts, then it is likely that box modeling or patch modeling are your best options.

11. *Will you need various LOD models?*

 This is a question you should always ask yourself at this stage, regardless of all previous considerations. If you need LOD versions, you should consider all other options before working from primitives, box modeling, or patch modeling. If you choose patch modeling (and the game engine doesn't use patch models to create LOD on its own), the polycounts between procedurally generated LOD models will be large, and it may require work in Edit Mesh or Editable Poly to bring the polycount down. If you choose box modeling, you should try to create the lower LOD models as you work toward the highest.

12. *Extrusion, possibly followed by Edit Mesh or Editable Poly*

 If your model is nearly flat, you might consider starting with extrusion and proceeding to Edit Mesh or Editable Poly.

13. *Primitives, followed by Edit Mesh or Editable Poly*

14. *Lathe*

 This gives you excellent control over the polycount and mapping.

15. *Loft*

 This gives you excellent control over the polycount and mapping. Very complex models can be built using this procedural approach.

16. *Box Modeling*

17. *Patch Modeling*

18. *Did you build your model for an existing texture?*

 This choice was made previously. If your answer is yes, it is now simply a matter of applying UVWs, assuming you haven't done that as you modeled.

19. *Does the default mapping work for your particular model?*

 If so, you should strongly consider using it, since it may mean that you can probably make various LOD models without the need to remap the model. Consider the various lofted models as examples.

20. *Did you answer no to all of the questions above?*

 If the model is relatively low poly, or otherwise quite simple, it still may be the case that UVW Map and Unwrap UVW are your best options. Otherwise, you will need to unwrap your model in order to apply UVWs.

21. *Chilliskinner*

 Unwrap your model and planar map it before reassembling it.

22. *Planar mapping, Unwrap UVW*

23. *Default mapping, Unwrap UVW*

24. *Texporter*

 Use Texporter to make a template that you will use to paint the texture map.

25. *Paint your texture*

 You may paint the texture from scratch or you may use reference images, selecting the various parts and fitting them to the template.

GLOSSARY

alpha channel Digital images often store color information separately for each primary color. Three separate channels store red, green, and blue values. An additional channel can be added to many types of digital image. When it is used as an indicator that certain parts of the image are transparent to various degrees, it is called an alpha channel.

bezier splines 3D curves, the shape of which is controlled by vertices placed by the user and by "handles," which can be adjusted to define the shape of the curve between the vertices. Pierre Bezier developed bezier curves in the 1970s.

bitmap An image (or other set of data) represented as an array of dots. In bitmap graphics, an image is made up of many of these dots, called "pixels." Each pixel in the image is described using one or more bits; the number of bits per pixel determines how many different colors (or shades of gray) can be displayed. In a one-bit system, there is only one bit per pixel, and the result is a two-color image. Two bits allow four possible values per pixel. Eight bits allow 256 colors. "Bitmap" is used to refer to both the image and to the file that contains the data for the image.

box modeling A heavily manual modeling approach that involves starting with a simple primitive, such as a box, and creating from it any model whatsoever by moving vertices around one at a time or in groups, adding vertices, welding vertices, and dividing and/or extruding faces and edges.

bump mapping In bump mapping, a bitmap is used to add detail to a model without adding more polygons. Operations performed during the lighting of an object make the surface appear to have detail that is not present in the geometry. Bump mapping uses a grayscale image or only the value information from a color image. If you have a gray bump map image, a white dot creates a bump on the surface it was mapped to, while a black dot in the bump map would appear as a dimple on the surface.

closed mesh A 3D model in which the surface completely encloses some volume. A closed mesh can be said to have an outside surface and an inside surface, which is never visible.

coordinate system A method of representing points in a space of given dimensions by coordinates. 3D computer graphics generally uses the Cartesian Coordinate System, in which the coordinates of a point are its distances from a set of perpendicular lines that intersect at an origin. The labels x, y, and z are used to refer to the three dimensions and to the three perpendicular lines, called "axes."

contrast The degree of difference between the brightest and darkest parts of an image.

edge In a polygonal model, an edge is a line segment that connects two vertices. A triangular polygon has three edges.

edge loops Edge loops are circular patterns of polygon edges defined by the user in some software to aid in facial animation.

edged faces When Edges Faces are displayed in 3D Studio MAX, the polygon outlines are drawn over the shaded surface of all models.

editable mesh In 3D Studio MAX, an editable mesh is a model that allows for the editing of its vertices, edges, faces, polygons, or elements, as if an Edit Mesh modifier had been added to the stack.

editable poly In 3D Studio MAX, an editable poly is a model that allows for the editing of its vertices, edges, borders, polygons, or elements.

extrusion A 3D modeling process by which two-dimensional shapes are given thickness in the third dimension, making them 3D models.

face A surface element, bounded by three or more line segments, connecting three or more points (also called a "polygon"). Typically, three-sided polygons are called "tris," and four-sided polygons are called "quads." In 3D Studio MAX, a face is three-sided, while a polygon has four or more sides.

faceted shading A style of shading where each polygon is filled with a single color.

game engine The software part of a game, which, among other things, handles the lighting, physics, user input, and rendering. The game's design and plot, animations, world, and character art are displayed and executed by the engine.

global coordinate system (*See* **coordinate system**.) In 3D software that allows for the use of various coordinate systems, the global coordinate system is the one that never changes. (Also called a "world coordinate system.")

global origin The center of the computer graphics universe—the point where the x, y, and z axes intersect. In 3D software that allows for local (and other) origins, the global origin is the one that never changes. (Also called "world origin.")

Gouraud shading One of the simplest forms of smooth shading, Gouraud shading uses linear color interpolation.

hardware platform The hardware on which a game is built, such as the Playstation 2, the Xbox, or your PC.

interpolation The process of estimating a missing value by taking an average of known values at neighboring points.

isometric Literally, "equal measurement"—applied when the true dimension of an object is used to construct a drawing representing that object on a two-dimensional surface. An isometric is often a single view with vertical lines representing height, and in which width and depth are measured at 30 degrees to the horizontal plane.

level Term used to refer to a single environment in a multi-environment game where gameplay moves progressively from one environment to the next.

line A one-dimensional entity; it has a length, but no width or depth.

local coordinate system Some 3D software provides greater and more convenient control over transformations of objects by giving each object its own local coordinate system. Each local coordinate system can be transformed relative to the world, and each object is transformed with its own local coordinate system.

map (*See* **level**.)

mapping The process of specifying the manner in which a bitmap or procedural texture is applied to a surface.

material In 3D Studio MAX, a material is a collection of attributes that define the look of a model's surface.

Meshtools A plugin offering a set of additional tools (created by Laszlo Sebo). This toolset complements the existing tools associated with Poly Objects in 3D Studio MAX, and includes a number of selection and geometry editing tools.

modifier stack A kind of list of all operations performed to create a model in 3D Studio MAX. Specifically, it lists the modifiers used.

NURBS Curves Non-Uniform Rational B-Splines; 3D curves, similar to bezier splines, which can be used to define NURBS surfaces. The relationship of NURBS curves to NURBS surfaces is much like that of polygonal edges to polygonal faces.

opacity map A method of using a digital image to specify varying degrees of opacity over the surface of a model.

open mesh A 3D model in which the surface *does not* completely enclose a volume. Thus, the inside surface of an open mesh model, if drawn, may be visible when looking at the outside of the model.

origin The center of a given coordinate system; the point where the x, y, and z axes intersect.

orthographic A technique for representing three-dimensional objects on a two-dimensional surface. A typical orthographic drawing uses three views, each perpendicular to the others.

parametric modeling Any modeling approach that allows adjustments to the model by changing one or more parameters in the software.

patch A surface similar to a polygon, but made up of splines or NURBS curves rather than straight line segments.

patch modeling Modeling with patches; spline-based modeling.

Phong shading A method of smooth shading that uses vertex normal interpolation. Phong shading produces smoother surfaces and more accurate highlights compared to Gouraud shading.

pivot point Center of transform of an object.

pixel Computer images are composed of many discrete dots of color; each dot is called a picture element, or pixel. A computer monitor displays pixels (so does a television). Pixels are also the dots of color that make up a digital image; however, these pixels may not correspond directly to the pixels on a computer monitor. For example, a digital image may be displayed on your monitor in such a way that numerous screen pixels form a single pixel of the digital image.

planar mapping A basic type of UVW mapping in which a texture or other map is applied to a surface via linear projection.

planar projection A two-dimensional rendering, often of a three-dimensional object, and often viewed along one of the three axes without perspective.

point A location in 3D space; a zero-dimensional entity that has no width, length, or depth.

poly object In 3D Studio MAX, another way of referring to an editable poly.

polygon A surface element bounded by three or more line segments, connecting three or more points (also called a "face"). Typically, three-sided polygons are called "tris," four-sided are called "quads." In 3D Studio MAX, a face is three-sided, while a polygon has four or more sides.

primitive A simple geometric shape such as a cube, sphere, or cylinder.

quad A four-sided polygon.

quad menu A type of menu used in 3D Studio MAX; when the user clicks the right mouse button in a viewport, four menus open simultaneously on four sides of the cursor so that each menu can be reached with minimal movement of the mouse.

render The drawing of 3D models by a computer.

rotation The turning of an object about its center, origin, or pivot point.

saturation Vividness of color. An image with 0 color saturation has no color, like a black and white photograph.

scale Increase or decrease in the size of an object.

seam Unwanted lines that show up in textures; commonly, seams appear where the left and right (and top and bottom) edges of a tiled texture meet. Seams can be painted so that they are not apparent when a texture is tiled. Seams can also appear when parts of a texture that are not next to one another in the texture image are placed next to each other—on the surface of a model, for example.

set piece A model that is intended as an aesthetic center of interest in a game environment. A set piece often contains more polygons than the average model used in a given game.

shading The drawing of each polygonal surface of a model responding to light, not just the line segments that define each polygon. Shading can be very simple, as in the case of flat shading, where each face is filled with a single color. Of course it can be much more complex, including, for example, highlights and/or texture maps.

skew A transformation in which an object is effectively translated by varying amounts along an axis.

skinning Creating a new texture to change the look of an existing player model in a digital game.

smoothing group Groups of faces can be assigned to smoothing groups. Smooth shading is performed between faces within a smoothing group, but not between neighboring faces in different smoothing groups.

software platform The software that makes a game run; *see* **game engine**.

solid texture (*See* **world coordinate mapping**.)

spline A curved line; bezier splines are one type.

spline cage A mesh made up of a network or "cage" of intersecting splines, used to create patch surfaces.

spline interpolation A non-linear interpolation that simplifies the process of creating curved lines.

sub-division A process by which the polygons of a surface are divided to increase the total number of polygons. These additional polygons can be used to increase the amount of surface detail. A smoother derived surface can be created from the lower polygon "cage."

surface The boundary of a three-dimensional figure. "Surface" can be used to refer to a polygon or to an entire polygonal or spline surface.

surface normal Often calculated for each polygon of a model, a surface normal is a ray that runs perpendicular to the plane of the polygon from the center to infinity in the direction the polygon is facing. Used in lighting calculations.

texture mapping (*See* **UVW mapping**.)

texture set A number of textures that have a common theme, often intended to be used together.

tile Tiling is the repeating of a single texture over a large surface.

transformation Changing the position, rotation, or scale of an object.

translation A transformation of the position of an object.

tri A three-sided, or triangular, polygon.

UVW mapping The process of specifying the manner in which a bitmap or procedural texture is applied to a surface.

vertex, vertices A location in 3D space. "Vertex" is singular, "vertices" is plural.

vertex normal The normal of a vertex is the average of the surface normals of all faces of which that vertex is a part.

vertex normal interpolation The process of estimating a surface normal value by taking an average of known vertex normals at neighboring points, used in lighting calculations for surfaces.

viewport In 3D Studio MAX, the different orthographic views are displayed in separate windows within the interface. These windows are called "viewports."

weld The fusing of two or more vertices into a single vertex.

wireframe A drawing of a model in which only the edges of the polygons are drawn.

world coordinate mapping A type of mapping that is a common default in level or map editors. In such a system, textures have an absolute size; in the case of *Quake III Arena*, a texture map of 256 pixels square occupies 128×128 units of world space. Apply any texture to a surface and it will have this type of mapping applied. If the surface sits with one edge at 0,0,0, the center of the coordinate system, then the texture that appears on that surface will have one corner at that point—and the opposite corner at 128,128,0. Textures tile by default, so the entire surface will be covered by repeating or "tiling" the texture. (Also called "solid texture.")

world origin (*See* **global origin**.)

GLOSSARY